THE
DRESS
DETECTIVE

Bloomsbury Academic
An imprint of Bloomsbury Publishing Plc

50 Bedford Square 1385 Broadway
London New York
WC1B 3DP NY 10018
UK USA

www.bloomsbury.com
BLOOMSBURY and the Diana logo are trademarks of
Bloomsbury Publishing Plc

First published 2015
Reprinted 2017 (twice)

British Library Cataloguing-in-Publication Data
A catalogue record for this book is available from the British Library.

ISBN: HB: 978-1-4725-7398-8
PB: 978-1-4725-7397-1
ePDF: 978-1-4725-8053-5
ePub: 978-1-4725-8054-2

Library of Congress Cataloging-in-Publication Data
Mida, Ingrid.
The dress detective : a practical guide to object-based research in fashion / by Ingrid Mida and Alexandra Kim.
pages cm
Includes bibliographical references and index.
ISBN 978-1-4725-7398-8 (hardcover) — ISBN 978-1-4725-7397-1 (pbk.) 1. Fashion—Research—
Handbooks, manuals, etc. 2. Clothing trade—Research—Handbooks, manuals, etc. 3. Fashion design—
Research—Methodology—Handbooks, manuals, etc. I. Kim, Alexandra. II. Title.
TT497.M54 2015
746.9'2072—dc23
2014049148

Designed by Evelin Kasikov
Printed and bound in India

Cover image: Detail of sleeve on cream silk bodice, c.1890s.
Gift of Alan Suddon, Ryerson FRC1999.06.006.
Photo by Ingrid Mida.

To find out more about our authors and books visit www.bloomsbury.com.
Here you will find extracts, author interviews, details of forthcoming events
and the option to sign up for our newsletters.

THE
DRESS
DETECTIVE

A PRACTICAL GUIDE
TO OBJECT-BASED RESEARCH
IN FASHION

INGRID MIDA

ALEXANDRA KIM

SOCIETY OF
ANTIQUARIES
OF LONDON

Bloomsbury Academic
An imprint of Bloomsbury Publishing Plc

B L O O M S B U R Y
LONDON · OXFORD · NEW YORK · NEW DELHI · SYDNEY

Contents

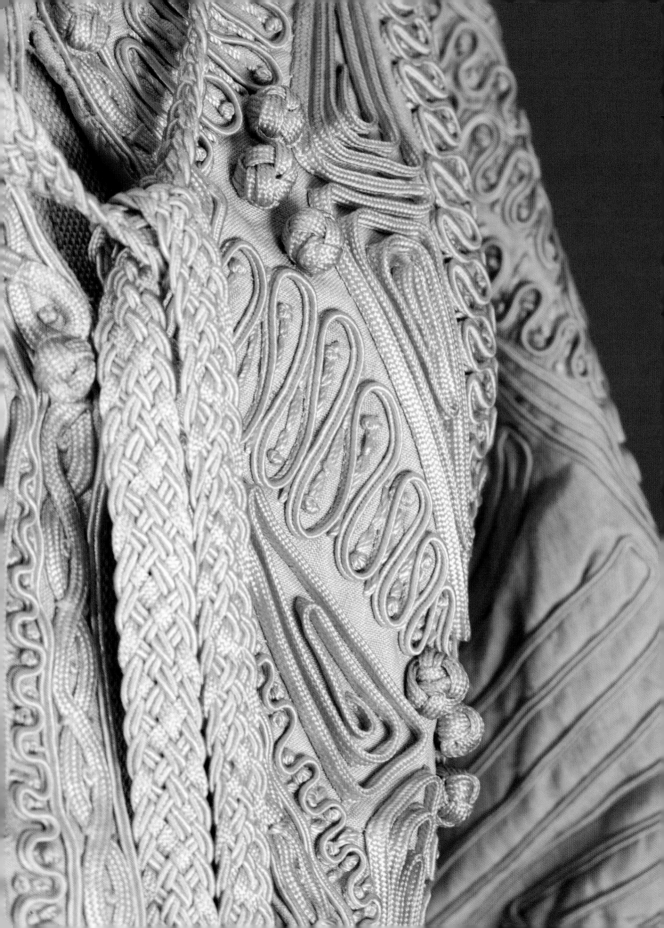

Foreword

Stella Blum, former Curator-in-Charge of The Metropolitan Museum of Art's Costume Institute, and the first director of the Kent State University Museum, believed deeply in the education of those embarking on careers focused on dress and dress history. Her philosophy for object-centered research was based on her oft-repeated phrase, "learning to look." In this book Ingrid Mida and Alexandra Kim provide a pathway for this essential skill. What the authors describe as "Observation," "Reflection" and "Interpretation" is precisely what Stella Blum had in mind. Real looking is not something one can accomplish with a quick glance, and indeed, the authors advocate "slow looking." It is so easy today to take a quick digital image of an object and assume that the image will tell you everything you need to know, anytime. To the chagrin of many, upon viewing an image apart from the object, it is almost impossible for the image to have captured all of the information necessary to adequately understand the complexity of detail, or the significance of any specific item of dress.

The difficulty of understanding the dress artifact increases the further removed the researcher is from the time and place of the object's creation. The conventions of making a dress at any given moment in history, and in any particular place, are part of a broad and inclusive cultural context. In many cases, both the wearer and the maker are unknown. With bespoke examples of Western fashion the decisions of the client and dressmaker or tailor together determine the garment. Was the client conservative or avant-garde? Was the maker attuned to the fashion of the time? What were the political, social, and economic considerations? In the case of apparel created outside the tradition of Western fashion, the necessary explorations of time and place expand profoundly. Very often there are no absolute answers, and the researcher finds it necessary to hypothesize.

OPPOSITE

Bodice of cream silk ladies' jacket
c.1914. Gift of Katherine Cleaver, Ryerson
FRC2014.07.473A. Photo by Ingrid Mida.

The reader will find Ingrid Mida and Alexandra Kim especially helpful in the formulation of research hypotheses. The authors have listed questions within the text, and as a checklist in the appendices, that the researcher should ask when looking at a dress artifact. These questions provide a sound basis of inquiry. Observable facts alone are only part of the process of understanding a garment. It is only natural for an observer to make assumptions about a piece of clothing based on personal experience. Discovering which of these assumptions are warranted and which are not is critical to understanding the reality of the object. The authors term this aspect of study "Reflection." It is only after careful observation and reflection that the artifact can be understood thoroughly enough to be interpreted through exhibition or publication.

Apart from mass-produced clothing, each dress artifact is as unique as the person who ordered, purchased and wore it. It might even be argued that observable facts of wear make mass-produced garments unique. The ambiguities to be found in any object-based study of dress make the interpretation of the artifact fraught with issues. Many objects belie the most widely proclaimed theories. As the authors advise, fashion theory can only assist the researcher in the analysis and evaluation of the evidence gained through observation and reflection. There are rarely absolute conclusions, but there can be well-reasoned hypotheses. Above all, it is the cultural complexity inherent in the dress artifact that resists generalization.

The Dress Detective reveals the challenges facing those committed to object-based research in dress and dress history. In doing so it provides a guide for the thorough understanding of a dress artifact. Those of us who have spent our careers considering the questions detailed in this book know the rewards of "learning to look." We know the frustrations and pleasures of deciphering cultural contexts, and the sense of accomplishment when understanding is achieved. Dress is so much a part of life that its cultural significance is often overlooked. Any item of apparel has much to reveal about the time and place of its creation, and the unique forces that gave it shape and substance.

Jean L. Druesedow

Kent State University Museum
November 18, 2014

Acknowledgments

It takes a cadre of people to produce a book. The authors would like to acknowledge all the staff at Bloomsbury involved in the production, especially editor Emily Ardizzone, who initially suggested that we take on this project.

There are many people that facilitated the research and photography of garments used in the case studies: Katherine Cleaver, Charlotte Fenton, Lexy Fogel, Lu Ann Lafrenz, Jazmin Welch, and especially Robert Ott, Chair of the School of Fashion at Ryerson University. We wish to express our appreciation to those that assisted with our research, including Neil Brochu, Hilary Davidson, Sophie Grossiord, Laure Harivel, Patience Nauta, and Catherine Orman.

We also give sincere thanks to our friends and colleagues, who supported the need for this book, including Jean Druesedow, Edwina Ehrman, Amy de la Haye, Alison Matthews David, and Lou Taylor.

We are very grateful to the Society of Antiquaries of London for choosing us as recipients of the 2014 grant from the Janet Arnold Fund, to facilitate the purchase of images for this book. We would also like to express our thanks to the Sir Arthur Conan Doyle Literary Estate for permission to include the extract from *The Adventure of the Blue Carbuncle*.

Finally, we would like to extend our deepest thanks to our families who cheered us on through the most difficult moments, including Dan Mida, and the late Magdalene Masak, as well as Henry Kim, Sheena and Patrick MacCulloch, and Laura MacCulloch.

Ingrid Mida and Alexandra Kim

Introduction

"Then, what clue could you have as to his identity?"

"Only as much as we can deduce."

"From his hat?"

"Precisely."

"But you are joking. What can you gather from this old battered felt?"

"Here is my lens. You know my methods. What can you gather yourself as to the individuality of the man who has worn this article?"

I took the tattered object in my hands and turned it over rather ruefully. It was a very ordinary black hat of the usual round shape, hard and much the worse for wear. The lining had been of red silk, but was a good deal discoloured. There was no maker's name; but, as Holmes had remarked, the initials "H. B." were scrawled upon one side. It was pierced in the brim for a hat-securer, but the elastic was missing. For the rest, it was cracked, exceedingly dusty, and spotted in several places, although there seemed to have been some attempt to hide the discoloured patches by smearing them with ink.

— SIR ARTHUR CONAN DOYLE (1892: 75)

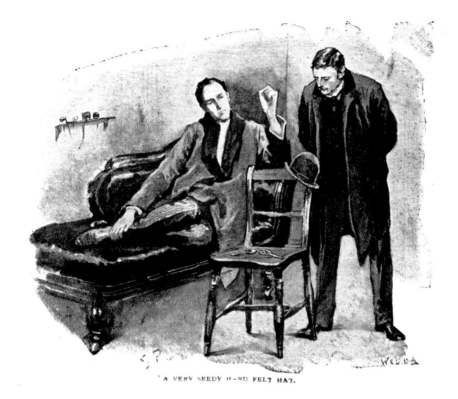

'A VERY SEEDY HARD FELT HAT.'

Figure 0.1.

**Illustration of Sherlock Holmes and
Watson by Sidney Paget for "The
Adventure of the Blue Carbuncle,"
Strand Magazine January 1892, p.73.**

In this scene between Sherlock Holmes and Watson from *The Adventure of the Blue Carbuncle,* by Sir Arthur Conan Doyle, Watson struggles to read the clues in an ordinary black hat (Figure 0.1). For Sherlock Holmes, its appearance—discolored red silk lining, the initials, the dust, the spots—tell a story of a man who was an intellectual, was once well-off, but who had fallen upon hard times, recently had his hair cut, and whose wife had ceased to love him.

Unlocking the personal and cultural narratives hidden in the folds of a garment is a little bit like being Sherlock Holmes. A dress detective looks for and interprets the clues, including the details of cut, construction and embellishment, evidence of how the garment was worn, used or altered over time, as well as the relationship of the garment and its materials relative to the body and the period from which it came (Figure 0.2). The close analysis of dress artifacts can enhance and enrich research, providing primary evidence for studies that consider fashion and clothing from perspectives such as history, sociology, psychology, and economics.

Material culture analysis is a research methodology that considers the relationship between objects and the "ways in which we view the past and produce our narratives of what happened in the past" (Pearce 1992: 192).

Clothing and accessories, including hats, footwear, jewelry, hairstyles, tattoos, and other forms of body adornment (hereafter referred to as "dress"), are objects created by man and thus reflect the cultural milieu in which they were designed, created and worn. Unlike the textual accounts of history, ordinary objects such as clothing can be seen as "less self-conscious and potentially more truthful" about a culture (Prown 1982: 4).

The study of material culture has a long history as a discipline, especially in the fields of anthropology and art history. In fashion studies, some scholars do not appreciate the value of examining actual garments, dismissing such work as no more than a cataloguing exercise. In 1998, curator Valerie Steele wrote: "Because intellectuals live by the word, many scholars tend to ignore the important role that objects can play in the creation of knowledge.

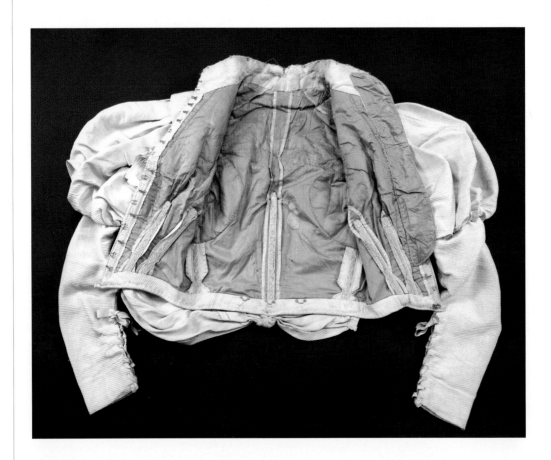

Figure 0.2.

Cream silk bodice c.1890s.
Gift of Alan Suddon, Ryerson
FRC1999.06.006. Photo by
Ingrid Mida.

Even many fashion historians spend little or no time examining actual garments, preferring to rely exclusively on written sources and visual representations" (1998: 327). In 2013, curator Alexandra Palmer echoed this sentiment when she wrote: "The seemingly old-fashioned museum-based approach of fashion studies, which begins with a description of the object, is a complex and underutilized approach for new scholars" (2013: 268).

This book aims to serve the scholar who is unfamiliar or new to object-based research in fashion, and includes checklists and case studies to articulate a skillset that has, until now, largely been passed on informally, typically from curator to assistant. Written in plain language, this book can also be used by anyone with a family heirloom or dress artifact to help discover the biography of the object.

The book begins with a brief history of object-based research in fashion studies, highlighting the work of some key players who have advocated for this type of research over the last century; for example, Doris Langley Moore, Jules David Prown, and Alexandra Palmer. Chapter 2, "How to Read a Dress Artifact," introduces a *Slow Approach to Seeing* as the praxis to yield optimal results from an examination of dress artifacts. Subsequent chapters reveal and explain the steps of Observation, Reflection, and Interpretation. The selected case studies in the latter half of the book illustrate how this approach can be used with a variety of different types of Western dress artifacts, dating from the early nineteenth century to the present day, and are ones that might typically be encountered when using a museum or study collection. These case studies articulate the methodological framework for the process, illustrate the use of the checklists, and show how evidence from the garment itself can be used to corroborate theories of dress or fashion. The "Checklist for Observation" and the "Checklist for Reflection" are included as appendices.

REFERENCES

Conan Doyle, A. (1892), 'The Adventure of the Blue Carbuncle," *The Strand Magazine*, January: 73–85.

Palmer, A. (2013), "Looking at Fashion: The Material Object as Subject," in S. Black, A. de la Haye, J. Entwistle, R. Root, H. Thomas and A. Rocamora (eds.), *The Handbook of Fashion Studies*, London: Bloomsbury: 268–300.

Pearce, S. (1992), *Museums, Objects and Collections: A Cultural Study*, London: Leicester University Press.

Prown, J. (1982), "Mind in Matter: An Introduction to Material Culture Theory and Method," *Winterthur Portfolio*. 17 (1): 1–19.

Steele, V. (1998), "A Museum of Fashion is more than a Clothes-Bag," *Fashion Theory*, 2 (4): 327–335.

Taylor, L. (2002), *The Study of Dress History*, Manchester: Manchester University Press.

1 A Brief History of Object-based Research with Dress Artifacts

These surviving clothes illustrate the reality of children's dress in all its different qualities of fabric and construction. The identities of the children who wore them do not always survive with the clothes, but each surviving garment bears the imprint not only of the child who wore it, but also of part of a way of life.

— ANNE BUCK (1996: 15)

Whether saved at the back of a closet or preserved at great expense in archival storage as part of a museum or university study collection (Figure 1.1), dress artifacts have a history that can be read and interpreted. In an analysis of the surviving wardrobes of the Messel family, curator Amy de la Haye wrote that clothing that is kept beyond its fashionable life often has "symbolic qualities" and holds "personal memories" for the owner (2005: 14).

Although we all wear clothes, it can be difficult to unpack the multifaceted narratives embedded within these objects, since garments as artifacts embody "complex composites with multiple histories" (Palmer and Clark 2005: 9). Designed to be worn or adorn the body, garments incorporate functional elements, as well as symbolic and aesthetic qualities that echo the cultural norms of a particular time and place. Inherent in the design and production of clothing are technical choices reflecting the cost and availability of materials (Figure 1.2), such as the use of a zipper instead of buttons, or synthetic fabrics instead of natural fibers. The garment or accessory can also reveal the multitude of design choices that may serve to highlight or obscure certain parts of the body, reinforce or neutralize gender, or imbue political or social messages. In its use and wear, dress is subjected to the demands and whims of its owner, bearing the marks

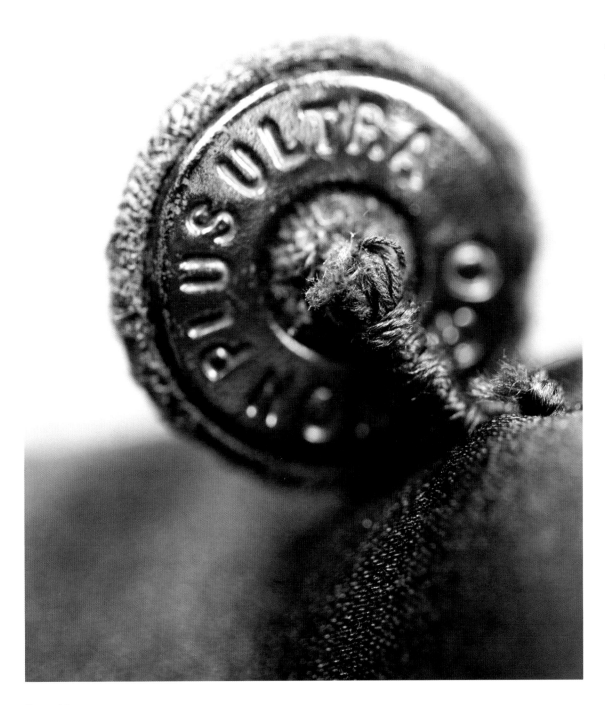

Figure 1.2.

Button on men's tailcoat, 1932.
Gift of Maureen Harrington,
Ryerson FRC2002.02.001A.
Photo by Ingrid Mida.

and strains of wear, as well as decomposition from the effects of light, moisture, pests, and soiling.

Collecting dress artifacts to illustrate the history of Western dress is a relatively new aspect of museology. Although many museums initially preserved garments within their textile collections, or collected artifacts from aboriginal or indigenous peoples as an anthropological exercise, the formation of separate departments collecting objects of Western dress did not occur until well into the twentieth century. For example, the Victoria and Albert Museum opened in 1852, and established its first collection of dress, as opposed to accessories or decorative textiles, after receiving the costume collection of the painter Talbot Hughes (1869–1942) in 1913. Similarly, the Metropolitan Museum of Art in New York opened in 1866, but the Costume Institute was not established until 1946.

The terms "dress" and "fashion" are sometimes used interchangeably, and although the precise definitions are contested, there are subtle differences in meaning. The term "dress" is used in this book in reference to all clothing and accessories that exist in material form, including hats, footwear, jewelry, hairstyles, tattoos, and other material forms of body adornment. The term "fashion" is used to describe garments and accessories that adorn the body in a manner that reflects the "the cultural construction of embodied identity," as it is defined by the journal *Fashion Theory*.

Object-based research has its origins in the fields of anthropology and art history, and many renowned scholars, including Igor Kopytoff and Daniel Miller from these disciplines, have made important contributions to the field of material culture research.[1] Within fashion studies, the history of object-based research using dress artifacts is comparatively brief, and this chapter focuses on some of the key figures whose work has particularly influenced the approach to studying dress artifacts that is advocated in this book.

Among the first to appreciate the value of studying dress artifacts was private collector and self-taught dress historian **Doris Langley Moore** (1902–1989), who argued that the evidence found in the garments themselves belied the optical illusions seen in print (1949: 16f.). Langley Moore measured over 2,000 dresses, corsets and other garments with a waist, to refute the myths that women wore corsets to achieve an eighteen-inch waist, and that women had grown taller since the eighteenth century (Langley Moore 1964: 21). Her impressive collection (Figure 1.3) became the foundation of what is now the Fashion Museum in Bath, England, where research appointments are available to students and visiting scholars.[2]

LANGLEY MOORE COLLECTION

Object:

Country: Date:

Inscription
 or label:

Material:

Measurements:

Description:

Source: Room:

 Case:

Approximate value: (For remarks see other side)

Figure 1.3.

**Doris Langley Moore
Collection Record Card,
undated.** Private collection.

Another early advocate for object-based research was dress historian and curator **Anne Buck** (1910–2005). During her tenure as Keeper of the Gallery of English Costume, at Platt Hall in Manchester, England, between 1947 and 1972, Buck championed rigorous research of surviving garments as a way of better understanding how dress of the past was produced, worn and appreciated.[3] She viewed dress as a natural part of the history of culture and society, using literature, oral history, and archival material to complement evidence found within the garments themselves. She advocated the examination of dress objects to identify alterations and recycling, not only as evidence of the shape of the wearer, but also to illustrate changes in fashion, taste, and status (Jarvis 2009: 136). Anne Buck also had a keen interest in the dress of the ordinary person, expressing the view that working class dress was as important as the clothing of the elite.

Janet Arnold (1932–1998) is perhaps best known for her meticulously drawn patterns and line drawings of historic dress in her series of books, *Patterns of Fashion*. These books have offered detailed insight into examples of surviving garments for museum curators, conservators, and dress historians, as well as providing inspiration to costumers and designers. Arnold's work advocated the value of inspecting garments first hand, and continually demonstrated the way in which studied observation could yield key information about construction and the wearing of dress. Her 1973 *Handbook of Costume* delivered a guide to the riches of dress collections held in many British museums, and also offered advice about taking a pattern from surviving garments.

Although art historian **Jules David Prown** was not the first to propose a model for artifact study, his advocacy for object-based research is still cited by fashion scholars.[4] In 1980, Prown wrote an article called "Style as Evidence," in which he suggested that stylistic analysis, often used as an art-historical procedure, could be of value to scholars in other fields. Prown argued that style, defined as "the way something is done, produced or expressed," offered a non-textual link to the past that was more authentic than textual accounts. Using case studies of furniture and silver tea sets, Prown concluded that the analysis of the stylistic qualities of those objects allowed "direct sensory experience of surviving historic events, not necessarily important events, but authentic events nonetheless" (1980: 208), and that this type of engagement could yield "a different kind of cultural understanding" for those that could overcome their reluctance to work with non-textual materials.

In 1982, Prown published an oft-cited article, "Mind in Matter: An Introduction to Material Culture Theory and Method," which articulated his suggested methodology by which to conduct object-based research. Prown reiterated that beliefs are presented less self-consciously in objects, and therefore offer a more truthful expression of cultural beliefs of another time, and also that objects can serve as primary evidence of the cultural views of those that made, purchased or used those items, and by extension, the society from

which they came. Prown intentionally framed this approach in general terms to be applicable to all types of objects, ranging in functionality from those created to serve utilitarian purposes, such as machines or musical instruments, to those expressing purely aesthetic functions, such as art. Prown's categorization of object utility also included items such as clothing that serves both functional and aesthetic purposes. Prown stated that objects that survive the test of time give the researcher the opportunity to have a direct sensory experience with the past, as well as offering a more honest and representative retelling of the past than might exist in written form. Borrowing from the fields of art history, archeology, and science, Prown's methodology for object analysis is set out in three discrete stages of investigation that are defined as Description, Deduction and Speculation. These broad stages of examination are broken down further into specific steps, in order to guide the researcher through this type of analysis for any category of object. Within the article, Prown noted that clothing, as a form of adornment and a reflection of personal identity and values, was an area that was ripe for future research (1982: 13).

Valerie Steele, the Director and Chief Curator of the Fashion Institute of Technology Museum, New York, was Prown's student at Yale University, and used his methodology for object-based research while she was a student, to analyze several nineteenth-century garments, including a bodice and skirt (1998: 330). In doing so, she became one of the first fashion scholars to adopt Prown's methodology for the study of dress artifacts. In one of the early articles in the journal *Fashion Theory*, Steele encouraged this type of research, and wrote that it can "provide unique insights into the historic and aesthetic development of fashion" (1998: 327).

Alexandra Palmer, the Nora E. Vaughan Curator of The Textiles and Costume Collection at the Royal Ontario Museum, in Toronto, has long advocated an interdisciplinary approach to fashion scholarship that includes material culture analysis. Noting the influence of Jules Prown in her book *Couture and Commerce: The Transatlantic Fashion Trade in the 1950s,* Palmer traced the production of couture fashion in Paris and distribution in North America to assess how real women adapted, wore and altered couture pieces to suit their lifestyle. In studying actual couture garments and tracing their origin, use and afterlife, Palmer also challenged the myth that couture was worn by elite women for a single season and then discarded. Palmer noted that few academics succeed in combining material culture with other research methods, and "remain bound in theoretical rhetoric" or adopt it "as decorative illustrative material" (2001: 8). Palmer explained her methodology as a combination of object analysis, oral history, archival research, and other documentary research. In *The Handbook of Fashion Studies,* Palmer reiterated that object-based research is not an innate aptitude of the researcher; even while it may be "assumed that we already have the necessary critical skills to evaluate fashion, when in fact it is a research skill that is learned like any other form of scholarship" (2013: 268).

In the book *The Study of Dress History*, **Lou Taylor** considered the history and nature of the void between the research of object-focused dress and textile historians and the research of economic and social historians. Noting the marginalization of fashion research as a continuing issue for academics in the field, Taylor concluded that the "most dynamic research in dress history has indeed now fused artifact-based and theoretical approaches. Where the 'valid' fine line is to be drawn between Prown's process of 'leading out' from the object into theory, or working back from theory to object is the essence of future debate" (2002: 85).

CONCLUSION

Although there is a rich legacy of object-based research in dress, there is no singular framework that offers a clear and systematic approach to the study of dress artifacts. The work of Jules Prown, although developed for artifacts in general, seems to be the methodology that continues to be cited by fashion scholars, including the 2014 book *Exhibiting Fashion: Before and After 1971,* by Judith Clark and Amy de la Haye, with a case study of a Chanel outfit worn by Diana Vreeland.

Dress artifacts are unique, embodying the haptic qualities of cloth, the aesthetic and structural qualities unique to fashion, the traces of the person that used and wore the garment, as well as aspects related to its production and distribution. These multi-layered and complex dimensions can be difficult to unravel, especially in a garment that might conflate stylistic interpretations of the latest fashions, or that has been altered to suit multiple wearers. Valerie Steele once wrote that many of her students had difficulties with the deduction and speculation steps of the Prown process, and often ended their essays with "a string of unanswered questions" (1998: 331). The authors' experiences in guiding students in museum and study collections has shown that many students are unsure about working with dress objects, especially in terms of what to do with the evidence that they have gathered. The following chapters are intended to minimize the anxiety and confusion by developing a practice-based framework unique to dress artifacts that articulates each of the steps necessary to read and reflect systematically on the evidence contained in a dress artifact. In doing so, we have taken on Patricia Cunningham's call to fashion scholars: "We should do whatever it takes to answer our research questions and, above all, when we think our questions take us beyond artifacts, we must shift, look back, and then reconsider the artifact. There is more there than we think" (1988: 78–79).

Notes

1. The scope of this book does not permit mention of all the scholars who have made important contributions to the field of material culture research. For a poignant analysis of the biography of a thing, read anthropologist Igor Kopytoff's essay, "The Cultural Biography of Things: Commoditization as Process" (1986: 64–91). For a comprehensive analysis of the relationship between anthropology and fashion, see Sarah Fee's essay, "Anthropology and Materiality" (2013: 301–324). For a consideration of the relationship between material culture and fashion studies, see Daniel Miller's essay on "Material Culture" in the online Berg Fashion Library resource (http://www.bergfashionlibrary.com/).

2. In 1963, Doris Langley Moore transferred her collection of dress to the city of Bath, opening under the name "The Museum of Costume." In 2007, the museum's name was changed to "The Fashion Museum."

3. The private collection of dress artifacts owned by London medical doctors C. Willett (1878–1961) and Phillis Cunnington (1887–1974) was sold to Manchester City Council in 1947, and used to create a museum at Platt Hall. Having taken up dress collecting as a hobby, the husband and wife team became self-trained dress historians, and wrote a number of books on dress.

4. In 1973, E. McClung Fleming published an article, "Artifact Study: A Proposed Model," in which the author noted that, outside of art history and anthropology, little work had been done to develop a theoretical framework for artifact study, or to understand "the ways in which the artifact explicitly implements, expresses, and documents a particular way of life" (1973: 154). Fleming proposed a model to study artifacts that incorporates four steps, including: Identification, Evaluation, Cultural Analysis, and Interpretation. Fleming describes the process in general terms but does not mention dress artifacts, concluding the article with the statement that "the study of material culture deserves to take its place among other humanistic disciplines" (1973: 154–175).

References

Arnold. J. (1972), *Patterns of Fashion: Englishwomen's Dresses and their Construction 1660–1860*, London: Macmillan.

Arnold, J. (1973), *Handbook of Costume*, London: Macmillan.

Arnold. J. (1977), *Patterns of Fashion 2: Englishwomen's Dresses and their Construction 1860–1940*, London: Macmillan.

Arnold. J. (1985), *Patterns of Fashion 3: The cut and construction of clothes for men and women 1560–1620*, London: Macmillan.

Arnold, J. (2000), "Janet Arnold: List of Publications," *Costume*, 34: 3–6.

Baumgarten, L. (2002), *What Clothes Reveal: The Language of Clothing in Colonial and Federal America*, New Haven: Yale University Press.

Buck, A. (1979), *Dress in Eighteenth Century England*, London: B. T. Batsford.

Buck, A. (1996), *Clothes and The Child: A Handbook of Children's Dress in England 1500–1900*, New York: Holmes & Meier.

Clark, J. and De la Haye, A., with Horsley, J. (2014), *Exhibiting Fashion: Before and After 1971*, New Haven: Yale University Press.

Cunningham, P. (1988), "Beyond Artifact and Object Chronology," *Dress*, 14: 76–79.

De la Haye, A., Taylor, L. and Thompson, E. (eds.) (2005), *A Family of Fashion: The Messels: Six Generations of Dress*, London: Philip Wilson.

Fee, S. (2013) "Anthropology and Materiality," in S. Black, A. de la Haye, J. Entwistle, R. Root, H. Thomas and A. Rocomora (eds.), *The Handbook of Fashion Studies*, London: Bloomsbury: 301–324.

Fleming, E. McClung. (1973), "Artifact Study: A Proposed Model," *Winterthur Portfolio*, 9: 153–173.

Granata, F. (2012), "Fashion Studies In-between: A Methodological Case Study and an Inquiry into the State of Fashion Studies," *Fashion Theory*, 16 (1): 67–82.

Jarvis, A. (2009), "Reflections on the Development of the Study of Dress History and of Costume Curatorship: A Case Study of Anne Buck OBE," *Costume*, 43: 127–137.

Kawamura, Y. (2011), *Doing Research in Fashion and Dress: An Introduction to Qualitative Methods*, New York: Berg.

Kopytoff, I. (1986), "The cultural biography of things: commoditization as process," in A. Appadurai (ed.), *The Social Life of Things*, Cambridge: Cambridge University Press: 64–91.

Küchler, S. and Miller, D. (eds.) (2005), *Clothing as Material Culture*, New York: Berg.

Langley Moore, D. (1949), *The Woman in Fashion*, London: Batsford.

Langley Moore, D. (1964), *Museum of Costume: The Story of the Collection*, Bath Museum Pamphlet.

Langley Moore, D. (1971), *Fashion through Fashion Plates 1771–1970*, New York: Clarkson N. Potter.

Levey, S. (1984). "The Collections and Collecting Policies of the Major British Costume Museums," *Textile History*, 15 (2): 147–170.

Levitt, S. et al. (2006), "Obituaries: Anne Buck, OBE". *Costume*, 40: 118–128.

Miller, D. (1987), *Material Culture and Mass Consumption*, Oxford: Basil Blackwell.

Miller, D. (2014), *Material Culture*, Berg Fashion Library, online resource. Available at: http://www.bergfashionlibrary.com.

Palmer, A. (1997), "New Directions: Fashion History Studies and Research in North America and England," *Fashion Theory*, 1 (3): 297–312.

Palmer, A. (2001), *Couture & Commerce: The Transatlantic Fashion Trade in the 1950s*, Vancouver: UBC Press.

Palmer, A. (2013). "Looking at Fashion: The Material Object as Subject" in S. Black, A. de la Haye, J. Entwistle, R. Root, H. Thomas and A. Rocomora (eds.) *The Handbook of Fashion Studies*, London: Bloomsbury: 268-300.

Palmer, A. and Clark, H. (eds.). (2005), *Old Clothes, New Looks: Second Hand Fashion*, New York: Berg.

Prown, J. (1980), "Style as Evidence," *Winterthur Portfolio*, 15 (3): 197–210.

Prown, J. (1982), "Mind in Matter: An Introduction to Material Culture Theory and Method," *Winterthur Portfolio*. 17 (1): 1–19.

Steele, V. (1998), "A Museum of Fashion is more than a Clothes-Bag," *Fashion Theory*, 2 (4): 327–335.

Strong, R. (2000), "Janet Arnold: An Appreciation," *Costume*, 34: 2.

Taylor, L. (2002), *The Study of Dress History*, New York: Manchester University Press.

Taylor. L. (2004), *Establishing Dress History*, New York: Manchester University Press.

"The Costume Institute," (n.d.). The Metropolitan Museum of Art. Available at: http://www.metmuseum.org/about-the-museum/museum-departments/curatorial-departments/the-costume-institute.

Figure 2.1.

**Detail of cream silk wedding
slipper, c.1889–1890.** Gift
of Ruth Dowling, Ryerson
FRC1987.04.001A+B.
Photo by Jazmin Welch.

2

How to
Read a Dress
Artifact

Material objects matter because they are complex, symbolic bundles of social, cultural and individual meanings, fused onto something we can touch, see and own. That very quality is the reason that social values can so quickly penetrate into and evaporate out of common objects.

— ANNE SMART MARTIN (1993: 141)

This chapter sets out a practice-based framework for conducting object-based research in dress. Building on the methods used by dress historians and museum curators, as well as the theoretical foundation for material culture research, articulated by scholars such as Jules Prown, this new framework is specific to dress artifacts, and is intended to guide the researcher through the process using a checklist-based approach.

All types of clothing and accessories that adorn the body, such as dresses, shoes, purses, hats, and jewelry, are artifacts of material culture, providing evidence of the cultural and social history of a period. Created to serve a range of functional and aesthetic purposes, garments and accessories may communicate concepts of identity, gender, class, belonging, aesthetics, or other social values. When a garment or accessory is divorced from its former owner and preserved within a museum, university or private collection, it becomes a dress artifact and is given a second life. The item will never be worn or altered again, and its object biography is extended. Ideally, a garment enters a collection with a provenance record that includes information about the owner or owners, where and when the item was purchased, where the item was worn, and photos of the wearer. For example, the cream wedding slippers shown in Figure 2.1 were accompanied with a note from the donor that reads:

These slippers were worn by Mary Lawson of Caledon who wed
Edward Dowling (a telegraph operator) of Bolton in 1889 or 1890.
There is no record of where the marriage took place – either Bolton
or Caledon. Miss Lawson had a sister who lived in Buffalo so the
slippers may have been purchased there. For the wedding, Miss Lawson
wore a pale gray, long satin dress.

This type of information can materially affect the relative importance and value of an artifact, but this information is not always known, available or recorded when the item is accepted into a collection. Nevertheless, each artifact has a narrative embedded within the garment.

This book is designed to assist the researcher in acquiring all the information from the artifact that might unlock these stories, illuminate its cultural context, or answer a specific research question.

Garments and accessories are distinctly different in material form and character from other objects of material culture, in that objects of dress bear some relationship to the body that wore them. Typically made of cloth, a garment can serve to protect, adorn, mark or obscure the body. The fact that dress is worn on the body also means that the actions of the body become imbued in the cloth, especially at points of contact with body parts that move, such as the elbows, the knees, or parts that sweat. These marks provide evidence of a personal history in the garment's biography, and "a single garment may be significant because of the relationship between its particular material form and the body that wears it" (Dant 1999: 86). This intimate relationship to the body offers the researcher additional clues to create a narrative for that artifact.

In suggesting a methodical approach to the reading of dress artifacts, based on the unique characteristics related to their cut, construction, textiles, labelling, use and wear, the authors have drawn on their experiences in assisting students, faculty, and researchers. The checklists provided in the appendices, and annotated in the subsequent chapters, are designed to guide the researcher systematically through the process. Since access to dress artifacts in museum collections is typically predicated on having a specific research question, and is usually only possible through a prearranged research appointment with time constraints, this methodology is designed to be practical and easy to use. This chapter provides a general overview of the framework, and subsequent chapters provide detailed guidance for each step.

The process of conducting object-based research in dress can be divided into three main phases, including:

Observation: Capturing the information from the dress artifact
Reflection: Considering embodied experience and contextual material
Interpretation: Linking the observations and reflections to theory

1. OBSERVATION

The first step in analyzing an artifact, whether a dress or a painting, involves the observation and description of that artifact. In the methodology advocated by Prown, this first step is called "description", and factual evidence related to the object is obtained and recorded, recognizing that the object is being read at a particular moment in time, and will have changed in some manner since its initial creation. This initial phase of description, as outlined by Prown, includes the measurement and recording of the physical dimensions of the object, an expansive description of the materials used in creating it, and an analysis of the decorative properties and implied representations seen in the object under examination, with emphasis on the visual character of the object in terms of color, light, texture, rhythm and form.

As an alternative, this book proposes *Observation* as the first phase of object-based research and incorporates all the steps necessary to capture the information presented by the dress artifact (Figure 2.2). The goal of the

Figure 2.2.

Bodice detail of peach silk and chiffon dress, Edgley Toronto, c. 1910–1912. Anonymous Gift, Ryerson FRC2013.99.036. Photo by Ingrid Mida.

first phase is to secure enough factual information to be able to create a rich description of the artifact that can provide a visual image of the garment if the text was read aloud. The Observation phase outlined in the checklist has been designed specifically for dress artifacts. Moving from general to specific, the checklist offers a question-based methodology to guide the researcher through the examination of dress artifacts. Observation of all aspects related to the artifact, including elements related to construction, textiles, labels, and evidence of use/wear/alteration, are detailed in the checklist, and annotated extensively in Chapter 3.

The underlying premise is a method of looking, which we call a *Slow Approach to Seeing*. Like other slow movements that advocate patience, a *Slow Approach to Seeing* promotes looking carefully and thoughtfully, to appreciate all the evidence at hand. Sherlock Holmes carefully considered the visual clues in the hat before him, while Watson did not. Dress artifacts are particularly challenging since minute details can easily be missed, especially if there are time constraints. Making a mental shift to slow down, work methodically and carefully, and taking the time to make close observations are the keys for success.

2. REFLECTION

Reflection is a phase of contemplation. In Prown's methodology, the second step in conducting object-based research is called "deduction," during which Prown suggested that the researcher engage in an emotional and sensory engagement with the artifact, in order to help identify cultural and personal biases. Since this step is often confusing to researchers, we propose an alternative and more comprehensive phase of *Reflection*, which is designed to take place after the examination has been completed.

The stage of Reflection is a time of thoughtful contemplation that is separate and distinct from the Observation phase. This contemplation builds on our innate knowledge of whether or not we would wear a garment, and whether it would fit or be comfortable on our body. This emotional and sensory engagement with the object often takes place subconsciously, especially since we are drawn to garments that we like and might wear. In this stage, the researcher is invited to pause and reconsider their experience of examining the garment, making written notes that are more personal in nature as to how the garment felt, smelled, and looked, since these reactions are a guide to the shifts in cultural beliefs between the time at which the garment was created and the present. Noticing these shifts helps the researcher consider how the garment relates to the period and society from which it originated. Although the process of reflection occurs intuitively, writing down these types of personal observations helps the researcher identify personal biases,

Figure 2.3.

**Cabinet card portrait by
Hess of Picton, Ontario
c.1885.** Private Collection.

and consider cultural shifts in belief. For example, being repulsed during the examination of a fur garment might signal attitudinal changes in contemporary society towards the wearing of fur (Figure 2.3).

Another important aspect of the Reflection phase is the gathering and analysis of other sources of contextual material, such as provenance records, identification of similar garments in other collections, supporting images and textual material. Provenance files, if available, offer the researcher valuable information as to the class and status of the wearer. In addition, identification of similar garments or other items that were created by the same designer—that exist within the same collection or within other collections—can offer additional benchmarks for comparison. If the researcher were conducting a wardrobe analysis, or was interested in the social history of the donor, identifying and studying garments worn by the same person can offer a rich source of data about a person's stylistic, color and material preferences. Supporting images, such as photographs, fashion illustrations (Figure 2.4) or paintings, and textual material, such as records, diaries, letters, and periodicals, can be fertile sources of information for this stage of reflective analysis.

3. INTERPRETATION

The third phase of research brings it all together. In Prown's methodology, this step is called "speculation," and the researcher is expected to synthesize the descriptive information with the emotive and sensory information gathered in the deductive phase, into a hypothesis that explains the evidence at hand. It is at this stage of the research where Prown notes that divergence offers insight into the unconscious aspects of another society or culture. This step can be problematic for many students and researchers, in that there is no clear way forward with the evidence that has been gathered from the dress artifact, and as Valerie Steele has noted, can lead to a "string of unanswered questions."

This book proposes an alternative phase of research called *Interpretation*. The interpretation of results requires the researcher to draw widely from their experience, as well as from fashion theory, in order to synthesize the material gathered during the Observation and the Reflection phases of research. A single dress artifact can be used to support the development of a variety of research hypotheses or research questions. The Interpretation phase is the most creative and imaginative aspect of this type of research, and there can be no single prescription for the interpretation of the clues, since each researcher has different goals in conducting this type of research. The seven case studies included in this book offer a sampling of the possibilities.

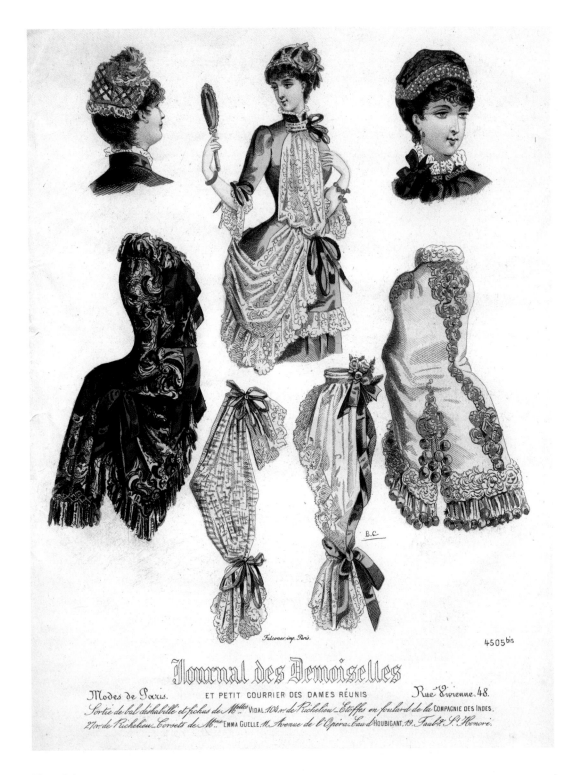

Figure 2.4.

Fashion Plate, *Journal des Demoiselles*,
undated (c.1885–1887).
Private Collection.

THE *SLOW APPROACH TO SEEING*

The guiding principle behind the careful examination of a dress artifact is the adoption of the *Slow Approach to Seeing*. Like Sherlock Holmes, a dress detective has to take sufficient time to patiently observe the subtle clues that are embedded in a dress artifact: for example, a loose stitch, a small patch of wear, a piece of fabric that has been inserted at the waist, a receipt in the hatbox, initials in the lining, a pocket sewn closed. The details of construction, the patterns of wear, the signs of alteration, and other clues may be revealed with careful observation. This type of looking—the *Slow Approach to Seeing*—requires a mental shift. The researcher must make a commitment to slowing down, and to working thoughtfully and methodically through the evidence at hand.

Before commencing an examination of a dress artifact, the researcher must resolve to be mindful and present. Specifically, the dress detective should pause, turn off other distractions, and mentally commit to slow down. Fixing the gaze on the garment and considering every small detail, the dress detective might draw the garment in their mind, seeing each and every feature, before taking notes or making a sketch. Even if time limitations preclude such a leisurely approach, a careful researcher will take a few moments to make the mental shift to slow down and focus on the task at hand.

The *Slow Approach to Seeing* requires a commitment to careful observation, which allows one to notice the strain in a nineteenth-century buttonhole that might indicate the wearer wore the bodice during the early stages of pregnancy (Figure 2.5); to observe a plastic zipper in a dress that stylistically appears to be from the 1930s, suggesting it is a contemporary remake; or perhaps to find a eighteenth-century textile in a nineteenth-century dress, suggesting reuse as styles changed. Details such as these are noticed only with patient observation, and the checklists have been developed to facilitate a systematic approach.

In advance of visiting the research facility, the researcher should read over the checklists, and consider the questions in relation to their own research goals, assessing whether the focus of the research is on the designer, the type of garment, methods of construction, a period of history, theories of gender, sexuality or identity, cycles of production and consumption, the social history relative to the wearer, the object biography, or something else. In knowing the objective of the research, the dress detective can best allocate the available time. Also, the researcher will, ideally, undertake some advance contextual research about the designer, the type of garment, and the period, in order to be well-prepared during the appointment.

Figure 2.5.

Strain in buttonhole on black silk bodice, c.1870s. Gift of Bob Gallagher, Ryerson FRC1999.05.011. Photo by Ingrid Mida.

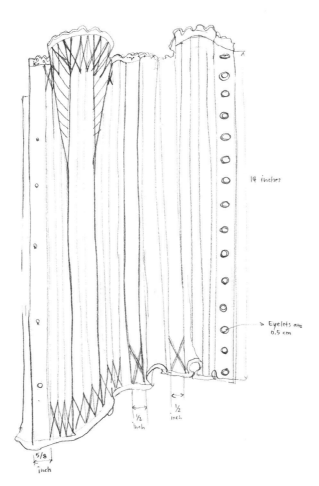

14 inches

› Eyelets are
0.5 cm

½
inch

½
inch

5/8
inch

Figure 2.6.

Annotated sketch
of corset case study,
by Ingrid Mida.

METHODS OF DOCUMENTATION

Documentation is a key element of research, especially since small details can
be quickly forgotten, or merge into a fog of general impressions. Coming armed
with a notebook and pencil is essential, since laptops, pens and cameras may
or may not be permitted in certain facilities. A well-equipped toolkit might also
include a measuring tape, a magnifying glass, and a camera with the ability to
disable the flash.

Sketching is a method of helping the mind to slow down and, in the
process of doing so, take notice of small details, as well as to calculate the
relationships of one part of a garment to another. These quick drawings are also
useful as a place to record measurements, since it may later be unclear where
the measurement began and/or ended. For many people, the idea of sketching
may be quite daunting, yet the goal is not to create a work of art, but simply
to aid the process of observation. The sketch might end up being a crude line
drawing (Figure 2.6), but this is a valuable method of recording key information
and embracing the *Slow Approach to Seeing.*

If time permits, an annotated line drawing of the garment, both front and back, is ideal. Translating the cut and construction of a garment into lines on a page requires close attention, and an accurate drawing necessitates careful notation of each element, including the cut of the bodice, the details of seams, the fullness of a sleeve-head relative to the wrist, the length of the skirt, or the attachment of trim. Many dress historians, including Norah Waugh, Janet Arnold and Jenny Tiramani in the United Kingdom, and Dorothy Burnham in Canada, have used drawing as a method that guides their analysis of the cut and construction of garments.

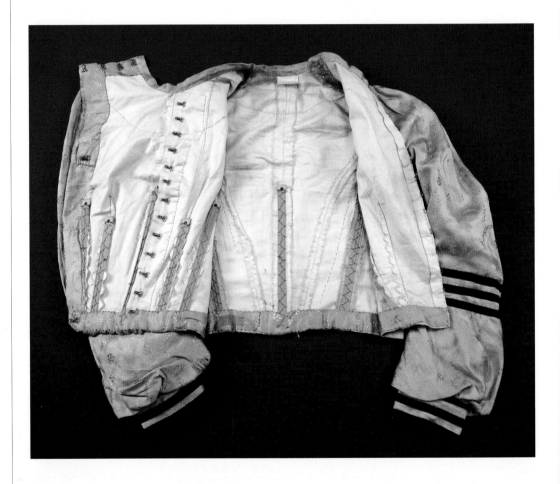

Figure 2.7.

Inside of green silk bodice, c.1900–1905. Gift of Alan Suddon, Ryerson FRC1999.06.010. Photo by Ingrid Mida.

Since most research appointments come with time limitations, it can be tempting to capture key features of the garment with photography. However, caution is advised in using only photography as a method of recording information, since so much more can be gained in the close observation and handling of the artifact (and there is always the danger of a technical failure with modern technology). It is easy to snap photographs and think that sufficient information has been captured to later read the dress artifact. Photography is recommended as a memory aid and documentary tool, but not as the primary method of research.

Permission from the museum or university study collection is typically required to take photographs for research purposes. The process of photographing the garment should be conducted in a way that minimizes handling. This means that all photographs of the front part of the garment should be completed *before* opening the garment to see the inside, and before turning it over to examine and photograph the back (Figure 2.7). In general, flash photography is not permitted. In some cases, professional photographs may be available for purchase. Be aware that publication of photographs of the artifact, online or print, usually requires additional written permission (and likely payment of fees) from the museum or study collection, and/or designer.

Most museums will provide gloves for the handling of collection artifacts, although in some cases, researchers are not permitted to handle the garment at all. In such situations, the supervising curator or assistant will handle the garment to allow you to examine and photograph it. Furthermore, avoid wearing clothing or accessories that might inadvertently damage a garment, such as dangling necklaces or jagged jewelry that might get caught in a textile, or long scarves that might hang onto an examination table.

REFERENCES

Arnold. J. (1972), *Patterns of Fashion: Englishwomen's Dresses and their Construction 1660–1860*, London: Macmillan.

Arnold. J. (1977), *Patterns of Fashion 2: Englishwomen's Dresses and their Construction 1860–1940,* London: Macmillan.

Arnold. J. (1985), *Patterns of Fashion 3: The cut and construction of clothes for men and women 1560–1620,* London: Macmillan.

Burnham, D. (1973, reprinted 1997), *Cut My Cote*, Toronto: Royal Ontario Museum.

Dant, T. (1999), *Material Culture in the Social World*, Philadelphia: Open University Press.

Dowling, Ruth, (1987), Letter to Katherine Cleaver, September 28; Ryerson Fashion Research Collection Donations Binder 1981–1989.

Palmer, A. (2001), *Couture & Commerce: The Transatlantic Fashion Trade in the 1950s,* Vancouver: UBC Press.

Prown, J. (1982), "Mind in Matter: An Introduction to Material Culture Theory and Method," *Winterthur Portfolio.* 17 (1): 1–19.

Smart Martin, A. (1993), "Makers, Buyers, and Users: Consumerism as a Material Culture Framework," *Winterthur Portfolio,* 28 (2/3): 141–157.

3 Observation

In other words: to look at an object is to inhabit it, and from this habitation to grasp all things in terms of the aspect which they present to it.

— MAURICE MERLEAU-PONTY (2002: 79)

The dress lies on a covered table awaiting examination and may be as limp and lifeless as a dead body (Figures 3.1 & 3.2). Where should a dress detective begin? This chapter outlines the specific steps to conducting the Observation phase for an examination of a dress artifact using the Checklist in Appendix 1. In order to identify all the evidence at hand, it is imperative to adopt the *Slow Approach to Seeing,* and work systematically through the Checklist. The key is to observe closely and work methodically, always being careful in handling the garment to minimize damage. The Checklist consists of forty questions, and has been divided into six sections:

1. General

2. Construction

3. Textile

4. Labels

5. Use, Alteration and Wear

6. Supporting Material

Figure 3.2.

Close up of black embroidered dress, c.1860s. Anonymous Gift, Ryerson FRC2003.10.001A+B. Photo by Ingrid Mida.

In using the checklist, it is recommended that the researcher make detailed notes, using terms that are specific to dress and fashion. The use of a fashion dictionary can be helpful to clarify the precise terms used to describe types of collars, sleeves, skirts, and other clothing features. Measurements of key parts of the garment (such as sleeve length, waist size, hem length, zipper length, button or bead size etc.) are encouraged to the extent that they will provide useful information. Annotations of the checklist are provided below.

GENERAL

In this section, the questions are designed to be broad in scope, offering an overview of the key identifying features of the garment or accessory. The idea is to take note of initial impressions before becoming overly concerned with the details.

1. What type of garment is it?

Note the associated gender for the garment. Define the artifact in broad terms, such as woman's evening dress, man's coat, girl's jacket, or boy's pair of shoes. If it is obvious, note whether it was used for a particular purpose, such as the CN Tower jumpsuit uniform illustrated in Figure 3.3.

2. What are the main fabrics that have been used to make the garment?

Are these fabrics predominately natural in composition (silk, wool, cotton, linen), synthetics, or a blend? Note that in contemporary garments it may be very difficult to identify textile composition.

3. What are the dominant colors and/or patterns of the garment?

Use basic color terms—red, yellow, blue, green, black—adding descriptors, such as *ruby red* or *emerald green* to clarify the shade. Color is perhaps one of the most difficult aspects of dress to record objectively, since each person sees color differently, and it can be difficult to find a color term which is both precise and universal. For example, the Dior jacket in Chapter 11 has been described as "ruby red" instead of burgundy or wine. Specify the dominant color first, and then identify the pattern, if any, such as floral, tweed, stripe, or polka dots.

4. Does the garment have any labels?

Observe whether there are designer labels, store labels, care labels, and/or size labels (Figure 3.4).

5. What decade or general period does the garment or accessory belong to?

Typically, the museum curator will have made an assessment as to the date or period of origin. If the artifact has no date attribution, this may become the focus of your investigation. Consideration of the silhouette, textile, and techniques used in construction, relative to other garments with documented attribution, will be necessary.

6. Can the garment be handled safely without causing further damage?

Historic dress can often be incredibly fragile, and even careful handling can cause additional, irreparable damage. Are gloves necessary? (Figure 3.5).

7. What are the most unusual or unique aspects of the garment?

Note your initial impressions of the most striking features.

8. Does the collection have any other garments like it, either by the same designer or from the same period?

These other garments may aid your research by providing useful comparisons in terms of construction, materials and decoration.

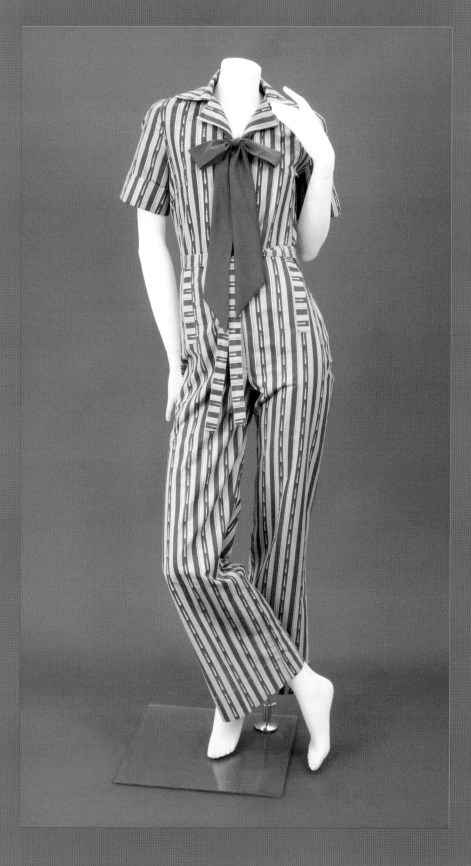

Figure 3.3.

**CN Tower jumpsuit
uniform, 1976.**
Anonymous Gift, Ryerson
FRC2013.99.003
Photo by Jazmin Welch.

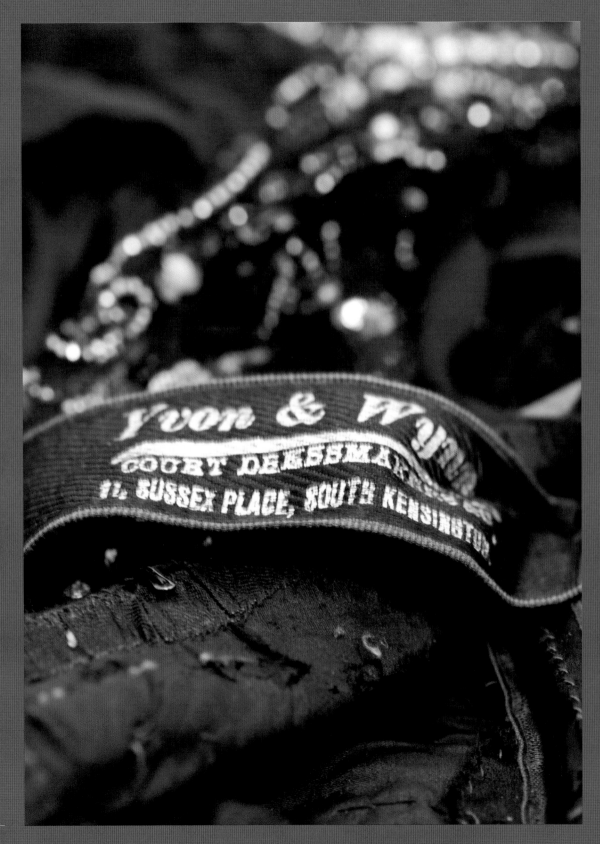

OPPOSITE
Figure 3.4.

ABOVE
Figure 3.5.

**Yvon & Wynn Court Dressmakers
Label, c.1900.** Anonymous Gift,
Ryerson FRC2013.99.050. Photo by
Ingrid Mida.

**Damage on pink silk bodice,
c.1900.** Anonymous Gift, Ryerson
FRC2013.99.048. Photo by Ingrid
Mida.

CONSTRUCTION

Observing how a garment has been constructed is invaluable in dating artifacts,
as well as in offering clues as to the cultural beliefs related to gender and
identity, since the structure of a garment can emphasize certain parts of the
body. It is useful to be aware of the developments in technology that altered
construction practices, such as the adoption of sewing machines and steel
hoops in the mid-nineteenth century.

9. Describe the main components of the garment.

For example, in the case of a dress, describe the bodice, skirt, sleeves, and
neckline. Make your terms as specific as possible (fashion dictionaries can be
very helpful for this), and record those measurements useful to your research.
Find a systematic way of working, to ensure that all major components of the
garment have been considered and recorded, such as working from the outside
inside, or starting at the top of the garment and working downwards, or from
left to right. Follow your inclination, but work methodically. If you are permitted

to touch the artifact, feeling the garment gently may reveal hidden details, such as padding, interfacing, or metal weights that help the garment hang correctly. Record relevant measurements in either imperial or metric units, keeping in mind that many textual sources that predate the 1970s will use imperial measurements. Also, consider which measurements are most relevant to the research question, and include measurements that give a sense of scale (such as waist or bust measurements), especially if the garment lacks a size label.

10. Does the structure of the garment emphasize one part of the body?

For example, the enormous *gigot* or leg-of-mutton sleeves of the 1890s provided emphasis to a woman's shoulders, and also comparatively diminished her waist.

11. Is the garment machine-stitched, handmade or a combination of these methods?

The patenting of the Singer sewing machine in the USA in 1851 was a watershed moment in terms of garment production, since before its introduction all garments were handmade.

Figure 3.6.

Snaps on blue velvet top, c.1939. Gift of
Sandra Garvie, Ryerson FRC1999.02.001A.
Photo by Ingrid Mida.

12. How is the garment closed or fastened?

Does it have a side/back/front zipper, or metal/plastic/self-fabric buttons, or other types of closure? (Figure 3.6).

Certain types of closures relate to specific periods, such as metal zippers being popular in the 1930s as a sign of modern construction. It is also worthwhile noting that fastenings are often changed on a garment, especially as their constant use means that they are susceptible to damage and therefore they may be of a later date than the garment itself.

13. Are there any front, side, flap, or hidden pockets?

In nineteenth-century garments, concealed pockets might be found inside bodices, in petticoats, or in skirt waistbands (Figure 3.7).

14. Are there any remarkable features in the construction?

For instance, does the garment incorporate a bias cut, or use of nontraditional materials or structural elements?

15. Is the fabric selvedge visible in the seams, and has this been incorporated into the cutting or construction of the garment?

If present, this self-finished edge of the fabric can reveal valuable information about the production of the garment's fabric. For example, if both selvedge edges are retained within the construction of the garment, this gives the finished width of the fabric. The selvedge can also reveal the care with which the garment was cut, particularly if the selvedge is used decoratively as a finishing element, as it was in the bodice shown in Figure 3.8.

16. Is the type of construction consistent with the dating of the garment?

Knowing when technology transformed fashion can be helpful here, such as the introduction of aniline dyes in the 1860s, or the increasing use of rayon and zippers in the 1930s.

17. Is the garment reinforced in any way?

Consider whether padding, wire, metal or cane hoops, leather binding, or boning has been inserted into the seams or hems.

18. Is the garment lined?

Linings can often help to reveal the history of a garment. It is common for linings to be replaced or altered over time as they are subject to greater wear than other elements of the garment. The quality of the lining fabric (silk, satin, polyester) may also offer clues about the economic status of the wearer.

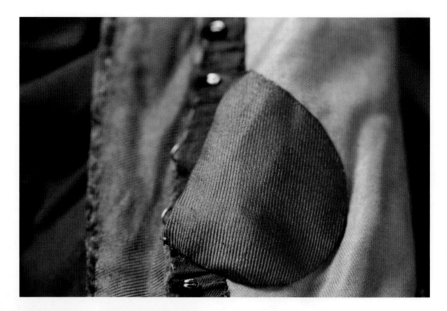

ABOVE
Figure 3.7.

**Concealed pocket on brown
bodice case study, c.1890s.** Private
Collection. Photo by Ingrid Mida.

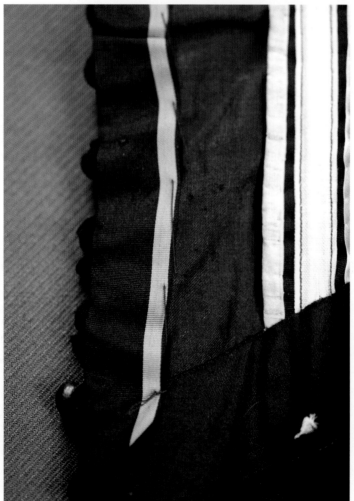

LEFT
Figure 3.8.

**Selvedge inside black silk
bodice, c.1870s.** Gift of
Bob Gallagher, Ryerson
FRC1999.05.011. Photo by
Ingrid Mida.

TEXTILE

The choice of materials used to create a garment affects the drape, the line, and the shape and appearance of the garment itself. Typically, garments are made from textiles, but might also be constructed from other materials such as metal (Figure 3.9), leather, paper, or wood. Knowledge of the unique characteristics of the textile or material used in creating a garment or accessory can greatly assist with a close analysis.

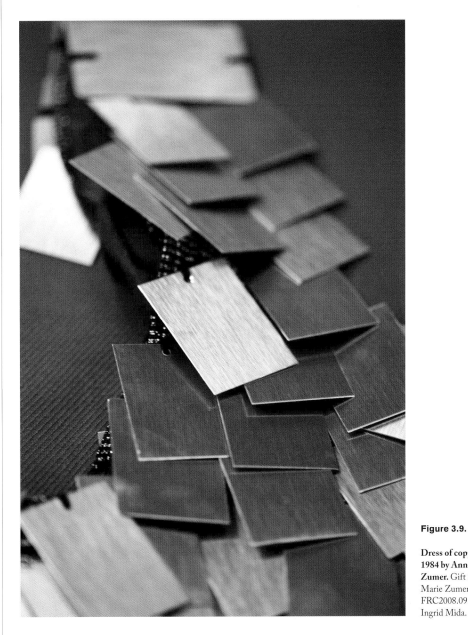

Figure 3.9.

Dress of copper paillettes, 1984 by Anne Marie Zumer. Gift of Anne Marie Zumer, Ryerson FRC2008.09.002. Photo by Ingrid Mida.

Figure 3.10.

Dress of shot taffeta, c.1950s.
Gift of Beate Ziegert, Ryerson
FRC1981.02.018. Photo by
Ingrid Mida.

When recording textiles, there are two main elements that it is helpful to capture. The first element is the fiber(s) used to make the fabric. Sometimes this will be relatively straightforward, and it will be clear whether a piece of material is made from silk or wool. Before the widespread adoption of synthetic textiles, such as rayon in the 1930s, the majority of clothing would have been made from wool, silk, linen, or cotton. These natural fibers could be combined to produce a vast array of fabric blends that differed in weight, finish, and appearance. It can be difficult to work out exactly which fibers have been used in a mix of natural fibers and in synthetic blends, but it might be possible to discern the main fiber, or to record your best guess.

The second main element of the fabric to note is its weave structure. This is the way that it is created on the loom, whether in a preindustrial hand-operated loom or fully mechanized process. It reveals the way in which the

threads cross over, and provides the finished fabric with much of its final character. Common weave structures are plain weave, twill weave (with its distinctive diagonal ribs), and satin weave (with a smooth surface). All these weaves can be made using a variety of fibers, so although people often talk about satin as if it was always made of silk, a satin weave could equally be made from synthetics.

There are many useful fabric dictionaries that can help guide you through the different types of weave structure, and provide you with the most common terminology, including online textile resources such as The Fiber Reference Image Library at Ohio State University (https://fril.osu.edu). Be aware that names for different types of fabric can change over time, and from place to place (for example, what is known as "calico" in the United Kingdom is called "muslin" in North America). A good magnifying glass is a very helpful tool for recording the weave of a fabric, because it allows you to examine the structure carefully.

19. What is the dominant textile or material that has been used?
Is it a natural or man-made fiber? If possible, identify both the fibers used, as well as the type of weave (Figure 3.10). A magnifying glass can aid with this step, but blended fabrics that incorporate an ever-increasing range of complex synthetics can make it difficult to identify the nature of the fibers in contemporary garments. Often the only way to work out the exact fabric types used in a modern garment is to read the accompanying care label, which identifies the fiber content in terms of percentages.

20. Has the dominant textile been subjected to a finishing process, such as bleaching, pressing, or glazing?
The type of finishing process may reflect certain fashions in textiles.

21. Have any other textiles been used in the garment or in the lining?
Garments can be a combination of textiles. Consider how the other fabrics have been incorporated into the design and construction.

22. Does the garment incorporate a stripe or pattern?
How has this been created? Is it woven into the fabric, or printed or formed by a different method, such as stenciling, painting, or manipulation of the fabric? (Figure 3.11).

23. Is there any form of applied decoration, such as appliqué, trim, lace, beading, embroidery, buttons, ruffles, pleated bands, or bows?
Are there signs—for example, small pinholes or stitch marks—that any such decoration has been removed? (Figure 3.12).

24. Has the fabric been reinforced in any way with padding, quilting, interfacing, wires, or boning?

This will help to provide valuable details about the construction of the garment. Often small areas of wear or damage offer the opportunity to see something of these otherwise hidden details, but be careful not to cause further damage.

25. Has the textile faded or otherwise changed in color with the passage of time?

Look under collars, pocket flaps, or other parts of the garment that have not been subject to fading from light.

ABOVE
Figure 3.11.

OPPOSITE
Figure 3.12.

Striped cotton purse c.1940s.
Gift of Jennifer Welsh, Ryerson
FRC2000.06.002. Photo by
Jazmin Welch.

Details of beading and rose on
Jenny dress, 1921. Gift of Jane
Dowsett, Ryerson FRC2001.02.002.
Photo by Ingrid Mida.

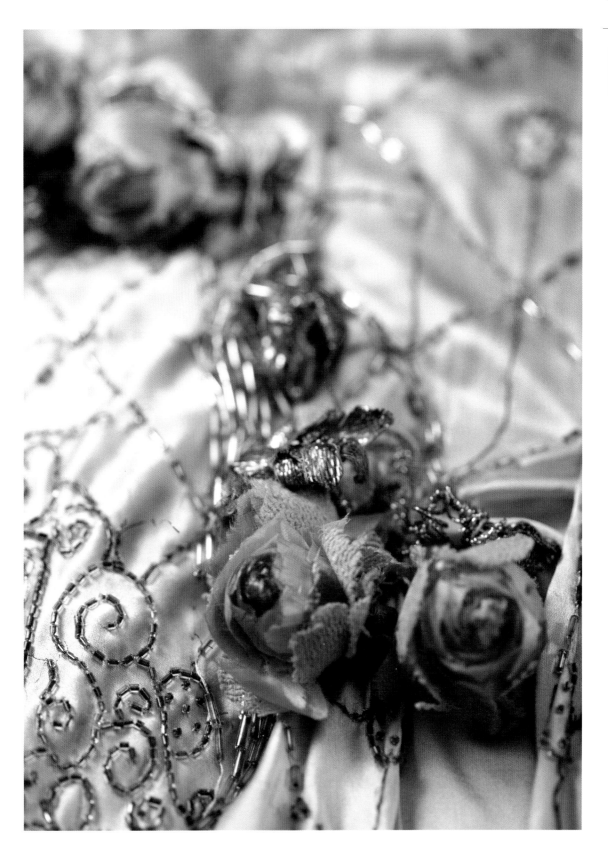

Synthetic Textiles

Artificial silk was first developed in France during the First World War and DuPont purchased the rights. Marketed under the name "Fibersilk", the product met with some resistance from consumers, and was renamed and remarketed by DuPont as "rayon" in 1924. This word combined "ray," to connote the sheen of silk, and "on," to suggest a fiber such as cotton. DuPont undertook intensive promotional campaigns including advertisements in *Harper's Bazaar* to promote rayon as a fashionable and easy-to-care-for alternative, and the company has continued to research and develop innovative textiles, introducing Dacron in the mid-1950s, and Lycra in 1959. The use of manmade fibers has increased over time, and in the 1990s, reached an approximate 50:50 ratio. In 2010, the production of manmade fibers represented 60% of world textile production (World Apparel Fiber Consumption Survey 2013: 2).

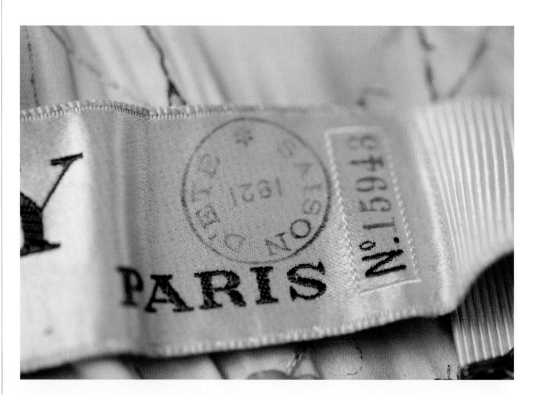

Figure 3.13.

**Couture numbering sequence
on Jenny dress, 1921.** Gift
of Jane Dowsett, Ryerson
FRC2001.02.002. Photo by
Ingrid Mida.

LABELS

Designer Charles Frederick Worth (1825–1895) is said to have been the first designer to use a label with his signature in his creations. Early in the twentieth century, designers such as Poiret, Chanel, Lanvin and Vionnet used their labels as a means of branding their garments and protecting their designs, and the use of the label as a brand marker has continued ever since. Some labels are also used to define authenticity, with elements like number sequences (Figure 3.13), or holograms offering the buyer assurance that the item is not a counterfeit copy. Labels can also serve to fill regulatory requirements in terms of defining textile content, size, care requirements, and origin.

Finding a label in a garment, either a designer label or store label, adds information relative to the maker and the way in which the garment was acquired. Labels or marks of ownership come in different forms, and occasionally, one might find the name of the owner embroidered or handwritten in a garment, In many contemporary garments the label is often sewn into the back neck facing, however, maker labels might also be found in side seams, skirt seams, waistbands, or shoulder seams.

The font as well as the text of a label can be invaluable in helping to provide the social and cultural context for a garment. Font styles can be a useful guide to the dating of a garment, especially since they relate closely to changes in graphic design. Label designs used by major designers and stores often changed over time, and have been well documented on various sites such as the Vintage Fashion Guild (http://vintagefashionguild.org).

26. Is there a maker label?

If so, is the label consistent with the designer's *oeuvre,* and does it offer clues as to dating, such as a number or season? Couture garments sometimes have handwritten labels identifying the name of the garment, and/or a unique number assigned to the piece (Figure 3.13).

27. Is there a store label to identify where the garment was purchased?

Does this reveal anything about the garment's history? Department stores often insert an additional store label into the garment. If the department store has gone out of business, this can offer clues as to the latest possible year of sale for the garment.

28. Are there any care labels or information about the garment?

Care labels are a relatively recent development in clothing manufacturing regulations, and appear most commonly in contemporary garments.

29. Are there any size labels in the garment?

Sizes differ by country, and are another relatively recent regulatory requirement.

30. Is there a marking inside the garment that indicates the specific owner of the garment, such as an embroidered initial, nametag, or laundry mark?

Quality tailors and dressmakers often included a label with the client's name inside the garment. Owners may personalize a garment (Figure 3.14). Uniforms also often have nametags, and costumes often include a label with the name of the theater or ballet company, as well as the name of the actor or dancer.

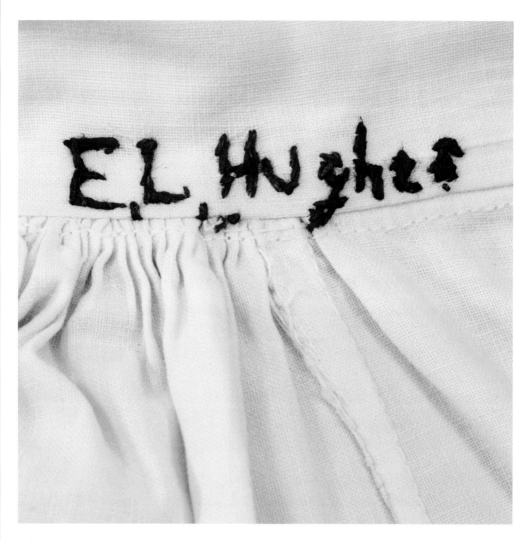

Figure 3.14.

Embroidered name on petticoat,
c.1890. Gift of Mrs. D. Lewis, Ryerson
FRC1986.09.101. Photo by Jazmin Welch.

USE, ALTERATION AND WEAR

In this section, questions prompt the researcher to consider the way in which the owner of the garment might have worn or altered the piece. Here, the focus is on observing how the garment changed over time, from its initial design and construction to its current state. Be aware that some garments in museum or study collections may have undergone conservation treatment that might involve the addition of material to support fragile areas, and/or to lessen the visual impact of areas of loss. These treatments are usually designed to be both reversible and subtle.

31. Has the garment been structurally altered in any way?
Are there patches, gussets, false hems or pieces added to extend the life? Where has the garment been let down, let out, taken in, or recut? Look for hems that have been let down, seams that have been let out, or additional pieces of fabric that have been inserted to accommodate an expanding figure. Have sections of the garment been cut away?

32. Where does the garment show wear?
Certain parts of the garment are subjected to greater movement than other parts of the garment. Look at the underarms, around the neck, over the joints (hips, knees, elbows), around fastenings, and at the hem. Look at any applied decoration to see if there are signs of tears pulling on the original fabric, caused by the decoration. Are there pin marks from jewelry or stitching? Have fibers worn thin in areas that are heavily rubbed, such as elbows, the seat of trousers and skirts? Does one shoulder on a woman's garment show signs of rubbing from a shoulder bag or purse?

33. Is the garment soiled or damaged in any way?
Have seams ripped, silk split, or fabric decomposed? Is there evidence of insect damage? Consider what these marks tell you about the history of the garment in terms of how it was worn and stored.

34. Has the garment been dyed to alter its original color?
Have trim or other forms of embellishment been unpicked or removed?

35. Does the styling of the garment conform to the predominant fashions of one period, or does it represent a hybrid, perhaps custom-made for the owner?
In the eighteenth and nineteenth centuries, textiles were so valuable that gowns would often be recut to conform to stylistic changes, or for fancy dress balls.

SUPPORTING MATERIAL

Ideally, all objects in museum and study collections would have object records that included material such as photographs of the wearer, bills of sale, and perhaps even notations as to the occasions on which the garment was worn, or the memories of the feelings it invoked for the wearer. In most cases, such information is not available at the time the item is accepted for donation, but it is always worth asking the curator if there is any supporting material, since such information can be extremely helpful in enriching the story of the dress artifact.

36. Does the collection have any provenance records associated with the garment?
If you are permitted access to the records, make a note of important information about the donor, prior conservation work, exhibitions of the artifact, or prior research related to the garment.

37. Are there any photographs of the garment?
Does the file include photographs showing the garment being worn by the owner? Was the garment photographed for the runway, an exhibit, fashion magazine or museum archive?

38. Are there any further documents or information about the garment that might indicate the original price of the garment?
Has the garment been included in a magazine or sales catalogue, or in any prior research?

39. Are there any manufacturer or store tags or original packaging associated with the garment?
Tags and packaging can serve as rich contextual material about the artifact under examination, as well as offering clues as to whether the garment was actually worn (Figure 3.15).

40. Are there any similar garments by the same designer, or by other designers from the same period, in this collection?
If conducting a wardrobe analysis, consider whether there are other garments from the same donor.

AT THE END OF YOUR APPOINTMENT

If possible, review your notes at the end of the appointment to make sure that you have recorded all key information. Make sure that you have recorded any museum accession number, or unique identification number, so it is easy

to identify the garment in your research, and in any future communication with collections staff. These numbers can often be confusing, so check with collections staff that you have recorded them correctly. After you leave the museum or collection facility, take a few moments to note your impressions and emotional reactions, since this will be helpful for the next phase of research.

Figure 3.15.

**Kenzo green cotton blouse
with purchase tag, c.1980s.**
Gift of Sandra Birnbaum,
Ryerson FRC2012.04.003.
Photo by Ingrid Mida.

REFERENCES

Calasibetta, C. M. and Tortora, P. (2003),
The Fairchild Dictionary of Fashion, New
York: Fairchild.

Cumming, V., Cunnington, C. W. and
Cunnginton P. (2010), *The Dictionary of
Fashion History*, Oxford: Berg.

Dupont History Timeline (2014). Available at:
http://www2.dupont.com/Phoenix_Heritage/
en_US/1924_a_detail.html

Keist, C. (2009), "Rayon and its Impact
on the Fashion Industry at its Introduction,
1910–1924." *Graduate Theses and
Dissertations*. Paper 11072. Available at:
http://lib.dr.iastate.edu/etd/11072.

Merleau-Ponty, M. (2002), *Phenomenology
of Perception*. Smith, C. (trans.),
London: Routledge.

World Apparel Fiber Consumption Survey
(2013). Food and Agricultural Organization
of the United Nations and International
Cotton Advisory Committee. Available
at: https://www.icac.org/cotton_info/
publications/statistics/world-apparel-survey/
FAO-ICAC-Survey-2013-Update-and-2011-
Text.pdf

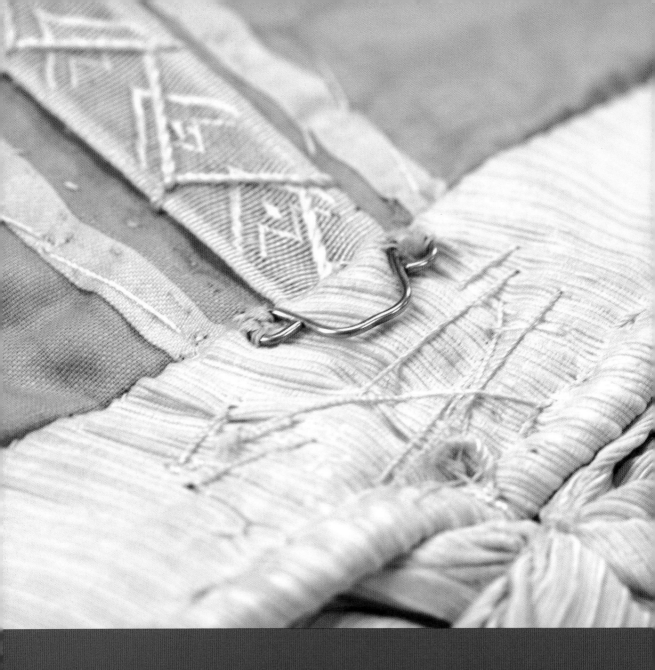

Figure 4.1.

Interior of cream corded silk bodice with bent hook c.1890s. Gift of Alan Suddon, Ryerson FRC1999.06.006. Photo by Ingrid Mida.

4

Reflection

Through stylistic analysis of objects, we encounter the past at first hand; we have direct sensory experience of surviving historical events ... that allows us to put ourselves, figuratively speaking inside the skins of individuals who commissioned, made, used, or enjoyed these objects.

— JULES DAVID PROWN (1980: 208)

In observing and handling clothing that was created and worn by others, we see, touch, and smell the past. We may or may not know the name or names of the people who made or wore the garment under examination, but their traces are there (Figure 4.1). We feel the texture, the weight, weave, and body of the cloth. We measure the fit of the garment. We witness the shape of the construction, the patterns of the stitching, and placement of the decoration. We see the stains, the patches of wear, and the repairs. We hold the past in our hands.

Clothing is a form of material memory, carrying the imprints of its intimate relationship to the body. In performing a close analysis of a garment, we attempt to unpack the object biography to reveal the stories locked therein. Although we might not be conscious of our personal and emotional involvement with the history of the object, it is there, implicitly coloring our observations and the results of our research, since each of us has a cultural stance that reflects the age of the time we live in. Unconsciously we make assumptions and judgments about nationality, class, gender, religion, politics, occupation, age, ethnicity, and sexuality during the course of our day, and in order to be objective in our analysis, we must acknowledge those assumptions, and work to overcome those distortions and biases.

In Prown's article "Mind in Matter," he recommended a step called "deduction," and intended it to serve as the means by which a researcher considered what it would be like to use (wear) the object, and hypothesize as to the cultural beliefs embodied therein. This imaginative engagement with the object is, for many students and researchers, a difficult step to understand, leading to much confusion and uncertainty as to how to proceed or interpret the results.

In this book, the second phase is called *Reflection,* and is oriented specifically to dress artifacts. In this phase of research, the researcher not only considers how their background, preferences, and biases can both affect and enrich the process, but also contemplates what other contextual material may be available, such as photographs, illustrations, paintings, and textual sources. It is this latter part that distinguishes our approach from Prown. In doing so, we aim to help the scholar consider the full range of material that might enrich an interdisciplinary study of a dress artifact.

Research is not necessarily a linear process, and progress is made in fits and starts. To get the most out of a research visit and not waste valuable curatorial resources, some research related to the object should happen in advance of a visit to an archive or collection. This is both necessary and valuable, and such information will undoubtedly affect the outcome. The subsequent examination of the dress artifact will reveal clues that raise questions, or that require additional information to interpret. The reflective stage of research acknowledges the natural flow of the research process, and is more iterative than linear.

The reflective phase includes twenty questions, and is divided into three components including: Sensory Reactions; Emotional Reactions; and Contextual Material. The *Checklist for Reflection* is provided in Appendix 2, and this chapter provides an annotated version. The goal is to unlock personal and cultural biases, as well as identify and consider contextual material that can further support a comprehensive analysis of the artifact. Once again, the researcher is encouraged to document their responses to the questions, in order to obtain an optimal result. Although it might seem easier to answer the checklist with the artifact at hand, it is recommended that this phase take place after the research appointment, since the broader impressions are relevant in this part.

SENSORY REACTIONS

Cloth is sensual, offering a non-verbal experience that invokes a range of senses, including sight, sound, smell and touch.[1] By being aware of the full range of possible sensory reactions that may be taking place on a subconscious level, the dress detective acknowledges the implicit judgments in play during the course of examining an artifact.

Sight

1. Does the garment have stylistic, religious, artistic or iconic references?
Consider Yves Saint Laurent's use of Piet Mondrian's painting motifs in creating the Mondrian dress in 1965, or Alexander McQueen's use of baroque imagery in his posthumous collection of 2010.

2. Is the garment stylistically consistent with the period from which it came?
Does it seem to reflect the influences of that period, or diverge from them? For example, if the collection record indicates a garment was from the 1960s, but it stylistically seems to reflect the *New Look* of the 1950s, this may signal something about either the accuracy of the record, and/or the stylistic choices of the wearer.

Touch

3. What is the texture and weight of the cloth or other materials used to construct the garment?
Is the texture soft and luxurious, or hard and unyielding? Has the texture of the material(s) changed over time? For example, once-soft, supple leather may become hard and cracked if not stored in optimal conditions for preservation. Would the garment be pleasant against the skin, or cause itching or chafing? Would any part of the garment touch or drag along the ground, such as a train or cloak?

Sound

4. Would a person wearing this garment make noise?
Consider the click of a stiletto on the floor, the swish of silk against the legs of a woman wearing a long dress, the snap of a parasol when it opens.

Smell

5. Does the garment smell?
Our noses can detect sweat, body odor, animal scents, dirt, and other musty smells imbedded in a garment, and these aromas of the past can cause a visceral reaction and even repulsion.

PERSONAL REACTIONS

Given that we are drawn inherently to objects that appeal to us in some way, it is important to reflect on what attracted you to the garment, and what you initially hoped to learn or discover through the process of object-based research. When

we look at a garment on display in a museum, we know intuitively whether or not we would wear that garment, and whether or not it would fit our body. This phenomenon can be used to consider our personal reactions to the garment.

6. What was the impetus to examine this garment?

Were you interested in the person who wore it, the maker, or some other aspect of its object biography?

7. Are you the same gender and size as the person who wore or owned the garment?

Did a person who was bigger or smaller than you wear it? Would the garment fit your body?

8. How would it feel on your body?

Would it be tight or loose? Would the garment cause discomfort or pain?

9. Would you wear this garment if you could? Is the style appealing to you?

Is it a color or pattern that attracts you? (Figure 4.2) Is the item visually appealing? This is a personal assessment, and there is no right or wrong answer; your assessment of the visual appeal is an indication of your preference and taste.

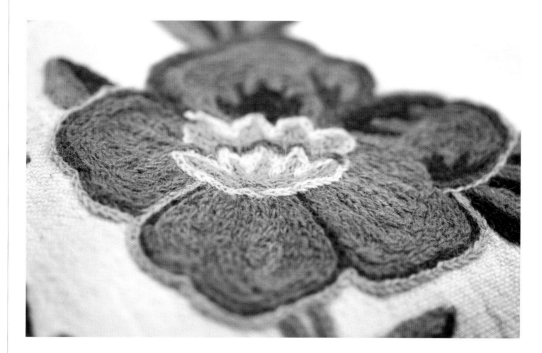

Figure 4.2.

Floral crewel pattern on coat c.1970s.
Gift of Donna Jean MacKinnon, Ryerson
FRC1993.04.004. Photo by Ingrid Mida.

10. Does the garment or accessory demonstrate a complexity of construction or element of mastery in the design? (Figure 4.3)
Also consider whether the dress artifact has a functional component to the design.

11. Did the maker want to invoke emotion, status, sexuality, or gender roles with the garment?
Does the garment seem to express humor, joy, sorrow or fear? (See the joyful prints in Figures 3.3 & 3.11).

12. Do you have an emotional reaction to the garment?
Does it appeal to you or repulse you? Does it remind you of something else? Consider whether your personal reactions are indicative of a shift in cultural beliefs. Can you identify a personal bias that should be acknowledged in your research?

The above questions are intended to help the researcher identify and acknowledge their personal biases and beliefs, since we may unwittingly transfer the expression of sexuality, gender roles, class, and status in the clothing from our particular time and place as normative, without considering how cultural beliefs have shifted over time and across cultures. Identifying the areas of divergence makes us alert to our own time and perspective. For example, being repulsed by a dress artifact in some way—by its smell, its appearance, its texture, the way it is cut or fit to the body, or some other aspect—is a clue to a shift in cultural beliefs, or a personal bias. This may occur with an object such as a fur stole constructed of the bodies of four minks with their heads and limbs left intact, which was once a sign of wealth and status, but now might invoke repulsion (Figure 4.4). This may also occur with an artifact of dress that we would not wear because it does not appeal to us aesthetically. Such gaps can reflect changes in society's cultural stance, and the impact of our aesthetic preferences on our judgment. By engaging with the object on a personal level, the stylistic preferences and cultural biases of the dress detective are made apparent.

CONTEXTUAL INFORMATION

Objects of dress do not exist in isolation. Their place in dress history is marked by what came before, what came after, and what others were making and wearing at the time. Dress artifacts may or may not have been fashionable at the time they were worn. The context—the circumstances that formed the setting for the creation, the marketing, the wearing, and the retention of that dress artifact—help to delineate the scope by which it can be fully understood and assessed. Contextual material—text and imagery

Figure 4.3.

**Detail of slashed leather dress by Yvonne
Lin 2012.** Gift of Yvonne Lin, Ryerson
FRC2013.04.001. Photo by Ingrid Mida.

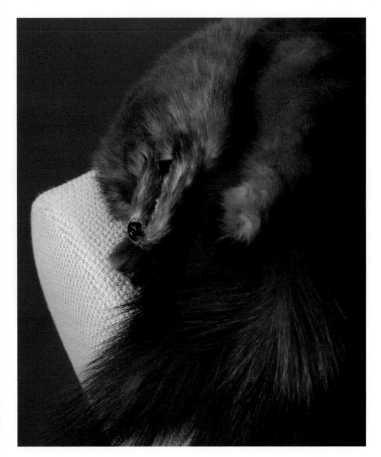

Figure 4.4.

**Detail of mink stole
c.1950s.** Anonymous Gift
Ryerson FRC2006.02.007.
Photo by Jazmin Welch.

relating to the object itself, the maker, and the owner—helps the researcher
interpret the clues revealed within the artifact itself.

In looking at any single object from a museum, it is important to remember
that such collections are not necessarily representative of what people actually
wore at any given period of time. Not every object merits the financial or curatorial
resources needed to extend its object biography into perpetuity, and many
costume collections privilege dress artifacts with high economic, aesthetic, or
inherent value, which often translates into dress worn for special occasions,
such as evening gowns or couture ensembles. Moreover, garments such as work
attire may be worn until they wear out, and are often underrepresented in dress
collections. Curatorial bias is also at play, since curators may be inclined to select
and preserve objects for which they have an affinity.

Ideally, all garments would come with information about the person that
wore the garment, where it was purchased (Figure 4.5), how much it cost, and
when it was worn, but often such information is not known, or has been forgotten
by the time the object enters the collection. If the donor is a known person or
celebrity, some clues might be found in newspaper, magazine, or online archives.

If the garment is donated by a person who wishes to remain anonymous, or has no records of provenance, other contextual information about the garment or others like it, will exist in the form of text or images in magazines (Figure 11.1), videos, runway shots (Figure 12.1), illustrations (Figure 4.6), advertisements or paintings. Similar objects may have been the subjects of study by other dress historians or fashion scholars, and a thorough literature search may reveal useful articles or books. An initial survey of material will allow the dress detective to reflect on the artifact's uniqueness as an object, as well as its place in fashion history, and to set up the final phase of research.

13. If you were permitted access to the provenance record for the artifact, what does this information reveal about the owner, and their relationship to the garment?

Such records may include letters from the donor about where they purchased the garment, when it was worn, what it meant to them, or why they kept it. If available, photos of the donor wearing the garment can offer visual references to how they accessorized and styled the garment.

14. Does the museum, study or private collection have other garments that are similar, or by the same designer/maker?

It is helpful to consider this information in advance of the visit, so that if possible these other items can be compared to the object under study.

Figure 4.5.

Undated purchase receipt for a hat from The T. Eaton Co. Limited. Private Collection.

MAGASIN DES DEMOISELLES

francs par an pour Paris. 12 francs pour les Départements . Avec 2 aquarelles (fac simile) 2 sépias, 7 albums de musique, 2 gravures sur acier. 14 vures de modes. 6 planches de tapisseries coloriées.1200 dessins de broderies patrons de grandeur naturelle, petits patrons, ouvrages à l'aiguille, filet 1 et crochet, ouvrages nouveaux, rébus illustrés, planche crochet couleur bleue : Planche de petits ouvrages fantaisie Or en Argent, etc.

Bureaux du Journal. 51. rue Laffitte

PARIS

Figure 4.6.

Fashion Plate, *Magasin des Demoiselles***, April 25, 1854.**
Private Collection.

15. Do other museums have similar objects?

Answering this question will help you determine the rarity and uniqueness of the object under study. Many museum collections around the world have begun the process of digitizing their collections, in order to minimize the handling of fragile garments, as well as provide open access to their collections. Due to database limitations, few of these collections have been optimized for Google, and therefore must be searched within the museum portal. A select group of searchable online collections from around the world are profiled in the textbox. What information can you learn from these other collections? Consider the number of similar garments in other collections and the type of information made available about the artifact, including books and/or journal articles.

16. Have other scholars written about this type of garment or the designer's work in books or peer-reviewed journals?

Reading the key scholarly texts can save valuable time, and improve the quality of the next phase of research, in making a valid interpretation of the evidence.

17. Are there similar garments or related ephemera (advertisements, fashion photographs, packaging, and other print material) available for sale on Etsy, eBay, online vintage retailers, or on auction sites?

These sites can offer a window into what people consider valuable or collectible. See textbox on auction websites.

18. Are there photographs, paintings, or illustrations of this garment, or of similar garments, in books, magazines, museum collections, or online?

Identifying visual references that include similar garments allows the researcher to consider how the garment was actually worn, and also provides information on social context.

19. Has this garment, or others like it, been referenced in documents, such as letters, or receipts, or magazines, novels, and other forms of written material?

Textual references offer additional clues as to the cultural attitudes related to the time period under consideration.

20. If the maker of the garment is a known designer, what information is available about them?

How does this garment fit into their *oeuvre*? Have there been exhibitions of the designer's work? Has the designer written an autobiography or been profiled in magazines or journals?

In answering the questions on what other contextual material is available, the researcher should focus on those areas that relate to their initial research goal. Not all the material may be relevant for a particular project or research question.

Selected Online Collections
(see References for website addresses)

Europeana

is an online portal into the collections of participating European museums and private archives. As of February 2015, this portal links to approximately 650,000 fashion related objects, such as dress artifacts, runway photographs, and other artifacts from museum collections and private archives. Searches will identify items from all participating museums, providing information on the artifacts, including creator/designer, date, type, format, museum, and copyright information.

The Metropolitan Museum of Art Costume Institute Collection

is home to more than 35,000 costumes and accessories, with the earliest piece dating back to the fifteenth century. This New York museum provides multiple images, as well as extensive descriptive information and provenance details for each item.

The Victoria and Albert Museum

holds more than 75,000 objects in the Textiles and Fashion Collection that spans four centuries. Their website gives access to information on their holdings. The information provided for each fashion item is extensive, including materials and techniques, marks and inscriptions, object history, as well as bibliographic references, videos, and related material.

The Powerhouse Museum

in Sydney, Australia. has about 30,000 artifacts in the costume and textile collection, including menswear, womenswear, and children's clothing, as well as fashion plates, drawings, photographs, textiles, swatch books, designer archives, and fashion magazines. The online catalogue includes a description, production date, and dimensions for each object. In searching their archives, a list of similar objects is automatically generated for review.

Auction Sites

Fashion as a collectible is a relatively recent phenomenon. Although at one time vintage clothing could be bought relatively inexpensively, that is no longer the case. Some of the world's finest art auction houses, including Christie's and Sotheby's, as well as a number of specialty auction houses—such as Kerry Taylor Auctions in London, and Karen Augusta Auctions in New York—hold regular sales of fashion collectibles. Studying their auction catalogues and websites can be another source of contextual information.

NOTE

1. Although taste is one of the five senses, it has been omitted from the discussion since tasting a dress artifact would be inappropriate from the perspective of health and conservation. If a dress artifact was made out of an edible material, such as chocolate or candy, it might be appropriate to imagine the way in which the taste buds would be activated during the wearing of such a garment.

REFERENCES

Blanckaert, P. and Rincheval Hernu, A. (2013), *Icons of Vintage Fashion: Definitive Designer Classics at Auction 1900–2000,* New York: Abrams.

Chan, S. (2007), "Tagging and Searching: Serendipity and museum collection databases," in J. Trant and D. Bearman (eds.) *Museums and the Web 2007: Proceedings,* Toronto: Archives & Museum Informatics, published March 1, 2007. Available at http://www.archives.com/mw2007/papers/chan/chan.html. Accessed January 23, 2014.

Europeana. Available at: http://www.europeanafashion.eu/portal/home.html

Merleau-Ponty, M. (2002), *Phenomenology of Perception.* Smith, C. (trans.), London: Routledge.

Metropolitan Museum of Art, Costume Institute. Available at: http://www.metmuseum.org/collection/the-collection-online

Petrov, J. (2012), "Playing Dress-Up: Inhabiting Imagined Spaces through Museum Objects," in S. Dudley, A. J. Barnes, J. Binnie, J. Petrov, and J. Walklate (eds.), *The Thing about Museums: Objects and Experience, Representation and Contestation,* London: Routledge: 230–241.

Prown, J. (1980), "Style as Evidence," *Winterthur Portfolio,* 15 (3): 197–210.

Prown, J. (1982), "Mind in Matter: An Introduction to Material Culture Theory and Method," *Winterthur Portfolio,* 17 (1): 1–19.

The Powerhouse Museum. Available at: http://www.powerhousemuseum.com/collection/database/menu.php

Victoria and Albert Museum. Available at: http://collections.vam.ac.uk

5

Interpretation

Clothing provides a remarkable picture of the daily lives, beliefs, expectations, and hopes of those who lived in the past.

— LINDA BAUMGARTEN (2002: VIII)

The garment has been examined and the evidence gathered. Drawings, notes and photographs have been carefully rendered. Personal reactions to the dress artifact—the feel and weight of the fabric, the smell and traces of the body, the cut, color and fit of the garment—have been considered. The object records have been read, and other contextual material, including the identification of similar objects in other collections, has been reviewed. What comes next?

Interpretation is the process by which a researcher links together all the evidence gathered during the other phases of research and offers an analysis as to its meaning. As one of the most challenging steps of object-based research, it is difficult to articulate the course of action definitively, since the goals of each researcher are different. The process is both imaginative and highly creative, requiring the researcher to assimilate the knowledge gathered in the other phases in the process, to find patterns, make conjectures, and draw conclusions.

Translating evidence gathered during the observation into a nuanced argument that can be used to intersect with and enrich theories of fashion, dress and material culture, cannot be prescriptive, since fashion is itself an interdisciplinary field that draws from a broad range of theoretical perspectives. A single dress artifact can be used to illustrate, and interpret a wide range of topics in fashion, including aspects of technology, social history, art history, sociology, psychology, anthropology, design history, cultural theory, cycles of production and consumption, as well as economics.

At the core of the interpretative phase of research is the development and consideration of what the evidence from the garment represents in terms

Figure 5.2.

Label inside Bill Blass dress,
Gift of Barbara McNabb,
Ryerson FRC1986.01.001A.
Photo by Jazmin Welch.

of a specific research question (Figure 5.1), Why did you consider it important to study this object and what did you expect to see? What aspect of fashion can this particular garment illuminate? (Figure 5.2)

Each researcher brings to the table a different skillset and background. Makers tend to focus on construction; art historians might concentrate on the aesthetic qualities of the garment, or how fashions are depicted in paintings and other media; sociologists might be more interested in the function of the garment in the wardrobe of its owner; and economists might be interested in processes of production and consumption. Whatever the nature of one's background, savvy fashion scholars read widely and across disciplinary boundaries.

The goal of this chapter is to help the researcher bridge the gap between what they have observed, what material they have gathered, and what to do next, since object-based research does not end with a description. The final stage of research requires an assimilation of all this material, in order to translate the evidence into a hypothesis, or a narrative that can be used to intersect and enrich theories of fashion and material culture.

USING FASHION THEORY IN INTERPRETING RESULTS

Fashion, as a cultural phenomenon, is a relatively recent field of independent study. The journal *Fashion Theory: The Journal of Dress, Body and Culture,* which defines fashion as "the cultural construction of embodied identity," was launched in 1997, to offer a forum for critical analysis and scholarship. However, there is no singular theory or overarching framework to describe fashion phenomena, since fashion intersects with disciplines that examine the full range of human activity. Within the field of fashion itself, the scope is also broad, including elements of design, production, merchandising, display, and consumption. The absence of an overarching framework can be confusing and confounding to the new scholar, but also offers the opportunity to be more imaginative and creative in interpreting results.

Theory—the set of ideas or the framework used to explain a particular phenomenon—can seem highly abstract and impenetrable. At the core, theory is speculation, and represents one learned person's opinion that has come to be generally accepted by other scholars over time. Theory comes in and out of parlance, as scholarship develops over time. At this juncture, undergraduate and graduate students in fashion are expected to be conversant with a range of key theorists, from Karl Marx to Michel Foucault.

Knowing which theorist to draw upon is highly dependent on the research project at hand, and cannot be prescriptive. However, if the researcher remembers that theory is in and of itself reflective of cultural beliefs, it makes the process seem much less intimidating. When theory can

be used to complement the interpretation of evidence, it is suggested that a thorough literature review be conducted to identify the key theorists, since any list of scholars or cultural theorists will be incomplete. It is not possible within the scope of this book to summarize all the major theorists whose work intersects with fashion, and could be used to illuminate the evidence found in examining dress artifacts. Some of the key cultural theorists and scholars include Roland Barthes, Jean Baudrillard, Pierre Bourdieu, Joanne Entwistle, Michel Foucault, Ulrich Lehman, Karl Marx, Georg Simmel, Thorstein Veblen, and Elizabeth Wilson, but there are also many others.

For example, according to French philosopher Michel Foucault (1926–1984), "A body is docile that may be subjected, used, transformed and improved." In his treatise *Discipline and Punish,* Foucault traced the adoption of methods of discipline over the body—once used primarily in armies, monasteries, and workshops —into a general mode of domination over the populace. "Discipline produces subjected and practiced bodies, docile bodies," and the body is disciplined through the structuring of time, space and gesture, to create self-regulation by the individual (Foucault 1977: 215). In applying Foucault's theoretical treatise to fashion, one might argue that there is a combination of societal forces acting on the fashioned body, which an individual may have internalized, and thus not be conscious of, in spite of the illusion of agency. In Chapter 7, the case study of the gray-blue sateen corset from the mid-nineteenth century, this artifact might be used to consider how societal forces encouraged the wearing of corsets as a form of disciplining the female body, using Foucault's theory of the docile body to illuminate and interpret the evidence. Instead, this chapter focuses on an alternate interpretation, related to the developments in technology associated with the production of the corset that allowed it to be made cheaply enough for all classes of women.

There is no right answer on how to interpret the evidence at hand. The aim in using theory is to illuminate the materiality of what is seen in the artifact, and create a well-reasoned argument in support of the underlying research question. This process may be iterative, requiring multiple attempts to reflect and reconsider the evidence in the artifact against the evidence obtained in textual sources, archives, or imagery.

Dress artifacts are complex composites of material and cultural values. Reading a dress is like reading a painting: both can be undertaken with scientific precision, but the interpretation is subjective. The guidelines established in this book are intended to assist in the gathering of evidence, but ultimately, the researcher must be both imaginative and rigorous in interpreting the results. The following seven case studies are provided to illustrate how evidence from a garment can be used in identifying the narratives and cultural beliefs that are embodied in dress artifacts. These items were selected to reflect a representative sample of fashionable Western garments that might be available to fashion scholars, and to address a variety of research questions.

Chapter 6 is the analysis of a primrose yellow pelisse c.1820, from a private collection. This wool coat offers a typical example of a garment produced before the advent of the sewing machine and mass-produced clothing, as well as one which, in its military detailing, demonstrates something of the fluid and creative relationship between men's and women's clothing. It can be used to engage with studies of sartorial consumption.

Chapter 7 considers a pale gray-blue corset from the late nineteenth century, from a private collection. The process by which corsets were internalized by women might be used as an example of Foucault's concept of the disciplined body, but corsets can also be used to consider technological changes in corset production, late nineteenth-century advertising of mass-produced garments, and/or the continuing inspiration of the corset for contemporary fashion.

Chapter 8 considers a brown velveteen and wool bodice of the 1890s, as an example of working-class dress, possibly homemade for Sunday best, from a private collection. Working-class dress and mass-produced garments are often underrepresented in museum collections, but these artifacts can also be used to help explain the mechanics of the fashion system, and the life cycle of garments.

Chapter 9 is an example of a man's evening suit with tailcoat and trousers c.1912–1922, from the study collection at Ryerson University (FRC2013.99.034A+B). A careful examination of this ensemble allows the analysis of the subtle complexities of men's clothing and fashion, refuting the traditional view that men's clothing changed little after the renunciation of flamboyant dress at the end of the eighteenth century.

Chapter 10 offers an analysis of a beaded wedding gown and headpiece attributed to Lanvin, undated and lacking in provenance, from the study collection at Ryerson University (FRC2013.99.004A+B). This couture garment and accessory have been altered, with the insertion of a new bodice and restitching of the beading on the sleeve, suggesting that a second wearer altered and reused them for another occasion. This garment also offers the opportunity to discuss the cultural significance of the wedding dress, and the poignancy of embodied memory, as well as illustrating how garments disintegrate over time.

Chapter 11 considers a ruby red silk velvet jacket by Christian Dior, New York from fall/winter 1949, from the study collection at Ryerson University (FRC2000.02.053). This couture garment was donated anonymously to the collection, and illustrates how thorough examination of its design details can help to date the garment. It can also be linked to Veblen's concept of conspicuous consumption, discussions of ideal feminine beauty, the embodiment of habitus through the lens of Pierre Bourdieu, or studies of the couture system.

Chapter 12 is a quilted silk, wool and tweed kimono-style jacket by Kenzo from fall/winter 2004. This jacket demonstrates the increasing trend for blending influences from Western and Asian cultures in contemporary fashion. Its hybrid construction, in a mix of fabrics and styles, offers an entry into theorist Jean Baudrillard's essay "Fashion, or The Enchanting Spectacle of the Code," in which elements of the past are recycled, and the heady frivolity of fashion is celebrated. As one of many objects in the study collection at Ryerson University that came from a single donor, this jacket (FRC2009.01.686) also allows consideration of how individuals construct identity through their wardrobes.

The case studies in this book are offered as examples of how the checklists may be used for the three distinct stages of object-based research: Observation, Reflection, and Interpretation. However, it should be noted that this format may or may not be appropriate for a scholarly essay, and the reader may wish to reformat their results, to offer a more fluid and integrated analysis.

REFERENCES

Barthes, R. (1985), *The Fashion System*, London: Cape.

Baudrillard, J. (1993), "Fashion, or The Enchanting Spectacle of the Code," in *Symbolic Exchange and Death*, London: Sage: 87–100.

Baumgarten, L. (2002), *What Clothes Reveal: The Language of Clothing in Colonial and Federal America*, New Haven: Yale University Press.

Bourdieu, P. (1998), *Distinction: A Social Critique of the Judgement of Taste*, Cambridge: Harvard University Press.

Davis, F. (1994), *Fashion Culture and Identity*, Chicago: University of Chicago Press.

Entwistle, J. (2000), *The Fashioned Body*, Cambridge: Polity Press.

Foucault, M. (1977), *Discipline and Punish*, English translation. New York: Pantheon Press.

Kopytoff, I. (1986), "The cultural biography of things: Commoditization as process," in A. Appadurai (ed.), *The Social Life of Things*, Cambridge: Cambridge University Press: 64–91.

Lehmann, U. (2000), *Tigersprung: Fashion in Modernity*, London: MIT Press.

Marx, K. (1992), "The Fetishism of the Commodity and Its Secret," in *Capital, Vol.1: A Critique of Political Economy*, New York: Penguin.

Simmel, G. (1957), "Fashion," *American Journal of Sociology*, 62: 541–558.

Veblen, T. (2007, first published 1899), *The Theory of the Leisure Class*, M. Banta (ed.), New York: Oxford University Press.

Wilson, E. (1985*), Adorned in Dreams: Fashion and Modernity*, London: I. B. Tauris.

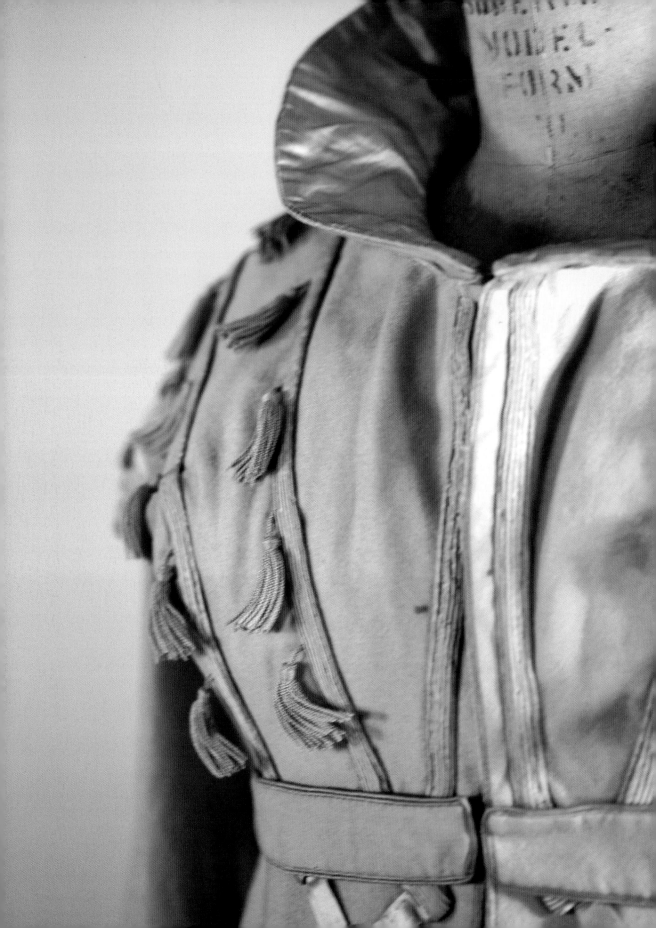

6

Case Study
of a Yellow Woolen
Pelisse

Many garments become separated from their provenance, and orphaned from the personal histories that might place them in the context of particular wearers and owners. Clothes, however, are some of the most intimate and compelling of all social history objects because of their close connection to the body, and a careful study of the physical details of a garment can often reveal much about its original use, as well as its successive "lives." This is what the cultural anthropologist Igor Kopytoff has described as the "biography of the object," charting the changing value of an object as it passes through time (1986: 90). Similarly, dress historian Linda Baumgarten highlights the value of "listening to clothes"; a practice of sensitive and meticulous study, to better understand their history and context (2002: 208–215).

This case study examines a yellow wool pelisse (Figure 6.1); a common type of women's early nineteenth-century outer garment, similar to a coat. This garment is distinguished by its elegant color scheme, graceful lines, and arresting decorative elements. The shape of this particular pelisse suggests a date of about 1820, when the skirt was beginning to develop a flared line, but the waist remained high. There are a few signs of wear and damage, but the pelisse is structurally sound, and it can be examined safely. The pelisse is part of a private collection from the United Kingdom, and while it has no provenance, and there are no details about the original wearer, aspects of the pelisse offer the chance to formulate a picture of the type of woman who wore it, along the lines of Kopytoff's "biography of an object."

OBSERVATION

Construction
The case study pelisse is made of fine yellow wool decorated with bands of silk piping (Figure 6.2). The pelisse has a high waist (measuring 29½ inches or 74.9 cm), with bust darts added to the front bodice sections to give extra fullness, and a center front opening. The back of the bodice has been cut in three sections, with the central section cut in a distinctive truncated diamond (Figure 6.3). The

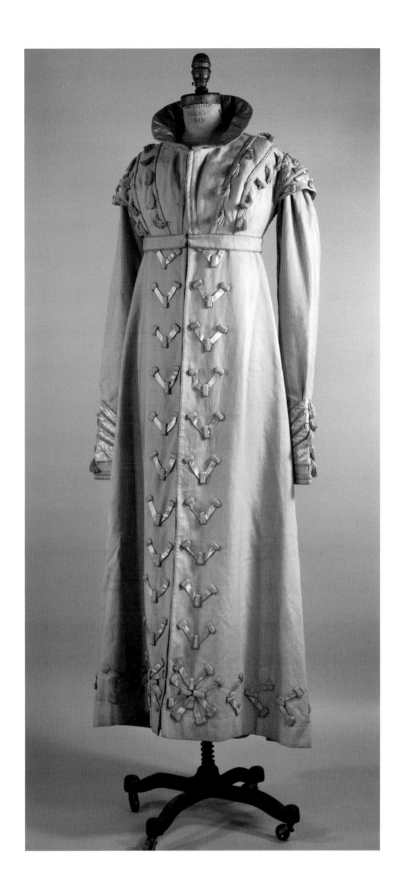

Figure 6.2.

**Front view of pelisse
on dress form.**
Photo by Ingrid Mida.

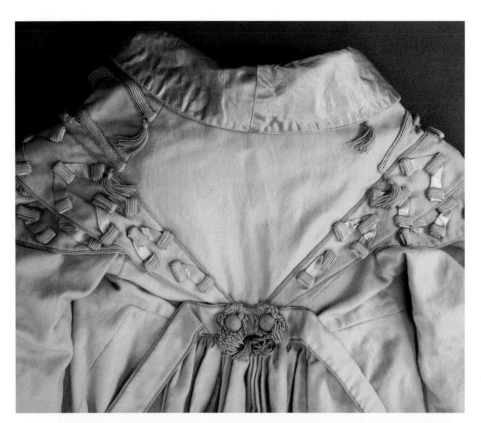

Figure 6.3.

Back of bodice.
Photo by Ingrid Mida.

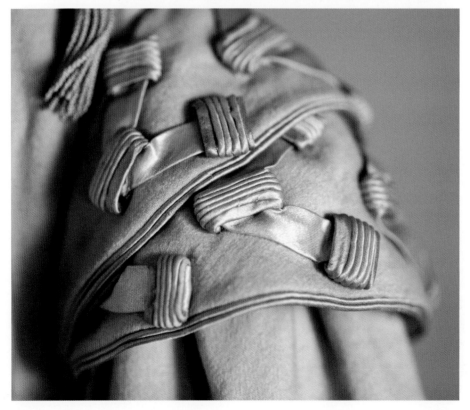

Figure 6.4.

Epaulette detail.
Photo by Ingrid Mida

exceptionally long sleeves (28½ inches or 72.4 cm long) have a low shoulder line, and are set far into the back of the bodice, with a slight gather at the shoulder seam, hidden by double epaulettes (Figure 6.4). Each sleeve is made from a single piece of fabric, with the seam falling under the arm. The bodice has a small rounded collar, and a self-fabric belt, which is 29⅝ inches (75.3 cm) long, around the high waistline.

The skirt of the pelisse has a slightly flared line, and has been cut in five sections. The fullness at the back of the skirt has been gathered into the waist seam with cartridge pleats. Each of the back skirt seams has a pocket slit, edged in pale yellow silk (Figure 6.5), but the right-hand slit has been carefully sewn up.

Figure 6.5.

Detail of open pocket slit. Photo by Ingrid Mida.

The bodice and sleeves are lined in a lilac silk that has also been used to face the collar and front skirt sections (Figure 6.6). There is a pale pink silk band covering the seam of the waistband that holds the pleating at the back of the waistband in place, and an interior ribbon of pale pink silk at the waist (45 inches or 114.3 cm) (Figure 6.7).

The striking decoration of the pelisse is created by the use of complementary silk piping. The main edges of the pelisse are finished with a row of double piping. Chevron trim, formed from tabs of the piping and pale yellow satin strips, runs down the opening and around the hem, as well as decorating the epaulettes (Figures 6.4 & 6.8).

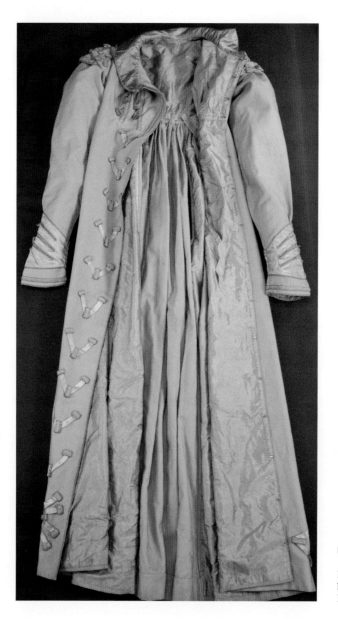

Figure 6.6.

Pelisse on table showing lining on skirt fronts.
Photo by Ingrid Mida.

Figure 6.7.

Detail of waist interior, showing cartridge pleating, silk band and ribbon. Photo by Ingrid Mida.

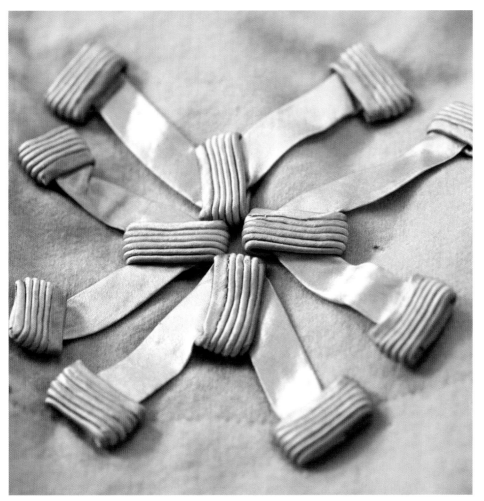

Figure 6.8.

Detail of the chevron and star, center front hem. Photo by Ingrid Mida.

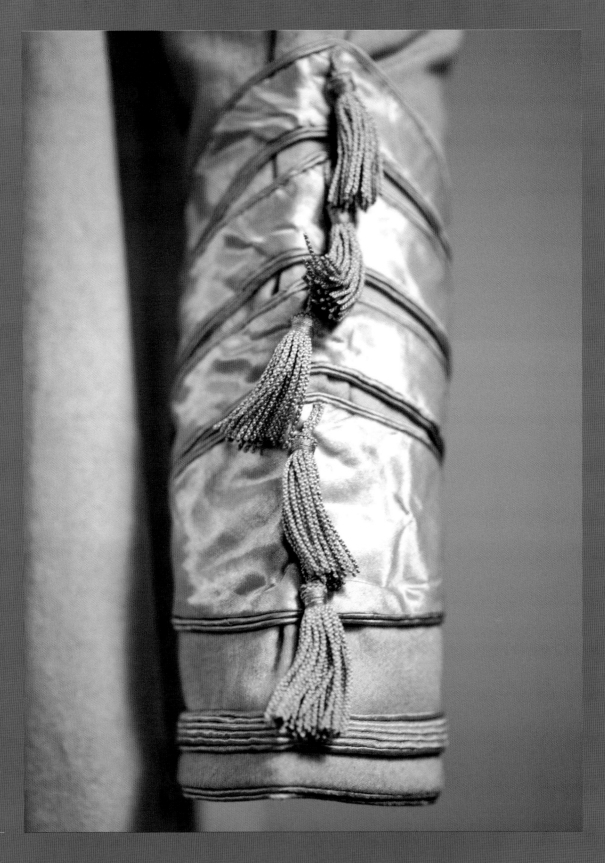

The bodice has further rows of piping placed diagonally across the front bodice sections, which are trimmed with lilac silk tassels. The cuffs are decorated with a deep band of pale yellow silk, cut with chevrons, in imitation of the braid on military uniforms, and finished with matching lilac silk tassels (Figure 6.9). The edge of the belt and the underside of the collar have been finished with matching piping. The back of the belt is decorated with two lilac silk tasseled rosettes (Figure 6.10).

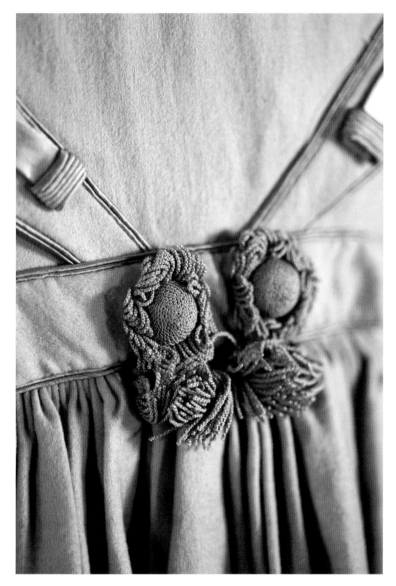

OPPOSITE
Figure 6.9.

ABOVE
Figure 6.10.

Cuff detail. Photo by
Ingrid Mida.

Rosette detail on back of belt.
Photo by Ingrid Mida.

The pelisse closes at the center front with fifteen brass metal hooks and eyes (Figure 6.11), but the belt has no obvious fastening (Figure 6.12). The garment has been sewn meticulously by hand, with small and even stitches throughout (11–12 stitches per inch in the backstitch of the major seams, and 16–18 stitches per inch for the running stitch on the facings and hem), clearly executed by a skillful dressmaker. The color of the thread has been carefully chosen to match the colors of the fabrics, and the wool of the coat is so fine that there is no need to finish the seam to stop fraying.

Figure 6.11.

Brass eye, detailing careful stitching to secure eye. Photo by Ingrid Mida.

Figure 6.12.

Belt, showing lack of fastening. Photo by Ingrid Mida.

Textiles

The pelisse is made from fine primrose yellow wool, and is partially lined with a lilac silk satin. The coat is finished with decorative elements made from the lilac and pale yellow plain-weave silk.

Labels

There are no labels, as is to be expected for an early nineteenth-century garment.

The Use and Wearing of the Garment

The pelisse is in remarkably good condition for a garment that is almost 200 years old. Examination of areas of fabric unexposed to the light (for example, under the epaulettes) demonstrates that both the wool and silk have faded over time (Figure 6.13). The lilac satin lining the skirt panels shows some signs of aging; the lilac is beginning to turn to a pale pink, and there are pale gray striations running through the fabric.

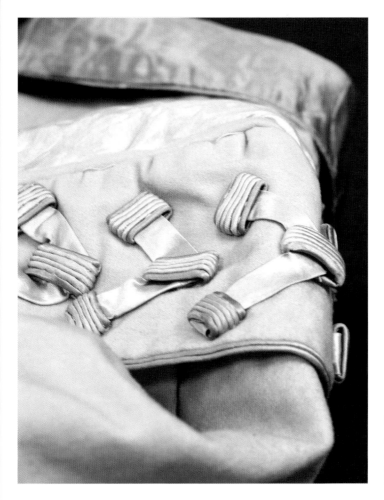

Figure 6.13.

Unexposed fabric from under epaulette showing original color. Photo by Ingrid Mida.

There are a number of signs of wear, including some small stains and evidence of insect damage (Figure 6.14), especially on the exterior of the coat. The piping has worn in a number of areas, especially around the cuffs and the front edge of the coat near the hem, and exposes the white cotton cord around which the silk cut on the cross is sewn. Surprisingly, the entire back center skirt panel is markedly soiled, although the soiling stops abruptly at the panel seams (Figure 6.15). Very few repairs seem to have been made to the pelisse, but there is a small repair in the back panel of the skirt where a yellow silk patch has been sewn to the inside.

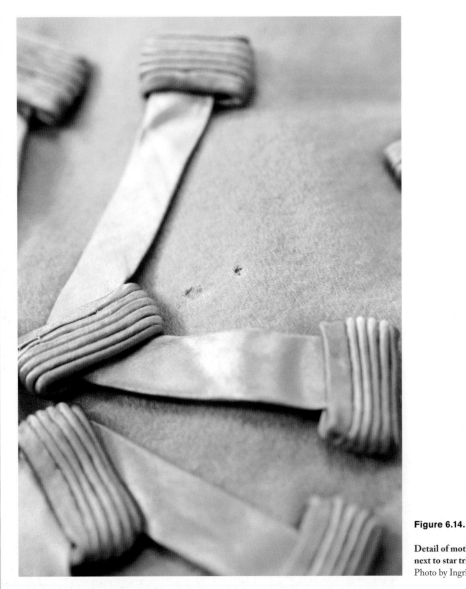

Figure 6.14.

Detail of moth damage, next to star trim detail.
Photo by Ingrid Mida.

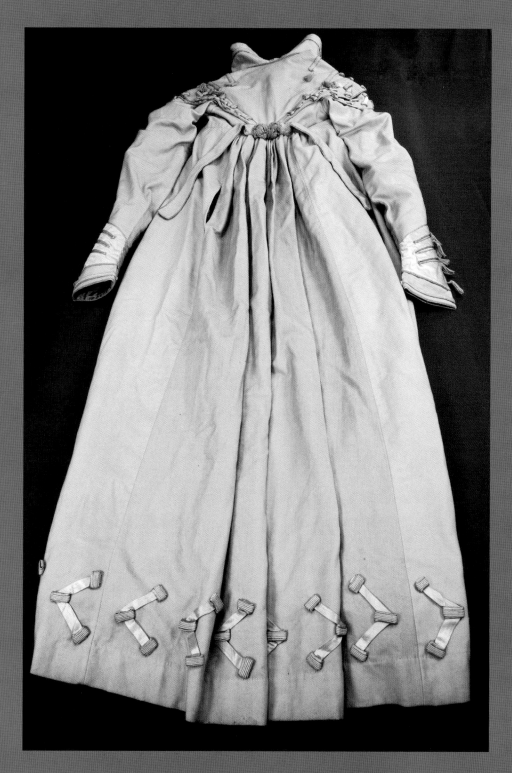

Figure 6.15.

**Pelisse back, showing the marked
soiling on the center back panel.**
Photo by Ingrid Mida.

REFLECTION

The overall appearance of this pelisse is one of stylish elegance; an effect produced by both the high quality of the fabrics used, and its slim silhouette. These impressions also suggest that this was a garment that was expensive to procure. The pale colors of the fabric emphasize the light and delicate feel of the garment, and suggest that it might have been part of a wedding ensemble or bridal trousseau. The high level of workmanship is also evident in the garment, with small, even stiches, and carefully finished seams.

One of the most noticeable elements of the pelisse is its long and slender line, conveyed through the high waistline, exceptionally long sleeves, and narrow shoulders (Figure 6.2). The military influenced decoration gives the pelisse a dashing air, tempered by the sense of feminine refinement offered by the delicate fabric coloring. It is possible to imagine this coat in motion, when the tassels on the bodice and cuffs, would sway gently, emphasizing the graceful steps of the wearer (Figure 6.16). Similarly, the cartridge pleating at the back of the coat would ensure a pleasing movement as the folds of fabric moved.

Figure 6.16.

Detail of three tassels.
Photo by Ingrid Mida.

While the ravages of time and use mean that fewer garments survive from the preindustrial era, those that have been preserved reflect a time when clothing, and the fabric from which it was made, were highly valued commodities, to be well used and cared for. A relatively high number of pelisses survive in museum collections, including the Victoria and Albert Museum, and The Costume Institute at the Metropolitan Museum of Art. These pelisses display comparable silhouettes, as well as similar colors and decorative elements. The piping and military inspired decoration on the case study pelisse are particularly common features for coats and dresses of the period, and many examples can be found. However, it is interesting to note that most of the surviving pelisses in museum collections are made from silk, rather than the fine wool used for this pelisse.

As a key element of a fashionable woman's wardrobe in the early nineteenth century, pelisses were often illustrated in fashion plates, and these images demonstrate the multiplicity of ways in which they were decorated, and the array of color combinations which were chosen (Figures 6.17– 6.19). A number of fashion plates illustrate pelisses very similar in shape and decorative features to this pale yellow pelisse (Figures 6.17 & 6.18). Pelisses are also depicted in portraits of the time, such as the elegant drawings of Lady Mary Cavendish Bentinck and the Countess Apponyi, by Jean-Auguste-Dominique Ingres.[1]

INTERPRETATION

The pelisse's fine fabrics, intricately worked decorative features, and careful preservation are all suggestive of a particularly special garment which, even without a detailed provenance, might offer clues about the physical qualities and social position of its wearer, as well as about the occasions on which it might have been worn. It could also be used to study:

1. The production of women's fashionable garments in the preindustrial age

2. Influences on fashion in the early nineteenth century, and the communication of fashion

As a type of early nineteenth-century outer garment for women, the pelisse was worn over the fashionable light muslin dresses that were typical of the neo-classical period. The pelisse may have been inspired by the fur-lined cloak that formed part of the Hussars' uniform. Indeed, women's pelisses often used warm and luxurious fabrics such as fur in their construction: in *Vanity Fair* Becky Sharp remakes a sable-lined cloak into a pelisse for herself (Thackeray 1967: 285). As the fashion plates in women's magazines of the time illustrate, the exact form of the pelisse was subject to the changing line of fashion, and pelisses might fall anywhere from the knee to the hem. Earlier pelisses were often cut without

Morning Visiting Dress.

Invented by Miss Pierpoint, & engraved for the Lady's Magazine, N.º 3, 1823.

1821. *Costume Parisien.* (2017)

Chapeau de gros de Naples, orné de plumes d'Autruche.
Robe de marceline, garnie en crev-és de satin.

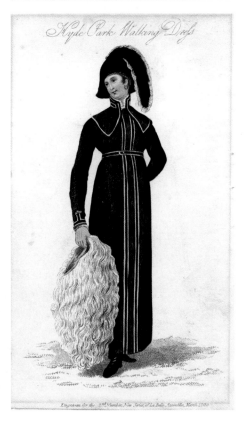

Hyde Park Walking Dress.

Engraved for the 3.º Number, New Series, of La Belle Assemblée, March 1810.

ABOVE
Figure 6.17.

Fashion Plate, *Lady's Magazine*, **March, 1823.**
Private Collection.

TOP RIGHT
Figure 6.18.

Fashion Plate, *Petit Courrier des Dames*, **1821.** Private Collection.

RIGHT
Figure 6.19.

Fashion Plate, *La Belle Assemblée*, **March, 1810.** Private Collection.

a waist seam, whereas those from around 1820 were constructed with a high waist, and a truncated diamond section in the back. Finally, during the 1820s, the pelisse became a kind of coat-dress, worn without another dress beneath (Arnold 1972: 54f).

How does this yellow pelisse help us understand not only the fashions of the time but also the wearer? In Linda Baumgarten's book *What Clothes Reveal*, she advocates the careful analysis of a garment to learn about the original wearer; an exercise that can help to dispel misconceptions about people of the past (2002: 52–75). One prevalent idea is that people of the past were always much smaller than they are today, especially in terms of their height. The dimensions of this pelisse counter this myth, and in doing so, not only help to refute this idea, but also to build up a biography of the object as suggested by Kopytoff. The measurement of 54½ inches (138.4 cm) from the center back neck to hem indicates that the wearer was a woman who was probably around 5 feet 9 inches (175.3 cm) tall, with the coat coming to her ankles. The shoulders of the garment are relatively narrow, as demonstrated by the 10½ inch (26.7 cm) measurement across the width of the diamond section in the back bodice. This is comparable to dimensions for the corresponding section in other outer garments of a similar date.[2] All the measurements of the pelisse present a picture of a tall and slender woman, whose height would not appear surprising today. Hilary Davidson's (2015) research into, and reconstruction of, a pelisse supposed to have been worn by Jane Austen, similarly suggests a garment worn by a relatively tall and slender woman.

Other evidence indicates how the wearer personalized the garment. For example, the pelisse has two pocket slits at its back, but the right-hand pocket slit has been sewn up with a different colored thread, suggesting that the wearer was left-handed, and decided to close the pocket slit that she was unlikely to use.

Similarly, the way the fabric has worn offers clues about the probable use of the garment, thus filling out a "biography" of its subsequent history. The surface of the pelisse is generally clean, with little evidence of spills or stains, but the light colored wool has clearly picked up a layer of general dirt and soiling, as shown clearly by the relatively unexposed fabric beneath the epaulettes (Figure 6.13). Additionally, the back skirt panel of the coat is markedly soiled, far more so than the rest of the coat, and this soiling follows the seam lines abruptly (Figure 6.15). This pattern of soiling is surprising, and suggests that there is something different about the fiber in this particular length of fabric that has caused it to wear differently from the lengths of fabric to which it was sewn.

The fact that the pale yellow wool has generally aged remarkably well for such a light color suggests that the coat may not have had a great deal of use. One possible explanation is that the coat formed part of a wedding trousseau, and was worn in the first year of marriage. Its light coloring would make it especially appropriate for a young woman, and a pregnancy fairly soon after the marriage might help to explain why the pelisse was put to one side

relatively quickly. Or it may be that the unusual but highly noticeable soiling of the back caused the wearer to put the garment aside. The possible connection to a marriage might also help to explain why such a costly garment was kept and saved, after comparatively little use, rather than being reworked into a different garment, which was common practice at the time (Baumgarten 2002: 182–99).

As the small and meticulous hand stiches in this garment suggest (Figures 6.7 & 6.11), the production of clothing before the advent of the sewing machine and mass-produced clothing was a very different experience from today. Before the eighteenth century, a tailor made most main garments for women, but by the early nineteenth century this role was firmly in the hands of a mantua maker or dressmaker (Arnold 1972: 9). Fabric would be bought first from a mercer's or fabric warehouse before being taken to a dressmaker to be made up into the garment. While the labor cost was a small proportion of the total, the relatively high cost for the fabric itself helps to explain why so many garments were remade.[3]

The fashion plates that appeared in the women's magazines of the day provide useful comparisons to the yellow pelisse. As a fashionable item of dress, the pelisse is a garment that appears regularly in the plates of the 1810s and 1820s. Many pelisses, illustrated from around 1820, show features akin to the pelisse in this case study. A blue silk pelisse, shown in an 1821 edition of the *Petit Courrier des Dames* (Figure 6.18), has decorative elements similar in feel to the pale yellow pelisse, including the shoulder emphasis, and the piped decoration that runs across the bust, down the front, and around the hem. Additionally, such fashion plates provided readers with valuable information about how to wear pelisses stylishly. For example, the woman illustrated in the *Petit Courrier des Dames* fashion plate (Figure 6.18) wears her blue pelisse with the collar turned up, as might have been the case with the yellow pelisse, allowing the decorative piping on the underside to be seen. The cuffs of the sleeves come down low over the hands of the fashion plate figure, and the pelisse hem skims around her ankles.

Another element emphasized by the fashion plates is the popularity of military inspired decoration for the fashions of the day. Although military uniforms had inspired elements of women's dress in the eighteenth century, especially in the styling of riding habits (Blackman 2001: 47–58), fashion plundered the ornate and stylish decoration of military uniforms for inspiration during the Napoleonic Wars. The *Hyde Park Walking Dress,* illustrated in the March 1810 edition of *La Belle Assemblée* (Figure 6.19), with its severe but elegant black wool pelisse, trimmed in gold braid and worn with a bicorn-style hat, has an evident military allusion. Decorative details referencing the trim and braid of military uniforms, especially that of the dashing cavalry regiments, remained popular throughout the 1810s and 1820s (Johnston 2005: 20). The silk cuffs of the yellow pelisse, with their chevrons and tassels, have clearly been fashioned to echo the decorative braid on military uniform (Figure 6.9), as have the lines of piping across the chest, and the chevron border around the opening and hem.

It is noteworthy that the yellow pelisse is made from fine wool, because almost all surviving examples of pelisses are made from silk.[4] Woolen pelisses would surely have been a practical choice to be worn over the fine muslin dresses in temperate and often chilly climates like England, so why do so few survive? In a final twist to creating the biography of this yellow pelisse, the garment itself suggests why this may be the case, since there are signs of insect damage that have affected parts of the garment (Figure 6.14). As one of the main animal fibers used in the production of cloth, wool is particularly susceptible to insect damage, and many nineteenth century woolen garments have suffered the ravages of insect damage, especially the clothes moth (Sandwith and Stainton 1991: 267).

It may never be possible to find out exactly who wore the pelisse, and why it was carefully preserved so that it still survives today. Nonetheless, by taking the time to carefully "listen to" the garment and record its physical biography, a picture of both the wearer and the pelisse's preservation history can be created. As a woolen pelisse of fine workmanship, it offers a beautiful and remarkable survival of early nineteenth-century fashions, and the traces of a stylish woman whose appreciation of her pelisse may have provided the reason for its preservation.

NOTES

1. *Lady Mary Cavendish Bentinck*, 1815, pencil on paper (RP-T-1953-209, Rijksmuseum, Amsterdam), and *Teresa Nogaraola, Countess Apponyi*, 1823, pencil on paper (1943.848, Fogg Art Museum, Harvard); illustrated in A. Ribeiro (1999), *Ingres in Fashion,* New Haven: Yale University Press, Plates 41 & 48.

2. Examples of women's early nineteenth-century outer garments, illustrated in Bradfield's *Costume in Detail 1730–1930,* have a truncated diamond piece in the bodice back with similar measurements: 97f, 99f,107f.

3. See, for example, Davidson (2015).

4. See examples in the collections of the Victoria and Albert Museum, and the Costume Institute, Metropolitan Museum of Art. While the fabric most commonly mentioned for pelisses in contemporary fashion magazines is *Gros de Naples*, a stout silk, they also describe pelisses made from "fine cloth," and other woolen fabrics (*Lady's Magazine*, February 1823: 126).

REFERENCES

Arnold, J. (1972), *Patterns of Fashion: Englishwomen's Dresses and their Construction 1660–1860.* London: Macmillan.

Baumgarten, L. (2002), *What Clothes Reveal: The Language of Clothing in Colonial and Federal America*, New Haven: Yale University Press.

Blackman, C. (2001), "Walking Amazons: The Development of the Riding Habit in England," *Costume,* 35: 47–58.

Bradfield, N. (1997), *Costume in Detail 1730–1930,* Orpington: Eric Dobby.

Davidson, H. (2015), "The Fashion and Strength of Jane Austen's Pelisse, 1812–14," *Costume,* 49 (2).

Johnston, L. (2005), *Nineteenth Century Costume in Detail*, London: V&A Publications.

Kopytoff, I. (1986), "The Cultural Biography of Things: Commoditization as Process," in Arjun Appadurai (ed.), *The Social Life of Things: Commodities in Cultural Perspective*, New York: Cambridge University Press: 64–91.

Pelisse, entry in *Oxford English Dictionary*. Available at: http://www.oed.com/view/Entry/139854?redirectedFrom=pelisse#eid, accessed June 15, 2014.

Sandwith, H. and Stainton, S. (eds.) (1991), *The National Trust Manual of Housekeeping*, London: Viking.

Thackeray, W. M. (1967, first published 1847–48), *Vanity Fair*, London: The Zodiac Press.

The Lady's Magazine (1823), Monthly Calendar of Fashions, London: S. Robinson, February 1823: 126.

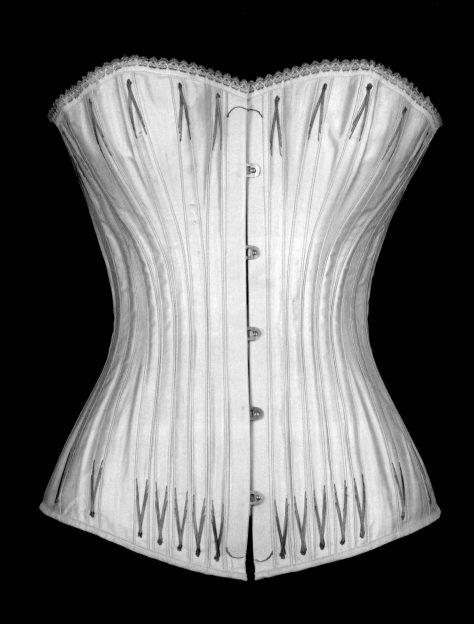

7

Case Study of a Gray-blue Sateen Corset

The corset has been described as one of the most controversial garments in history. Valerie Steele's seminal work on this topic has done much to challenge traditional, and often misleading, assumptions about the corset, which has been seen both as a garment of injurious oppression, forced upon women by the tyrannous dictator of fashion, or as a garment of fetishistic eroticism (2003: 88–90). Steele also emphasizes the complex seductive appeal that the corset held for nineteenth-century women and men, and recognizes that the corset continues to fascinate and inspire.

This case study considers a modest example of a gray-blue corset from the late 1890s, belonging to a private collection (Figure 7.2). Its heavily boned structure, with gussets at the bust and hips, and front and back fastenings, are all typical of 1890s' corsetry. The case study corset has a brand name stamped inside, indicating that this is the product of a Canadian corset company, but is remarkably similar to one made by an American company (Figure 7.1). In examining this undergarment, a more realistic and prosaic picture of nineteenth-century corset-wearing emerges, in which the ubiquity of corsets as an essential part of a woman's wardrobe before the First World War becomes evident.

OBSERVATION

Construction

The light gray-blue corset has two parts with a split busk and *broderie anglaise*-style trim. The corset is relatively short in the hip, curving over the stomach at the center front, and sitting higher at the back. (The center front opening is 15 inches or 38 cm long). Flared panels at the side allow the corset to spread over the hips (Figure 7.3). Similar panels provide accommodation for the breasts. The corset is stiffened by a combination of wide steel stays (⅝ inch or 1.6 cm) and narrower stays (¼ inch or 0.6 cm), probably made from a plant-based stiffener. The wider stays are found at the sides and back, with the narrower stays arranged in groups of three.

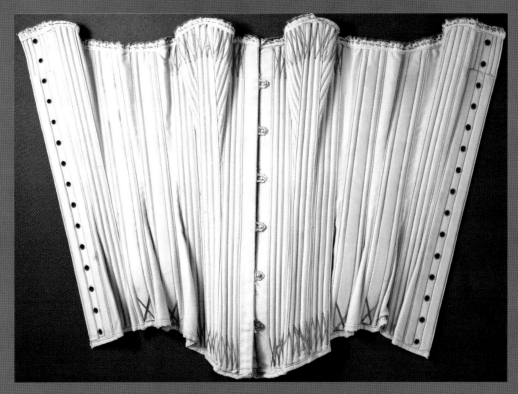

ABOVE
Figure 7.2.

Case study corset exterior flat. Photo by Ingrid Mida.

RIGHT
Figure 7.3.

Case study corset, laced closed. Photo by Ingrid Mida.

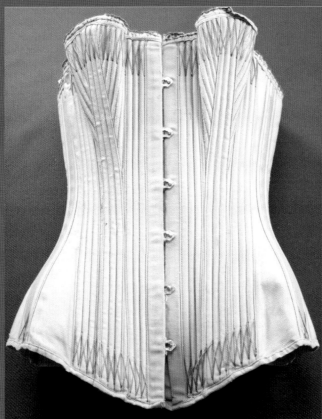

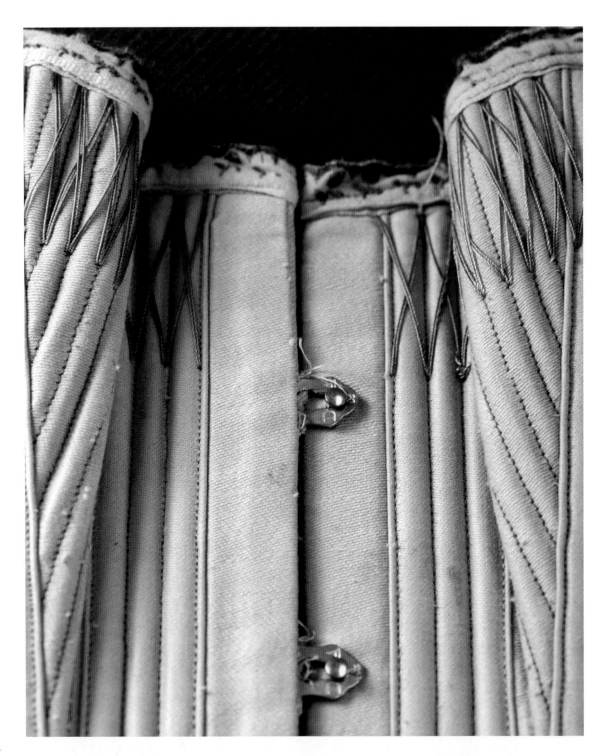

THIS PAGE
Figure 7.4.

Slot and stud fastenings down busk. Photo by Ingrid Mida.

OPPOSITE
Figure 7.5.

Detail of bust cup, showing flossing and trim along upper edge. Photo by Ingrid Mida.

The straight-sided busk (1⅜ inch or 3.5 cm wide) curves into the stomach at its lower edge, and is fastened with six metal slot and studs (Figure 7.4). At the back there are fifteen pairs of metal eyelets for the corset lacing; the original laces did not survive. The corset edges are finished with a binding of self-fabric, and the exterior is trimmed with decorative flossing in dark gray thread, and a narrow white machine-embroidered trim around the upper edge, in the style of *broderie anglaise* (Figure 7.5).

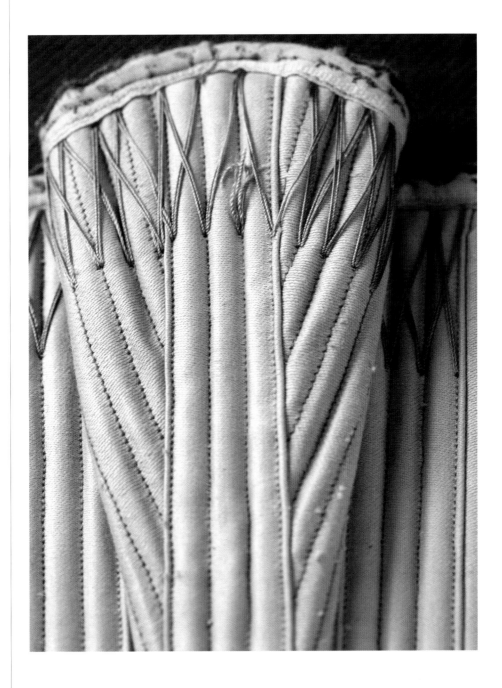

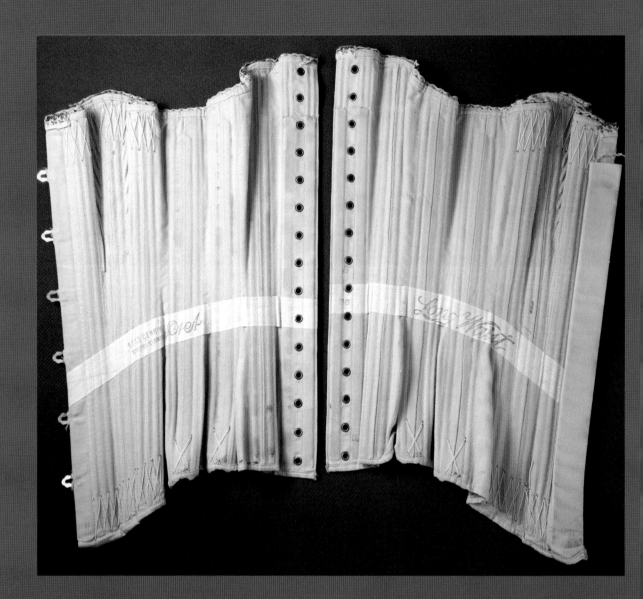

Figure 7.6.

**Corset interior flat,
showing interior cream
flossing.** Photo by
Ingrid Mida.

Corset-lacing allowed a wide degree of flexibility in the finished size of a corset, and most women would probably have laced their corsets with a few inches between the back opening, but it is usual to provide measurements for a corset laced fully shut. When laced closed, this corset has a waist measurement of 19¼ inches (48.9 cm), and a bust of 28½ inches (72.4 cm).

All the major elements of the corset, including the seams and channels for the stays, are machine-stitched. It is difficult to ascertain if the flossing (using cream thread on the inside) has been sewn by hand or machine (Figure 7.6).

Textiles
The corset is made from gray-blue cotton sateen, and the lining is the sateen fabric used reverse side up. The trim around the upper edge is made from cotton. The fabric may have faded over time from a more vibrant hue.

Labels
The cotton band is faintly printed with the words "*NONE GENUINE UNLESS STAMPED D&A*" and "*Long Waist*" (Figures 7.7 & 7.8). The initials "*D&A*" have also been stamped on the slot fastenings for the busk (Figure 7.9).

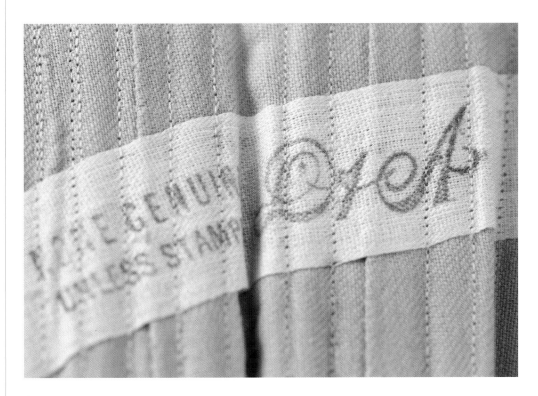

Figure 7.7.

Printed D&A inscription on cotton band. Photo by Ingrid Mida.

ABOVE
Figure 7.8.

**Printed inscription
"Long Waist."** Photo by
Ingrid Mida.

RIGHT
Figure 7.9.

**Engraved initials on
slot fastening.** Photo by
Ingrid Mida.

Use and Wearing of the Garment

There are two brass staples at the lower right hip that might have held in place a paper label, which has probably worn away over time. This suggests that the garment was not worn. This is supported by the fact that the corset shows no signs of major wear. The trim stitching has deteriorated in places, and the corset is covered in rust stains from the metal stays (Figure 7.10). The busk cover has frayed at the top, allowing the gray metal busk to be partially seen.

Figure 7.10.

Rust stain from metal stays.
Photo by Ingrid Mida.

REFLECTION

The rigidity of the corset inevitably conjures in the contemporary mind—used as we are to comfort and stretch in clothing—ideas of constriction and control, especially with the wide, stiff busk down the center front of the corset. Overall, the corset has a curious mixture of femininity and practicality. While the delicate coloring of the corset, the contrasting flossing, and the narrow trim have an air of softness, the cotton fabric and the relative plainness of the garment give it a more utilitarian feel. There is a feeling of modest prettiness rather than sensual luxury.

The private collection from which this corset originates contains a number of corsets made by the same Canadian company. While corsets do not survive in high numbers, because they tended to be used until worn-out, most museum collections have good examples of both high-end and mass-produced corsets. Often the mass-produced corsets are examples of unsold stock (Lynn 2010: 90), and there are some key museum collections of corsetry and supporting material related to specific corset companies, which include the Symington collection of corsetry at Leicestershire Museum Service in the United Kingdom, and examples of Royal Worcester corsets in the Metropolitan Museum of Art in New York (Figure 7.1).

The rich and seductive symbolism of the corset means that it appears in a range of nineteenth-century art, from paintings of women getting dressed to erotic prints (Figure 7.11), as well as a garment of sensuous desire in novels such as Balzac's *Cousin Bette* and Zola's *Nana*. More prosaic examples of corsets are illustrated in late nineteenth-century advertising in women's magazines and newspapers, as well as surviving trade cards, pamphlets, and packaging for corsetry (Steele 1999: 459–72).

INTERPRETATION

This rather ordinary and simple corset is characteristic of the many millions of mass-produced corsets sold at the end of the nineteenth century, and offers the chance to highlight the ubiquity of corsets as an essential part of a woman's wardrobe before the First World War. It could also be used to examine:

1. Technological changes in corset production

2. Late nineteenth-century advertising of mass-produced garments

3. The continuing inspiration of the corset for contemporary fashion

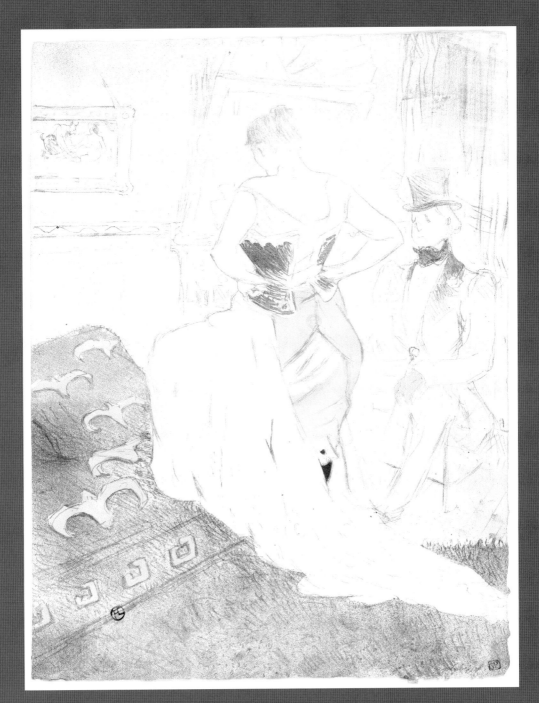

Figure 7.11.

Toulouse-Lautrec, Henri de (1864–1901). Publisher: Gustave Pellet, French. *Fastening a Corset, A Passing Conquest,* **from the series** *Elles,* **1896.** Crayon, brush and spatter lithograph with scraper, printed in five colors on wove paper, sheet: 20 11/16 x 15 15/16 inc. (52.5 x 40.5 cm). Alfred Stieglitz Collection, 1949 (49.55.58). Image © The Metropolitan Museum of Art. Image source: Art Resource, NY.

The reality of corset wearing in the nineteenth-century is often obscured by the sensationalist literature that tends to focus on the extremes of this garment to control and shape the body. Valerie Steele argues that to see the corset as merely a garment of repression denies any sense of female agency in the wearing of the garment, and fails to properly understand why it remained a fashionable and desirable garment with women of all classes for so long (Steele 1999: 463 & 2003: 1). Steele's work draws on both medical and contextual evidence to suggest that the image of tight-laced oppression, so commonly associated with the corset, is a grotesquely exaggerated lens through which to view the role of the corset in the nineteenth century.

One key point raised by Steele, which is well emphasized by the corset in this case study, is the fact that corsets were produced for and worn by women of all classes. Indeed, she highlights the fact that, for many women, and certainly in England, the idea of *not* wearing a corset was associated with moral looseness. It was, therefore, an essential garment, not only in terms of producing a fashionable ideal, but also in ensuring that a woman was properly dressed, according to the strict Victorian codes of etiquette (2003: 21–27). Steele refutes the ideas of the early twentieth-century economist Thorstein Veblen, who argued that the corsets were the preserve of wealthy and inactive women, because they would have prohibited active work (Steele 2003: 49). For example, at the end of the nineteenth century, the Symington corset company in Market Harborough, United Kingdom, produced the "Pretty Housemaid" corset, which, as its name suggests, was promoted specifically to a market of working-class women, with the claim that it was the "strongest and cheapest corset ever made" (Symington Fashion Collection, online resource). The range of prices for corsets further supports the theory that the majority of women wore corsets. In 1861, it is estimated that 1.2 million corsets were sold in Paris, with the most expensive silk corsets priced at 25–60 francs, and the cheapest around 3 francs (Steele 2003: 44). Furthermore, in the second half of the nineteenth century, most corsets took advantage of the split busk, patented in 1829 by Jean-Julien Josselin, and utilized the slot and stud fastening system patented by Joseph Cooper in 1848 (Lynn 2010: 86). These two developments made it much easier for women to put on their corset without the help of another person, and thus made them even more practical for women of the working classes.

Trade literature, including advertisements in newspapers, magazines, and shop catalogues, demonstrates that, by the end of the nineteenth century, an extensive range of mass-produced corsetry was available at the lower end of the market. This particular corset, marked "D&A," is clearly representative of this type of corsetry. An advertisement on June 12, 1900, in *The Ottawa Evening Journal* (Figure 7.12), notes that the D&A corset "has a yielding and comfortable hip construction that is absolutely unbreakable," and includes the prices of CAD $1.25 and $1.50. In 1900, the Dominion Corset Company claimed that its 45 Rue Dorchester, Quebec factory was the "the largest corset factory in Canada" (*Globe*

1900: 8). Corsets like this example employed less expensive materials, such as metal stays, a plain cotton sateen fabric, and machine-embroidered trim, which allowed them to be produced more cheaply. By 1911, the company produced 5,400 corsets a day, or 9 corsets a minute (Du Berger and Mathieu 1993: 39). The scale of the Dominion Corset Company operation, which sold its corsets well beyond Canada, also contributed to its ability to benefit from economies of scale.[1] Advertisements from New Zealand demonstrate that its corsets could be purchased in many parts of the British Empire (*Marlborough Express* 1918: 7).

The materials and methods of production observed in this corset demonstrate the way in which mass-produced corsets benefitted from improvements in technology over the nineteenth century. The introduction of metal eyelets in the 1820s (allowing garments to be laced without the risk of ripping the lace-hole fabric), along with the split busk, and the slot and stud fastenings of the 1840s, were early changes that allowed corsets to be fastened and adjusted with greater ease (Figure 7.4). The widespread

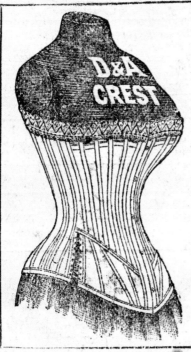

Figure 7.12.

D&A corset advertisement, *The Ottawa Evening Journal,* June 12, 1900, p.5.

adoption of the sewing machine in the mid-nineteenth century revolutionized the production of garments: in the case of the corset, it greatly simplified the process, and reduced both the time and cost involved. The text of a pamphlet produced in 1898 by the Royal Worcester Corset Company, which lays out the factory process of producing corsets, highlights many of these developments, from steam-molding to machine-flossing (Doyle 1997: 123–25). While it is not possible to tell whether the flossing on this particular corset was done by hand or machine (Figure 7.6), the increasing use of plant-based stiffeners for stays by this time allowed machines to be used for the flossing, without breaking their needle (Doyle 1997: 126). Similarly, metal stays provided a cheap alternative to the relatively expensive, and increasingly scarce whalebone, although as the metal stays in this corset demonstrate, they commonly rusted (Figure 7.10); an issue which remained until the introduction of plastic coating for metal stays in the twentieth century (Doyle 1997: 123). The machine-embroidered trim that finishes this corset provides a pretty but inexpensive alternative to more costly lace.

Despite the relative modesty, both in terms of price and materials, the gray-blue corset also provides evidence of the way in which the fashionable ideal of the time was one to which all social classes aspired. As the D&A advertisements from 1900 stressed, the motto of the company was "not how cheap, but how good," clearly referencing the way in which these humble corsets were still designed to produce a modish and modern figure for their wearers. While this corset makes use of serviceable materials, it still conforms to the stylish shape of more high-end examples from this period, which would have narrowed the waist, spread lightly over the hips, and produced a straight front to the abdomen, like the shocking pink satin example of a similar date in the collection of the Victoria and Albert Museum (T.738-1974). Additionally, corsetry, like other forms of underwear such as petticoats, increasingly adopted color in the second half of the nineteenth century, which added to its aesthetic, and often sensual appeal. The magazine *La Vie Parisienne* exclaimed, in the 1880s, that such vibrant examples of corsetry were "very elegant and extremely becoming. Evidently designed to be seen and … looked at!" (cited in Lynn 2010: 126). The light gray-blue of this corset offers a modest echo of this growing trend for color in underwear. It also suggests an evolution in the type of busk used for corsetry, as concerns about the effect of corsets on health prompted manufacturers to highlight the physical benefits of their models. Like the Victoria and Albert Museum's pink satin example, the corset of this case study has a straight busk, lightly curved at the stomach. These straight-front busks were promoted as less injurious to internal organs, while still supporting the stomach.

Finally, even in its simplicity the gray-blue corset suggests some of the reasons why nineteenth-century corsetry has offered such inspiration to modern-day fashion, reworked and updated by *haute couture,* pop stars, and fashion retailers. No longer an essential foundation for the fashionable figure,

or a symbol of female repression, designers and wearers have felt free to play creatively with its color, decoration, and use. Vivienne Westwood's fascination with the historic corset was shown resplendently in collections like *Harris Tweed* and *Dressing Up*. Similarly, Jean Paul Gaultier's confident use of the corset, as displayed in his outfits for Madonna's *Blond Ambition Tour,* highlights the way in which the armor-like shell of a corset now often suggests strength and ambition, rather than subjugation and weakness. Sarah Burton's reflection on the inspiration for the McQueen spring/summer 2013 collection encapsulates another aspect of the corset's appeal: "The collection is a study of femininity. We looked at erotica. Vargas girls, cages, corsets and crinolines and the idealization of the female form. Nothing is set in a particular period. It's about sensuality and skin but not nudity" (Burton 2012). Fashion, however, has not only appropriated the corset per se, it has also borrowed the fastenings, finishes, and stitches of nineteenth-century corsetry. Details on the gray corset, from the pleasingly curving lines of the stitching channels for the stays, to the lacing eyelets at the back, and the flossing over the stay ends, have all found their way into contemporary fashion design. In this way, the case study corset offers a tangible reminder, not only of the continuing draw of the corset's aesthetic and sensual appeal, but also its ability to fashionably shape and support women from all classes in the nineteenth century.

NOTE

1. The Dominion Corset Company began operating in Quebec in 1886, and closed in the 1980s.

REFERENCES

Burton, S. (2012), Alexander McQueen Website. Available at: http://www. alexandermcqueen.com/experience/en/ alexandermcqueen/archive/womens-springsummer-2013/. Accessed June 15, 2014.

Doyle, R. (1997), *Waisted Efforts: An Illustrated Guide to Corset Making*, Halifax: Sartorial Press.

Du Berger, J. and Mathieu, J. (1993), *Les Ouvrières de Dominion Corset à Québec, 1886–1988*, Sainte-Foy, Québec: Presses de l'Université Laval.

Globe (1900), Advertisement for D&A corsets, April 7, 1900, Toronto: 8.

Lynn, E. (2010), *Underwear: Fashion in Detail*, London: V&A Publications.

Marlborough Express (1918), Advertisement for D&A corsets, September 26, 1918, Marlborough, New Zealand: 7.

Steele, V. (1999), "The Corset: Fashion and Eroticism," in *Fashion Theory*, 3 (4): 449–473.

Steele, V. (2003), *The Corset: A Cultural History,* New Haven: Yale University Press.

Symington Fashion Collection, online resource of the Symington corsetry collection. Available at: http:// imageleicestershire.org.uk/view-item?i =11963&WINID=1402632168292

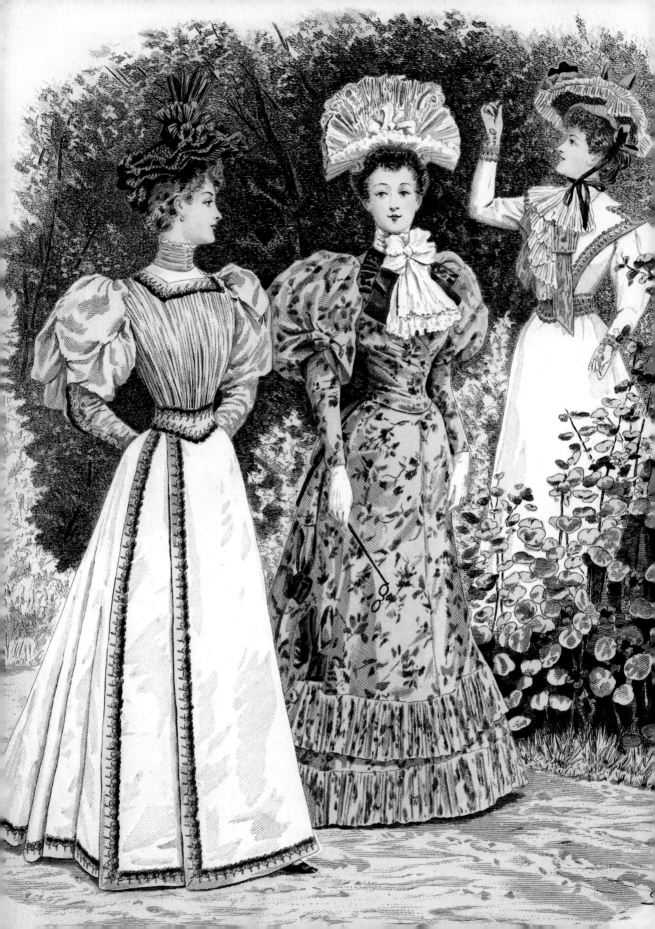

8

Case Study of a Brown Velveteen and Wool Bodice

OPPOSITE
Figure 8.1.

Fashion Plate, *Latest Paris Fashions*, August 1894.
Private Collection.

Until relatively recently, scholars have concerned themselves primarily with the dress of the fashionable elite, or the often idealized folk costumes of rural populations. As a result, working-class dress is often not well represented in museum collections; a fact that is aggravated by the low rate of survival for such clothing. However, the value of preserving and studying the dress of the working classes has come to be valued, not only as a way of shedding light on communities who are less well represented in textual records, but also as a means of more fully understanding the dynamics of the fashion system.

In this case study, we consider a woman's bodice of brown velveteen and wool, from a private collection. This bodice has no confirmed date or provenance, but its style suggests that it dates from the late 1890s, since the sleeve heads have a pronounced fullness that was a defining element of the fashionable dress of that time (Figure 8.1). The interior of the bodice reveals the complexity of its construction, and the lack of a label suggests that it was either homemade, or created by a dressmaker. Although there are some areas of wear, the bodice is structurally sound and can be safely examined. Carefully observing this fashionably styled garment made from a modest fabric offers the chance to consider the mechanics of the fashion system at the turn of the twentieth-century, as well as illustrating practices of dressmaking, and changing patterns of clothing production.

OBSERVATION

Construction

The bodice is fitted, with a slightly pointed waistline and full, puffed sleeves (Figure 8.2). It has a center front opening, with two shaping darts at the waist on each side of the opening, and the velveteen fabric, which forms the body, is draped loosely over the front to give a slight blouson effect. The waist measures 23½ inches (60 cm), and the bust measurement is 29 inches (73.7 cm). The bodice is relatively short in the waist, which is demonstrated by its center back length of 19 inches (48.3 cm) (Figure 8.3). The fastenings for the opening are covered by an additional tapered piece of velveteen that has been added to the right-hand side. The bodice has a standing collar of reddish-brown silk that is 2½ inches (6.4 cm) high.

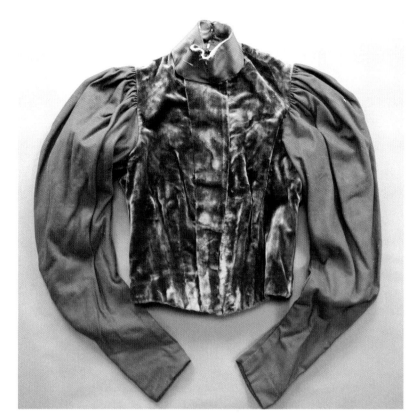

Figure 8.2.

Bodice front.
Photo by Ingrid Mida.

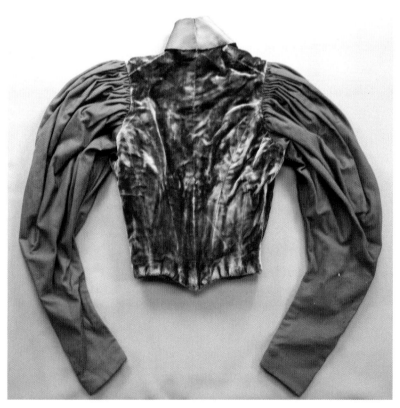

Figure 8.3.

Bodice back.
Photo by Ingrid Mida.

The brown wool sleeves (19 inches or 48.3 cm long) have a full sleeve head (12 inches or 30.5 cm at widest point), which is tightly gathered into the armhole around the top and back (Figures 8.4 & 8.5). They are cut in one piece, with a single seam down the inner arm, and graduate from the widest point near the shoulder to fit closely around the wrist (the wrist opening has a circumference of 7½ inches or 19.1 cm). A triangular gusset has been added at the lower back of the armholes to facilitate movement.

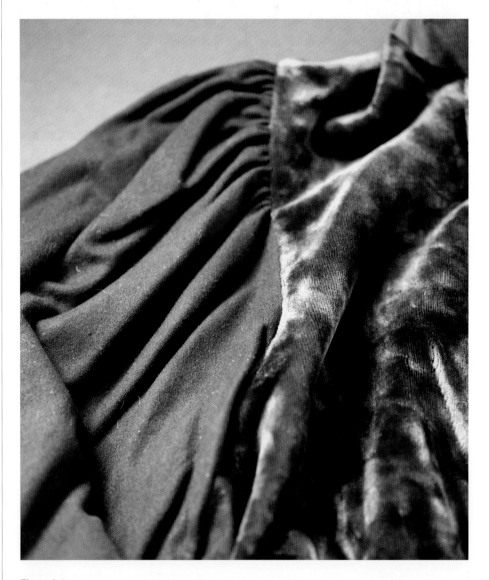

Figure 8.4.

**Gathers at shoulder
of full sleeve.**
Photo by Ingrid Mida.

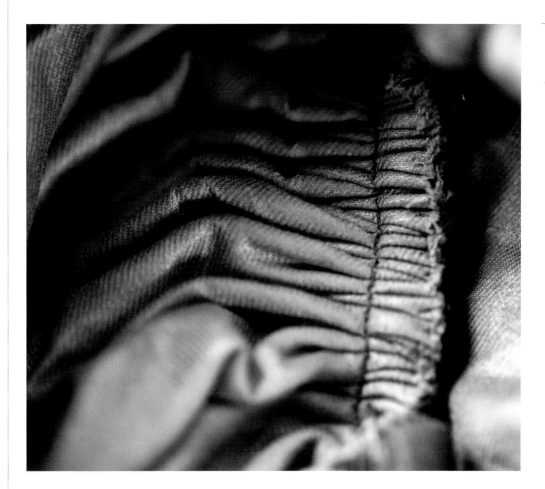

Figure 8.5.

Interior gathers at shoulder.
Photo by Ingrid Mida.

The interior of the bodice reveals the complexity of its construction (Figure 8.6). Six pieces form the back of the bodice, two pieces form each front section, and there is an additional tapered piece covering the opening. The body of the bodice has been lined with brown cotton that has been worked as one with the outer fabric, while the sleeves are lined with gray cotton. Sewn into the body of the bodice are ten metal stays, encased in black cotton (Figure 8.7). A black cotton belt has been stitched into the back of the bodice waist, over the stays (Figure 8.8). The slight damage to the silk of the collar reveals that it has been stiffened with three layers of buckram (Figure 8.9).

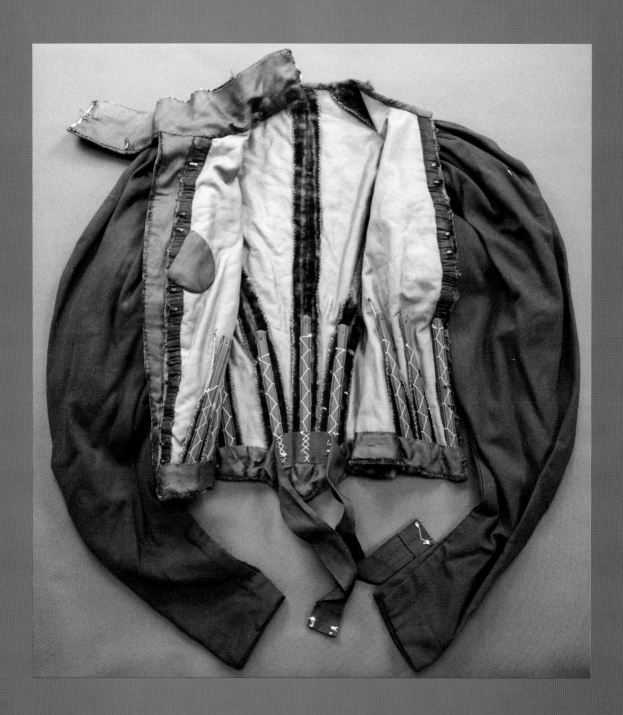

THIS PAGE
Figure 8.6.

**Bodice open to
show construction.**
Photo by Ingrid Mida.

OPPOSITE
Figure 8.7.

Detail of stay and seams.
Photo by Ingrid Mida.

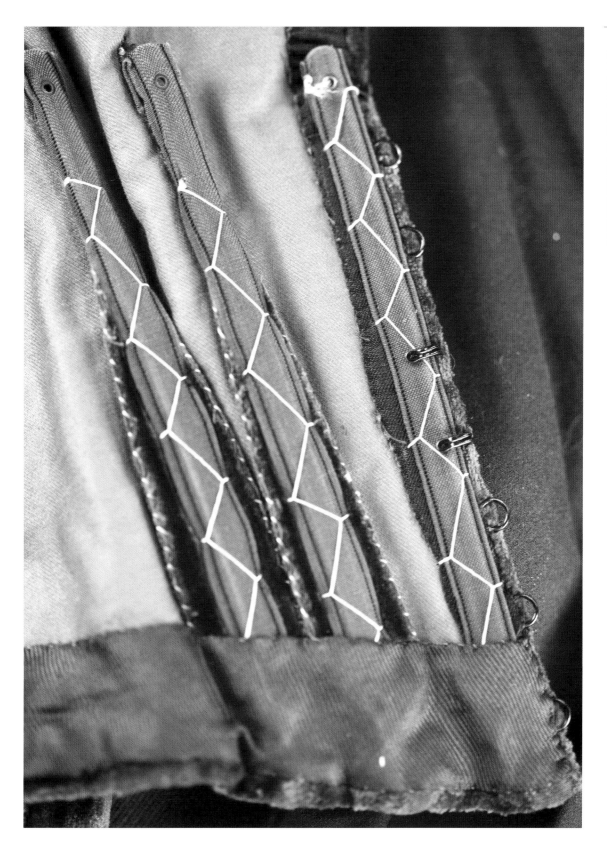

The interior of the bodice also reveals a small watch pocket sewn into the right-hand side (Figure 8.10), and coarse cream-colored cotton dress protectors sewn beneath the arms (Figure 8.11). The dress protectors are padded with a wool or cotton stuffing, and bear no name or marking, indicating that they were likely homemade.

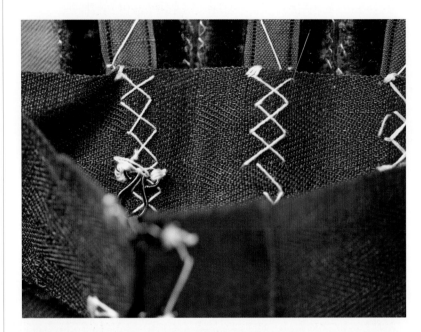

Figure 8.8.

Closure of interior belt.
Photo by Ingrid Mida.

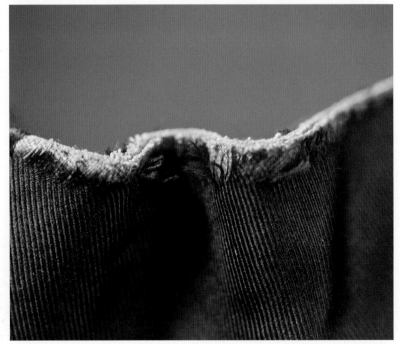

Figure 8.9.

Detail of collar damage revealing buckram.
Photo by Ingrid Mida.

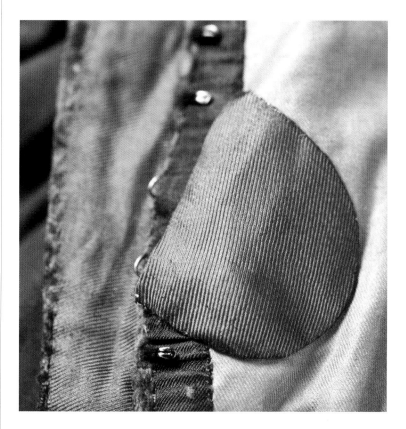

Figure 8.10.

Detail of watch pocket.
Photo by Ingrid Mida.

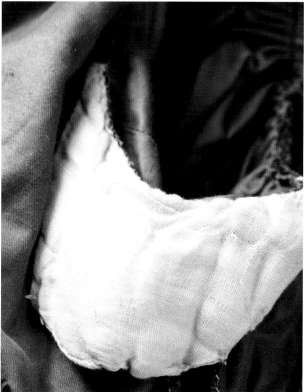

Figure 8.11.

Dress protector.
Photo by Ingrid Mida.

The bodice is fastened by a series of nineteen black painted metal hooks, and eyes down the center front. These have been sewn in alternating pairs, so that there are two hooks followed by two eyes on each side, to stop the bodice popping open (Figure 8.12). The hooks and eyes are secured under a black cotton twill tape with additional hand stitches to hold them firmly in place. Further metal hooks and eyes are used to fasten the collar and neckline.

The garment has been sewn by a combination of machine- and hand-stitching. The major seams have been machine-stitched, and the edges of the seams have been finished by overcasting in cream thread (Figure 8.7). The facings and the binding have been sewn by hand. The belt and stays have been secured with large hand stitches.

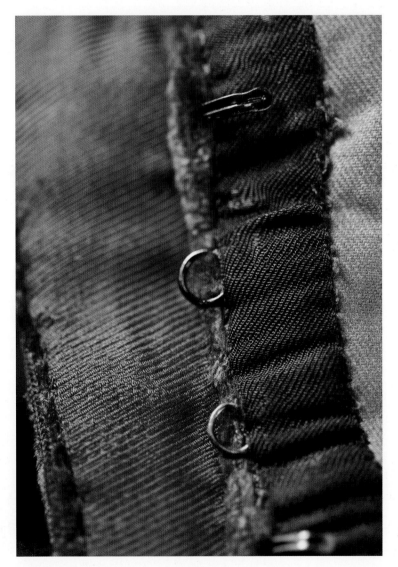

Figure 8.12.

Pairing of hooks and eyes down front opening.
Photo by Ingrid Mida.

Figure 8.13.

Wool and velveteen at left-hand shoulder. Photo by Ingrid Mida.

Textiles

The main body of the bodice is made from brown velveteen (a fabric imitating velvet), and the sleeves are made of brown wool (Figure 8.13). The collar is a brown ribbed silk. There are two cotton lining fabrics: medium brown twill has been used for the body; and gray twill has been used for the sleeve lining. The ribbed silk has been also used to bind the inner edge of the waist, and to face the additional strip that covers the opening.

Labels

There are no labels in the bodice.

Use and Wearing of the Garment

The bodice is generally in good condition. However, there are significant signs of wear to the edges of the collar and the silk binding around the neckline, as well as the edges of the velveteen. The collar has worn away to show the buckram stiffening (Figure 8.9), and the fabric on the inside of the collar has become shiny through wear. The pile of the velveteen has worn away, especially down the front opening and around the lower edge. In other areas there are signs that pressure on the velveteen (possibly from storage) has crushed the pile over time, to give the fabric a mottled appearance. The small irregular holes on the woolen fabric of the sleeves demonstrate some insect damage (Figure 8.14). There are no pin marks from jewelry or stitching, although there is one loose pink thread on the collar.

REFLECTION

The mixture of fabrics used to make the bodice presents a marked visual and textural distinction. The weightier wool of the sleeves contrasts with the soft, tactile appearance of the velveteen that forms the body of the bodice (Figure 8.13), and the lustrous sheen of the silk used for the collar. Despite the very plain, almost severe nature of the garment—an effect heightened by the lack of ornamentation—it has a visual appeal produced by the tonal harmony of the fabric colors, and the textural variation.

Elements in the garment are suggestive of the constrictive nature often associated with late nineteenth-century women's fashionable dress. The high, tight standing collar, and the additional boning in this bodice, indicate a garment that was not necessarily comfortable to wear.

Figure 8.14.

Insect damage on woolen fabric.
Photo by Ingrid Mida.

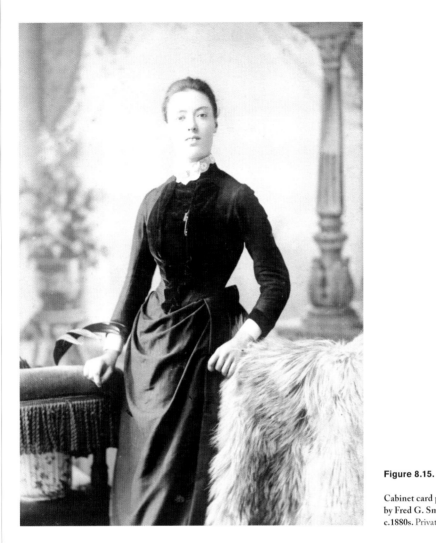

Figure 8.15.

Cabinet card portrait
by Fred G. Smith, Kent.
c.1880s. Private Collection.

Part of the research appeal of the garment is that it represents a type of object that is less likely to survive in a museum or study collection. Working and lower-middle classes would not be able to afford as many outfits or changes of dress as a wealthier person, as evidenced by advice literature, such as Florence White's *How to Dress Well on a Small Allowance* (1901). They were much more likely to wear the garment until it was worn-out, at which time it might be recut or reused for another purpose, such as rags.

This bodice comes from a large private collection, but there are no provenance records that provide information about the specific woman who might have worn it. Nor are there any photographs or other types of visual material directly associated with the bodice, although many examples of similar bodices can be found in cabinet cards and photographs of ordinary people (Figures 8.15 & 8.16). Photographs and engravings depicting general street scenes can also provide evidence of similar garments being worn in dynamic poses.

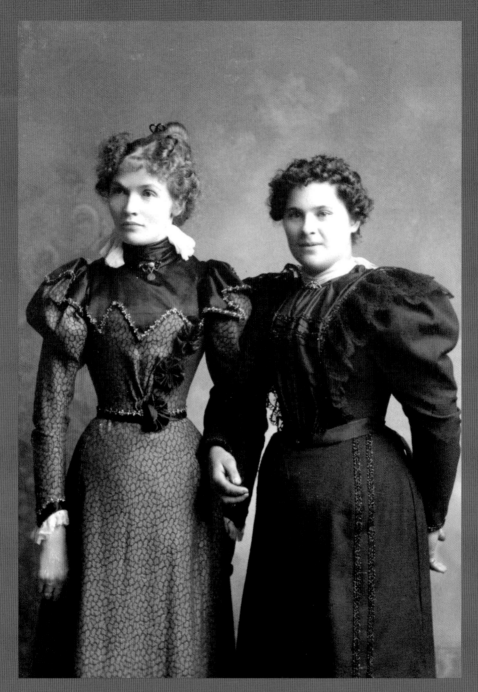

Figure 8.16.

**Cabinet card portrait by R.A.
Trueman & Co., Vancouver,
c.1890s.** Private Collection.

The private collection from which this garment originates has other bodices in different colors and fabrics that follow a similar fashionable line, and were clearly worn by women of a similar social class. Many museum collections also contain bodices that are comparable in date, fabric, and style, although the large museum collections, which are more likely to have their collections online, tend to have examples of upper-class fashionable dress. Bodices similar to this one are more likely to be found in the collections of small, regional museums.

INTERPRETATION

This bodice, with its fashionable shape and complex construction, made from widely available fabrics could be used to explore:

1. The mechanics of fashion and class as explored by theorists such as Georg Simmel

2. The notions of fashion and its dissemination in the 1890s, including the realities of fashionable dress, as compared to the idealized version presented in women's fashion magazines of the period

3. The practices of dressmaking and the clothing industry in the late nineteenth century

4. The types of garments that are preserved within historic dress collections

The fashions of the 1890s placed emphasis on the upper half of the body, most notably through the voluminous sleeves that dominated the fashionable silhouette for most of the decade. While bodices were usually built with a tightly fitting foundation, they were often given a billowing appearance by carefully draped fabric and plastron fronts. Paired with a full but relatively plain skirt, fashion plates in women's magazines of the decade illustrate the top-heavy silhouette that was embellished with a profusion of bows, ruffles and beading (Figure 8.1).

This relatively modest but stylish bodice offers the opportunity to consider the realities of fashion for the majority of women in the late nineteenth century. While the bodice demonstrates elements of the fashionable line illustrated in women's magazines, with its puffed sleeves and full front, its sleeve tops are twelve inches at their widest point, and much smaller than the vast gigot or leg-of-mutton sleeves seen in fashion plates or photographs from the time (Figures 8.1 & 8.16). Some of the sleeves seen in such fashion plates were so vast on the upper arm that they were cut in two sections; one for the upper and one for the lower arm, whereas this bodice has sleeves that were cut as a single piece.[1] Furthermore,

the bodice is without any applied decoration, such as bows and ruffles, that was so common at the time. There are not even any signs of stitch or pin marks that might indicate that the bodice was worn with jewelry or trim. The discrepancies between the brown bodice and the dresses illustrated in the women's magazines emphasize the hyperbole of the fashion plates; a reminder that they were devices of commerce and promotion, representing the extremes of fashion, and offering inspiration and idealism, rather than recording the everyday norm.

Notwithstanding the moderate silhouette and relatively plain decoration of the case study bodice, it is still a garment of fashion, as demonstrated by its conformity to the complexity and constriction of the styles of the 1890s. For example, the bodice has the high, tight collar that was so popular during the decade (Figure 8.2). It has been made rigid with layers of buckram, making it stiff and unyielding against the throat, and causing the wear patterns on the edges. The waist of the bodice measures a relatively small 23½ inches, and would have been worn over a corset; but it also has ten stays sewn into its interior (Figure 8.6), reinforcing a rigid posture in the wearer.[2] This bodice, with its striking visual contrast between the woolen sleeves and velveteen body, was clearly created with fashion taking precedence over comfort or utility.

The relationship of the bodice to the stylish modes of the time (Figure 8.1) also provides an opportunity to illuminate theoretical approaches to dress, which link the mechanics of the fashion system with the concept of class. Until recently, studies of fashion have concentrated largely on garments worn by those wealthy enough to afford spending a significant proportion of their income on fashionable clothing, with little consideration of practicality. Nonetheless, the concept of fashion was not limited to those with large incomes. The heartfelt disappointment of Anne of Green Gables, the well-known literary teenager of the 1890s, when she learns that her adoptive mother Marilla has made her new dresses without the fashionable puffed sleeves, is poignantly suggestive of the importance of fashion across the social spectrum.[3]

Many theorists have offered explanations about the way in which the latest ideas of fashion emerge and are disseminated. In 1904, German philosopher Georg Simmel argued, in his article "Fashion," that the lower classes expressed their desire for upward social mobility by copying the fashions of the upper classes, who in turn, sought to differentiate themselves by turning to new styles and fabrics (1904: 135). While scholars such as Edward Sapir (1931), Elizabeth Wilson (1985), and Gilles Lipovetsky (1994) have since reconsidered the mechanisms of the fashion system, Simmel's theory highlighted the integral importance of novelty in the idea of fashion, as well as the inherent dichotomy within fashion that encompasses both the desire to be original, and the longing to emulate and fit in. In this case study, the maker's choice of fabric and styling for the bodice represents an expression of these desires, since the bodice is made from moderately priced

4 T. EATON C^O. LIMITED 190 YONGE ST., TORONTO.

Dress Making Department.

<table>
<tr>
<td>

For Ladies' Dresses
and Tailor-made
Costumes made to
order only

</td>
<td>

This department is devoted exclusively to
dressmaking and ladies' tailoring, and the work
is of the highest grade only. All work done in
our own rooms under the most careful manage-
ment. On application we will forward promptly
samples of goods, estimates and measurement
blanks, and any other information required.

</td>
<td>

IMPORTANT.

When sending for
samples, give color,
style and price you
wish to pay, and they
will follow by return
mail.

</td>
</tr>
</table>

Tailor - made Costumes, Street Dresses, Separate Skirts, Separate Waists, Wedding and Evening Gowns Made to Order only.

Note carefully the following :

HOW TO TAKE A MEASURE.

Take your measurements carefully
and write them down plainly. Examine
your measures after taking to make sure
that all measurements and directions
are correct. Do not fail to pin to order
sample of cloth selected. We will
always make your garment of your first
choice of cloth, provided it is in stock
when order is received. Measures re-
quired for waists or jackets, to be taken
over any other garment to be worn
underneath. **Make no allowance for
seams.**

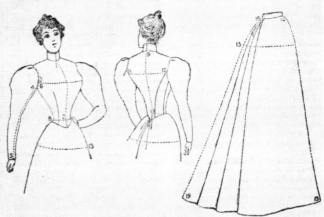

1. All around neck at bottom of collar.....................
1 to 2. From bottom of collar to waist line, not too long
3. Bust measure, all around body, well up under arms, not too
 tight...
4 to 5. Length of sleeve, inside seam
8. Size of waist all around
9 to 10. Length of back from bottom of collar to waist line,
 not too long ..
11 to 12. Across back
6 to 8. Under arm to waist line, not too long
13. Hip measure around body, five inches below waist line, not
 too tight. (This measure not required for waists)......
SKIRTS—Measures required. 14 to 15. Length in front from
 bottom of waist belt to desired length
18 to 19. Length in back from bottom of waist belt to desired
 length over bustle, if worn
13. Hip measure around body five inches below waist, not too
 tight..
8. Size of waist all around
 Please answer the following, yes or no :
1. Has the person any peculiarity of shape?.....
2. Has the person long neck?...............
3. Has the person short neck?..............
4. Has the person round back?..............
5. Give age................................

} Always measure
the person for
whom garment
is intended.

A SUGGESTION.

LININGS AND TRIMMINGS FOR ONE DRESS.

5 yards linenette or silesia lining, 10c yd (skirt)	\$0 50
2 yards linen canvas, at 12½c yd (skirt)	0 25
⅜-yard velvet binding (skirt)	0 19
2 yards silesia waist lining, at 15c yd (waist)...........	0 30
1 set dress bones (waist)	0 15
1 pair dress shields (waist).........................	0 15
2 spools sewing silk, at 5c	0 10
1 spool silk twist	0 02
Hooks and eyes	0 04
Waist and skirt belting	0 05
	\$1 75

Linings for skirt alone.............	\$1 05	
" waist	0 70	
	\$1 75	

The foregoing linings are excellent average quality. Finer
goods at slightly higher rates can be furnished if desired.

What about groceries?—We supply monthly shipments to some of our customers.

Figure 8.17.

**Dress Making Department page
from The T. Eaton Co. catalogue,
1898, p.4,** Private Collection.

fabrics (Figure 8.13). This choice of fabric reflects the wearer's desire to produce a smart and stylish image, despite having to choose fabrics that were within her means. Contemporary advice books regularly reassured women that being well-dressed was a matter of good taste, rather than spending large sums of money. For example, Harriet Brown, in her *Scientific Dress Cutting and Making* of 1902, counselled: "By well-dressed we do not mean expensively appareled. A becoming dress may be of inexpensive material" (1902: 53).

The relatively short waist of the bodice dates the garment to the second half of the 1890s, placing it at a key intersection in the production of women's clothing, which was on the cusp of great change.[4] The black cotton waistband is without any sort of stamped name or label, making it likely it was sewn by the wearer herself, or by a small local dressmaker, an occupational possibility open to women of modest means in the late nineteenth century. In the book *Home Dressmaking Made Easy*, Emma Hooper wrote: "The great majority of women are of what is styled 'middle-class circumstances' and they must become dressmakers for themselves or very often go without a new gown" (1896: 11). The introduction of the sewing machine and paper patterns in the mid-nineteenth-century, especially the vast number of patterns offered by the big American companies Butterick and McCall, eased the work of the home dressmaker (Kidwell and Christman 1974: 77; Kidwell 1979: 85). Books on home dressmaking, as well as magazine articles, offered additional advice and guidance.

For much of the nineteenth century, the role of the dressmaker in the production of womenswear continued to hold importance, in contrast to the steady rise of ready-to-wear clothing for men. Many dress historians have explained this inconsistency by the complexity in the cut, construction, and decoration of women's clothing during the century, making it relatively more difficult to produce in large quantities (Kidwell 1979: 108). By the 1890s, however, more and more women's clothing was being offered for sale in big department stores and mail-order catalogues. For example, North American retailers, such as Sears Roebuck & Co. and The T. Eaton Company Limited, offered dressmaking services in their mail-order catalogues that connected them to a vast market of prospective clients. The customer chose the style and the fabric and sent in their measurements as instructed in the catalogue (Figure 8.17).

Lastly, this bodice prompts reflection on the survival and preservation of different types of historic dress. It is noteworthy that the matching skirt to this bodice has not survived. The skirt of the 1890s, with its expansive volume of fabric and relative lack of decoration (Figures 8.1, 8.15 & 8.16), could easily have been cut up and used to make a different garment or household object. It is also possible that the skirt for this outfit was made of the same wool as the sleeves, and suffered more significant moth damage; a danger highlighted by the small amount of damage on the sleeves of the bodice (Figure 8.14).

It is a fact that most museum collections have privileged the dress of the fashionable elite, particularly special occasion dress. Such garments have often been seen as more valuable, both in terms of materials and design, and thus have been more likely to attract curatorial time and resources. As Katherine Brett, former curator in the Department of Textiles at the Royal Ontario Museum, wrote in the exhibition catalogue to *Modesty to Mod: Dress and Underdress in Canada 1780–1967*: "In every field of the household arts it is the treasured possession, and not the domestic chattel, that has been cherished and handed down from generation to generation for us to enjoy today. This is also true of clothing; it is the wedding dress or fine gown, worn once on a special occasion, that most often survives" (1967: vi). Furthermore, work wear and clothing of the lower classes would typically have been used until the garment was completely worn-out, or it would have been reworked for a younger family member, or cut up for quilts or rags, contributing to its low survival rate.

As scholarly interest continues to grow in studying the material culture of all levels of society, this bodice offers a stylish and pertinent example of fashion's influence across classes. Not only does it demonstrate the realities of following the fashionable ideal, in contrast to the exaggerated presentation of the latest styles and ensembles in the fashion press, but it also suggests the way in which a neat and elegant appearance could be created within modest means.

NOTES

1. For an example of a surviving dress with a sleeve in two sections see Arnold 1977: 46f.

2. For examples of 1890s' corsets see the advertisements in magazines such as *The Delineator* (Toronto edition); e.g. November 1892 and November 1893.

3. *Anne of Green Gables,* Chapter 11. In this chapter, Anne memorably tells Marilla in response to the argument that puffed sleeves look ridiculous, "but I'd rather look ridiculous when everybody else does than plain and sensible all by myself" (Montgomery 1996: 79).

4. In the first half of the decade, as shown in women's magazines and pattern books, bodices tended to sit lower, falling slightly over the hips. See also Arnold, 1977: 40f.

REFERENCES

Arnold, J. (1977), *Patterns of Fashion 2: Englishwomen's Dresses and their Construction c.1860–1940,* London: Macmillan.

Brett, K. (1967), *Modesty to Mod: Dress and Underdress in Canada 1780–1967,* Toronto: University of Toronto Press.

Brown, H. A. (1902), *Scientific Dress Cutting and Making,* Boston: Harriet A. Brown.

Hooper, E. M. (1896), *Home Dressmaking Made Easy,* New York: The Economist Press.

Kidwell, C. (1979), *Cutting a Fashionable Fit: Dressmakers' Drafting Systems in the United States,* Washington: Smithsonian Institution Press.

Kidwell, C. and Christman, M. (1974), *Suiting Everyone: The Democratization of Clothing in America,* Washington: Smithsonian Institution Press.

Lipovetsky, G. (1994), *The Empire of Fashion: Dressing Modern Democracy,* Princeton: Princeton University Press.

Montgomery, L. M. (1996, first published 1908), *Anne of Green Gables,* London: Seal Books.

Sapir, E. (1931), "Fashion," in *Encyclopedia of the Social Sciences,* New York: Palgrave Macmillan.

Simmel, G. (1904), "Fashion," *International Quarterly* 10: 130–55.

White, F. (ed.) (1901), *How to Dress Well on a Small Allowance,* London: Grant Richards.

Wilson, E. (1985), *Adorned in Dreams: Fashion and Modernity,* London: I.B. Tauris.

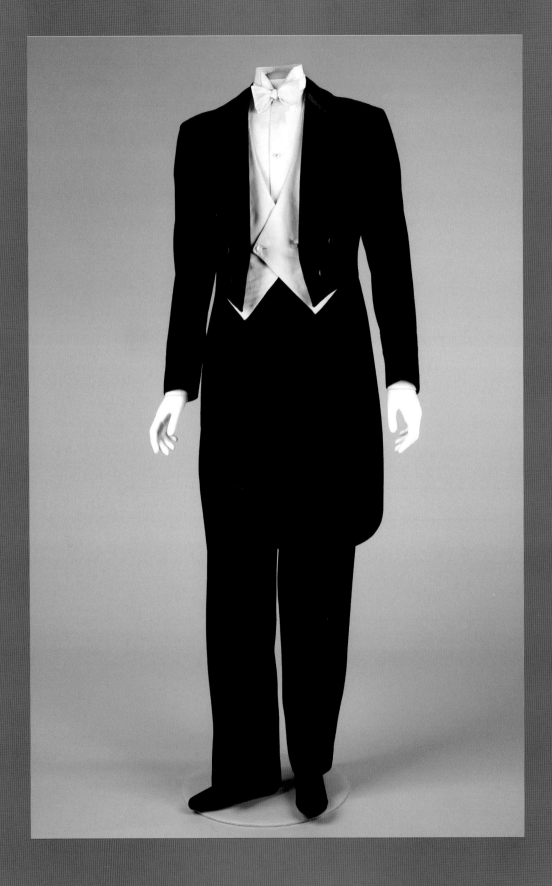

9

Case study of a Man's Evening Suit Tailcoat and Trousers

Menswear is often underrepresented in museum collections, and has received far less scholarly attention than the more noticeable changes and intricacies of women's fashion (Breward 1999: 8). Increasingly, however, fashion scholars and cultural historians are engaging with the more nuanced complexities of men's clothing and fashion, refuting the traditional view that men's clothing has changed little after the so-called "Great Masculine Renunciation" of elaborate fabrics and color, at the start of the nineteenth century.[1]

This case study considers a man's tailcoat and trousers, part of a formal evening suit—traditionally called a "dress suit" in the United Kingdom—belonging to a university study collection.[2] The tailcoat and trousers are made from fine black wool woven with a delicate stripe, and date from about 1912–1922. The subtle changes in the fashionable cut and construction of men's clothes mean that it is often more difficult to date menswear precisely, as compared to womenswear. No vest accompanies this suit; a surprising absence that suggests that the original did not survive. There is no provenance information to identify the donor or the occasions on which this garment was worn.

OBSERVATION

Tailcoat Construction

The high-waisted tailcoat is cut with a shallow point at the center, and two tapered tails (26½ inches or 67.5 cm long) falling from the back waist (Figure 9.2). The coat's high waist is 32 inches (81.3 cm), and the chest measures 35 inches (88.9cm). Each front section has two darts at the waist. The back is cut in six pieces, with a center back seam. The coat has natural shoulder seams and close-fitting sleeves, with buttons placed without working buttonholes to mimic closures at the wrist (Figure 9.3). The small collar has pointed tips and wide lapels, faced in black ribbed silk with notches on the upper edges. The coat is fully lined in black satin for the body of the coat, and cream cotton for the sleeves. There is diamond-quilted padding around the chest and arms (Figure 9.4), and additional padding at the

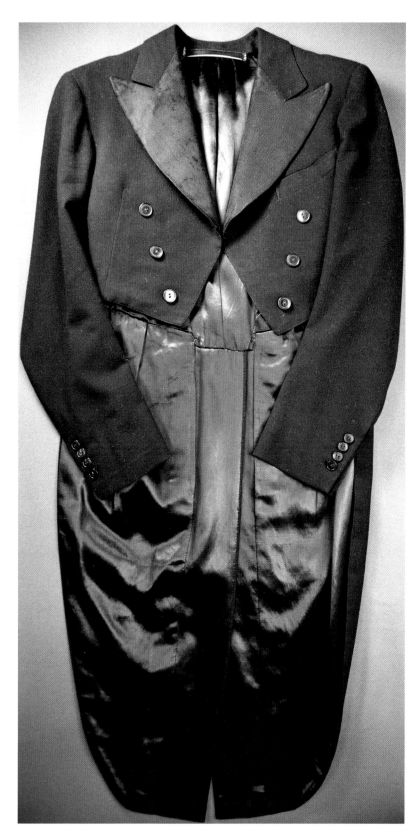

Figure 9.2.

Case study tailcoat.
Photo by Ingrid Mida.

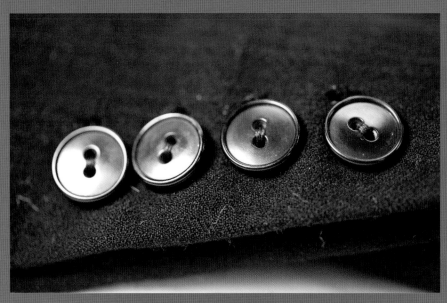

Figure 9.3.

Detail of buttons at sleeve cuff. Photo by Ingrid Mida.

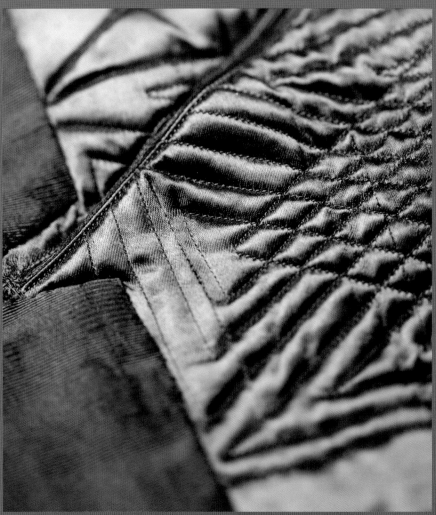

Figure 9.4.

Quilting inside coat. Photo by Ingrid Mida.

Figure 9.5.

Fly front of trousers showing buttons and moth larvae casts. Photo by Ingrid Mida.

back of the neck. Although the coat has no fastenings, there are black buttons down the front of the coat, imitating a double-breasted coat, and smaller black buttons at the wrist (Figure 9.3). The coat has one breast pocket on the left-hand side. There is also an interior breast pocket on the right-hand side, and concealed pockets inside the lining of both tails.

Trouser Construction

The high-waisted trousers have fairly wide, straight legs with a center crease, and a fly front with black painted metal buttons (Figure 9.5). There are additional buttons around the waistband for suspenders (Figure 9.6). The outer leg (44 inches or 111.8 cm) is decorated with a band of black braid down the seam. There is a back pocket on the right-hand side, pockets in both side seams, and a small, rounded interior pocket in the right-hand side of the waistband. Around the inside edge of each trouser leg hem is a narrow band of black leather (Figure 9.7). The fly front has been stiffened with pieces of black linen and cream cotton. The trousers' inner leg length is 30 inches (76.2 cm), and the waist measurement is 30 inches (76.2 cm). The suit has largely been machine-stitched, although there is some hand-stitching for finishing, which includes the buttonholes.

Figure 9.6.

Button for suspenders and braid on trousers. Photo by Ingrid Mida.

Figure 9.7.

Leather strip around the inner hem of trouser leg. Photo by Ingrid Mida.

Textiles

The tailcoat is made from finely woven black wool with a subtle stripe. The body is lined in black silk satin, and the sleeves with cream satin. The lapels are faced with black ribbed silk. The trousers are made from the same wool as the tailcoat, with the waistband lined in cream twill cotton.

Labels

At present, no attached labels exist and no visible maker's label is evident. However, the interior breast pocket of the coat has distinct stitch marks, from which a label has been removed (Figure 9.8). The notation "RS8576" has been marked in black ink on the right inside shoulder of the tailcoat (Figure 9.9), as well as on the inside of the right front pocket of the trousers.

Figure 9.8.

Detail of the missing stitches in coat where label was removed.
Photo by Ingrid Mida.

Figure 9.9.

**Handwritten marking
inside coat sleeve.**
Photo by Ingrid Mida.

Figure 9.10.

**Damage to lining of coat
sleeve.** Photo by Ingrid Mida.

The Use and Wearing of the Suit

This suit is missing the matching vest. It might have been lost or discarded
as a result of damage, soiling, or heavy use. There are no signs that the suit
has faded or been dyed, and in general, the suit displays few signs of wear.
The ribbed silk on the lapels of the coat is worn at the center front and the
uppermost points. Additionally, the cream sleeve lining is worn around the
armholes, and is splitting on both arms (Figure 9.10). There is also wear to the
ribbed silk on the inner lapel edge, and around the neckline. There are some
brown and black marks on the cream cotton waistband of the trousers that may
have been caused by the metal elements of a pair of suspenders. Around the
crotch, there is a white residue that looks like moth larvae casts, although there
is no sign of active moth larvae (Figure 9.5).

REFLECTION

This formal suit, with its combination of careful construction and good quality fabric, has a sense of tradition and occasion. The wool cloth has a weight and thickness indicative of quality. The intense black color gives the suit an appearance that is both severe and luxurious; a feel heightened by the interplay between the sheen of the ribbed silk lapel facings, and the matte black of the wool (Figure 9.11). The ensemble also invokes formality, dressing up, and strict social standards, and the care evident in its construction is suggestive of a former owner having status.

There are no provenance records for this suit to identify the donor who gave it to the university study collection. The collection has other examples of men's formal suits from the early twentieth century, as do many museum and study collections.[3]

Early twentieth-century evening suits can be found illustrated in a wealth of visual sources, from portraits (Figure 9.12) to tailoring advertisements in newspapers and magazines. They often appear in genre paintings of high society life, photographs of the rich and famous attending evening events, and in Hollywood films such as *Top Hat* (1935), starring the well-known actor and dancer Fred Astaire. Illustrations of evening suits in magazines and advertisements are usually accompanied by useful textual references to fabric, construction details and price. Other documentary evidence that might be considered includes tailors' records and retail catalogues.

Figure 9.12.

Cabinet card portrait, c.1890 by unknown photographer. Private Collection.

INTERPRETATION

This elegant example of men's early twentieth-century formal evening attire, with its dramatic tailcoat and accompanying trousers, can be used to explore:

1. Theories exploring the speed of stylistic change in men's clothing

2. The changes in the production of men's clothing, from bespoke and made-to-measure to the rise of ready-to-wear

3. Concepts of formality and class, expressed through the subtleties of men's clothing

4. Issues of gender and identity, expressed through sartorial choice

The evening suit, with its coat distinguished by distinctive tails and cut-away front, worn as formal evening dress, developed from the tailcoat of early nineteenth-century men's daytime fashionable dress. Like many items of male attire, the men's tailcoat underwent a process of sartorial fossilization, and in the second half of the nineteenth century, transitioned from fashionable men's daywear into formal evening wear (Byrde 1979: 82, 147).

Figure 9.13.

White *piqué* vest, c.1920s.
Gift of Norah Clarry, Ryerson
FRC1989.04.025. Photo by
Ingrid Mida.

The evening suit was worn with both black and white vests until after the First World War, as etiquette books around the turn of the twentieth century suggest (Humphry 1897: 93). Given that a white vest would show dirt more easily (Figure 9.13), it is highly likely that the missing vest for this suit was white and was discarded after becoming visibly soiled. The black wool tuxedo from 1927 by Jeanne Lanvin, in Figure 9.1, is shown with a white vest.

The traditional theory that men's clothing became static, conservative, and uniform at the end of the eighteenth century was the view most commonly held by dress historians, for much of the twentieth century, and is perhaps best characterized by the work of J. C. Flügel, in his 1930 book *The Psychology of Clothes*. Here, he proposed the idea of the "Great Masculine Renunciation" and declared that from the start of the nineteenth century, men's tailoring had become "the most austere and ascetic of the arts" (1930: 111). In doing so, Flügel drew on Thorstein Veblen's discussion of "the leisured classes'" consumption of fashion, where women's clothing, with its elaborate color, decoration and form, was the visible marker of a family's wealth and position in society, in contrast to the sobriety of the male wardrobe (Veblen 2007: 118–120). More recently, however, the work of dress and cultural historians, such as Christopher Breward and Fiona Anderson, have countered this interpretation, by demonstrating that menswear does, indeed, change over time, but that often these changes are much more subtle, exposed in the detail of construction and accessories (Breward 1999: 40; Anderson 2000: 405–26). While the basic components of the evening suit remained the same over many decades, details in cut, fabric choice, and shaping reveal the way in which the suit followed the subtly changing line of the fashionable male silhouette. The construction details of this tailcoat, with the slight points at the front of the waist, and wide, deeply notched lapel, suggest a date of about 1912–1922 (Figure 9.2). Tailcoats from the last decade of the nineteenth century tended to be cut straight across the front of the waist, and could have a rounded, shawl-like lapel, as well as an additional band of fabric below the front waistband, called a "strap," that largely disappeared after 1905.[4]

Dating this evening suit to about 1912–1922 places it at a dynamic intersection of tradition and change, both in terms of the production of men's clothing, and the increasing relaxation of sartorial codes for formal menswear. While Christopher Breward noted that traditional tailoring continued to play an important role in menswear well into the twentieth century, the role of ready-to-wear men's clothing was well established by the 1910s, with mail-order catalogues offering stock evening suits from the turn of the century (1999: 28). Nonetheless, wealthier customers might still choose to visit a tailor for a bespoke or made-to-measure suit, in order to secure a custom fit, and better quality fabrics offered by a tailor. The quality of fabric used for this evening suit—a finely woven wool with an understated stripe, which has worn well—suggests that it was a bespoke suit. This is supported by another, almost imperceptible detail. The close

relationship between good quality tailors and their clients is recorded in the label, often to be found in the inner breast pocket of a suit coat, which records not only the company name, but also the client's name and the date of the commission (Figure 9.14).[5] The coat of this suit has no such label, but the clear stitch marks in the inner breast pocket indicate that a label has been cut out and removed (Figure 9.8). It is possible that the person who donated the suit to the university collection wanted to remove any personal information. Another custom element evidenced in the construction of this coat is the padding, added into the lining at back of neck, which suggests that the wearer may have had a slight hollow back that they hoped to conceal by a well-crafted suit. Such individual details would only be found in a bespoke tailored suit.

The decade after the First World War was a time of great political and social upheaval, with profound changes evident across society. This transformation was especially evident in the lifestyles of the aristocratic families of Europe, and the carefully controlled codes of etiquette that governed their social functions and engagements. This included changes in the strict dress codes that, for so long, had formed a sartorial framework that determined dress for a dizzying array of occasions. As Fiona Anderson points out in her

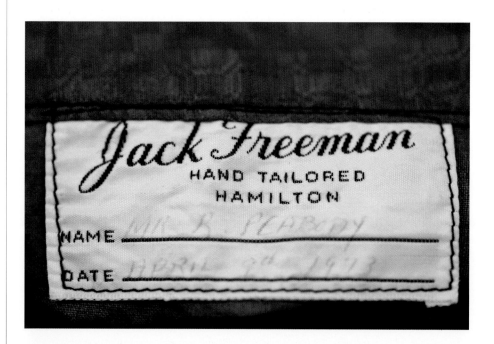

Figure 9.14.

Comparative tailor's label, Jack Freeman, in suit jacket, 1973.
Gift of Marilyn Peabody, Ryerson
FRC1986.03.03A. Photo by Ingrid Mida.

article, "Fashioning the Gentleman," this change was already underway for men's clothing at the turn of the twentieth century, as established assumptions about the relationship of class, masculinity, and fashion faced the challenge of social position based predominantly on wealth, rather than family background (Anderson 2000: 409). For example, the tuxedo (or dinner jacket) first made its appearance at the end of the nineteenth century, and increasingly gained acceptance as an alternative to formal attire for some evening functions (Byrde 1979: 148f). Established codes, however, proved difficult to alter radically before the First World War, as this quotation from a 1914 edition of *Harper's Bazaar* suggests: "The efforts to change the present style of evening tail coat have proved unsuccessful. There will be no change in its general outline from the past season. The short waistline, well opened fronts and graceful line to the draped skirts are the same" (1914: 54).

The clash between the old and the new is characterized by the contrasting attitudes to dress for formal occasions held by King George V and his son, Edward, Prince of Wales. While the King was noted for his adherence to the greatest level of correctness in matters of dress, his son's easy charm and youthful manner cast him as an obvious trendsetter for a new generation desirous of change. For example, while George V railed against the slightest change to formal dress codes, his son Edward abolished the wearing of frock coats for court occasions on becoming King Edward VIII, in 1936 (Dawson 2013: 201). Edward personally preferred a dinner jacket to the strictures of an evening suit, and many of his evening outfits were of midnight blue instead of the traditional black. According to Elizabeth Dawson, midnight blue was introduced as an alternative to black for eveningwear in the 1930s (2013: 205). The classically black suit of the case study, with its aura of old-fashioned formality, represents something of the last throes of such formal dress wear. After the Second World War, the dinner jacket won out as the most common form of evening dress for men, and the evening suit, with its tailcoat, was seen as increasingly archaic.

Although the man's tailcoat has largely disappeared from contemporary men's fashion, except for the most formal of occasions, the silhouette has been given a new lease of life as creative inspiration for the fashionable female wardrobe. There is a long history of the appropriation of elements from the male wardrobe into womenswear, even at times when social and cultural roles for the sexes were enhanced and underscored by sartorial difference. For example, in the 1870s, a period of highly differentiated gender roles, women's dresses and bodices often borrowed elements from menswear, including epaulettes and tails (Figure 9.15). Nonetheless, it was not until the twentieth century that the male suit began to be adopted by women in a more complete form. While early twentieth-century audiences would have been used to women performers donning male outfits like the evening suit in their impersonation of men, the wearing of an overtly masculine suit had the power to shock, as demonstrated memorably by the actress Marlene Dietrich, in the 1930 film *Morocco*.[6]

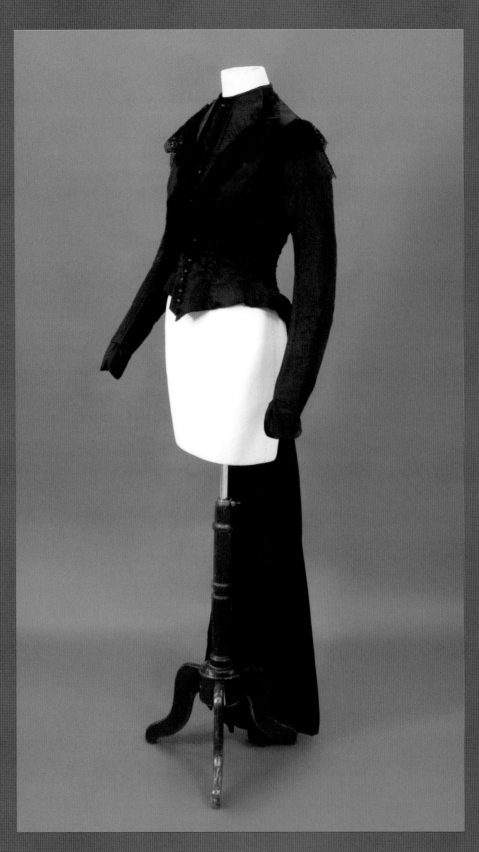

THIS PAGE
Figure 9.15.

Ladies' black silk bodice with tails c.1870s. Gift of Bob Gallagher, Ryerson FRC1999.05.011. Photo by Jazmin Welch.

OPPOSITE
Figure 9.16.
Smythe les vestes: **black womenswear tailcoat, fall/winter 2012.** Gift of Andrea Lenczner & Christie Smythe, Ryerson FRC2012.02.002. Photo by Jazmin Welch.

Modern fashion designers have increasingly looked to the male suit for inspiration for their womenswear collections, including Yves Saint Laurent, Yohji Yamamoto, and Alexander McQueen. Many have drawn directly on the tailcoat to fashion looks that have woven together the severity of masculine tailoring and fabrics with a feminine aesthetic, or that have explored the concept of the tailcoat's construction. For example, in 1968, Yves Saint Laurent created a silk velvet version of the tailcoat, to be worn with an embroidered tulle blouse. Alexander McQueen was well known for referencing the male tailcoat in his collections, beginning with his graduation collection, "Jack the Ripper," that was inspired by the Victorian tailcoat, and after his untimely death in 2010, the new head designer, Sarah Burton, chose to show an all-white, frayed tailcoat, as her own version of a McQueen classic, for her first collection, spring/summer 2011.

The university collection to which this evening suit belongs also holds several other womenswear garments that play with the idea of a tailcoat as inspiration. A black wool tailcoat, by *Smythe les vestes,* from fall/winter 2012 (Figure 9.16), closely follows the lines of a man's tailcoat, and models the blurred gender lines of dress in contemporary fashion. More dramatically, a

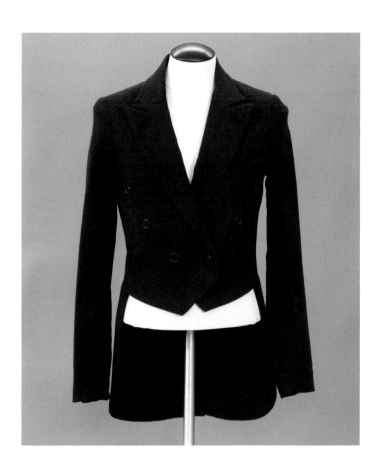

Figure 9.17.

Rei Kawakubo for *Commes de Garçons:* **tailcoat without a tail.** Gift of Karen Mulhallen, Ryerson FRC2006.01.023. Photo by Jazmin Welch.

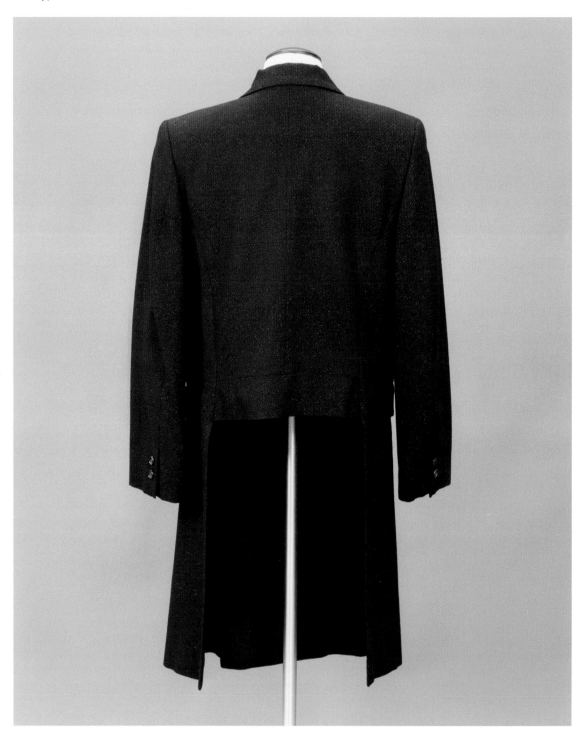

tailcoat by Rei Kawakubo, for *Comme de Garçons* (Figure 9.17), deconstructs the very idea of a tailcoat. At first glance, the single-breasted black wool tailcoat with gold metallic threads appears simple in construction, yet the coat's back reveals a striking omission; the coat has no tails, and is empty below the waist. It is a void that is strangely unsettling, playing with our notions of emptiness and completeness. In doing so, it emphasizes that the evening suit, like the one that is the object of this case study, has passed from an active garment of social formality to a source of inspiration, with romantic but old-fashioned associations.

NOTES

1. The phrase "The Great Masculine Renunciation" was coined by Flügel, in his 1930 book *The Psychology of Clothes*. For new approaches to considering menswear see the work of Christopher Breward, including *The Hidden Consumer* and *Fashioning London*.

2. This evening suit is part of the Ryerson University Fashion Research Collection (FRC2013.99.034A+B).

3. It can be difficult to identify comparable suits in online searches because collections have different ways of recording and describing these garments, including the terms "dress suits," "white tie," "evening dress," and "tailcoats." Although formal attire, like the subject of this case study, is often well represented in museum and study collections, in comparison to men's everyday suits, such as lounge suits or sporting suits, the suits are rarely accompanied by all the associated accessories (for example, the dress shirt, bow tie, top hat) which would have transformed them into a full evening ensemble.

4. Nora Waugh's *Cut of Men's Clothes: 1600–1900* includes an example of a pattern for a tailcoat from 1893 (Waugh 1964: 147).

5. The famous English tailors Henry Poole & Co. placed labels in their suits from at least the 1850s (Barnard Castle 2013: 4).

6. The American performer Ella Shields (1879–1952) was well known for her music hall performances dressed as a man, and her signature song was "Burlington Bertie from Bow."

REFERENCES

Anderson, F. (2000), "Fashioning the Gentleman: A Study of Henry Poole and Co., Savile Row Tailors 1861-1900," *Fashion Theory*, 4 (4): 405–426.

Barnard Castle. (2013), *Henry Poole & Co. Founder of Savile Row. The Art of Bespoke Tailoring and Wool Cloth at Bowes Museum*, Barnard Castle: Bowes Museum, exhibition booklet.

Breward, C. (1999), *The Hidden Consumer: Masculinities, Fashion and City Life, 1860–1914*, Manchester: Manchester University Press.

Breward, C. (2004), "The Dandy: London's New West End 1790–1830," in C. Breward, *Fashioning London: Clothing and the Modern Metropolis*, London: Bloomsbury: 21–48.

Byrde, P. (1979), *The Male Image: Men's Fashion in Britain 1300–1970*, London: B. T. Batsford.

Dawson, E. (2013), "Comfort and Freedom: the Duke of Windsor's Wardrobe," *Costume*, 47 (2): 198–215.

Flügel, J. C. (1930), *The Psychology of Clothes*, London: Hogarth Press.

Harper's Bazaar (1914), "The Observer," October 1914: 54, 96.

Humphry, Mrs. (1897) *Manners for Men*, online version available at: https://archive.org/details/mannersformen01humpgoog

Veblen, T. (2007, first published 1899), *The Theory of the Leisure Class*, M. Banta (ed.), New York: Oxford University Press.

Waugh, N. (1964), *The Cut of Men's Clothes: 1600–1900*, London: Faber.

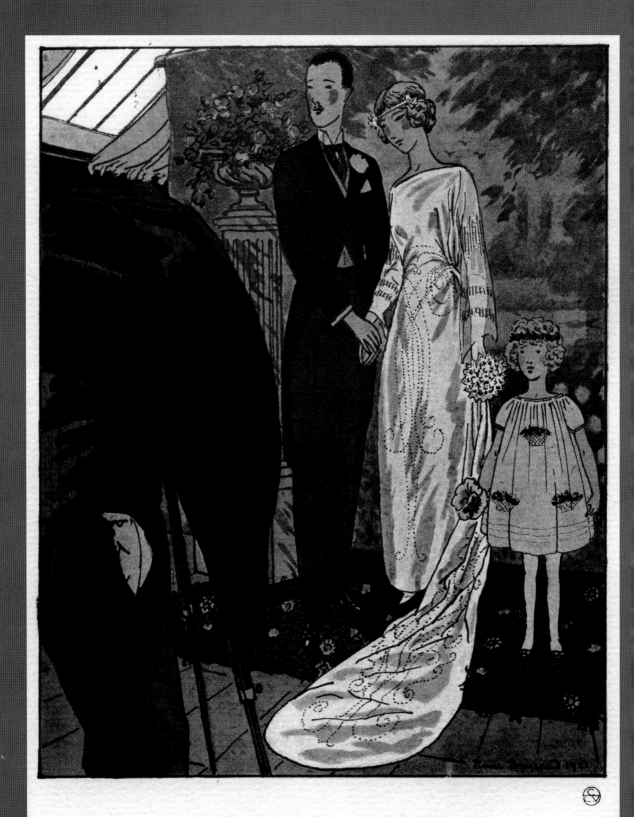

A LA VILLE VOISINE

ROBE DE MARIÉE, DE JEANNE LANVIN

10

Case Study of a Lanvin Wedding Dress and Headpiece

Wedding dresses are often worn only once and then carefully stored away, as a material memory of a significant life event. The emotional poignancy attached to these garments is evidenced by their high survival rate in women's wardrobes, as well as in museum and study collections.

This case study considers a beaded wedding dress and headpiece, attributed to French couturier Jeanne Lanvin (1867–1946), from a university study collection.[1] Both the dress and headpiece show evidence of alteration, suggesting that the ensemble was worn more than once. The dress and headpiece were donated anonymously to the university in 2007, and there are no associated donor records. Although the dress lacks a label, the headpiece contains a label that partially reads "*Lanvin, Paris/ FAUBOURG ST. HONORE,*" woven in a golden yellow script. The House of Lanvin is the oldest couture house still in existence in France, and celebrated its 125th anniversary in 2014.

At first glance, this is a classic example of a wedding gown ensemble (Figure 10.2). The floor-length gown with a train is made from cream-colored silk satin, a fabric and color often associated with the romance and opulence of weddings. The gown front is heavily beaded in an abstracted floral pattern. The matching headpiece has a rounded crown with an attached net veil, and is similarly embellished (Figure 10.3). The condition of the dress is poor, with extensive damage evident at the seam between the bodice and skirt, and handling of the garment has the potential to cause further damage to the dress (Figure 10.4). A careful study of the two items offers the opportunity to make an informed assessment about the probable date of the dress in its original form, and to understand more about the ways in which the dress may have been subsequently altered and reused.

OPPOSITE
Figure 10.2.

Front of wedding dress, flat.
Photo by Ingrid Mida.

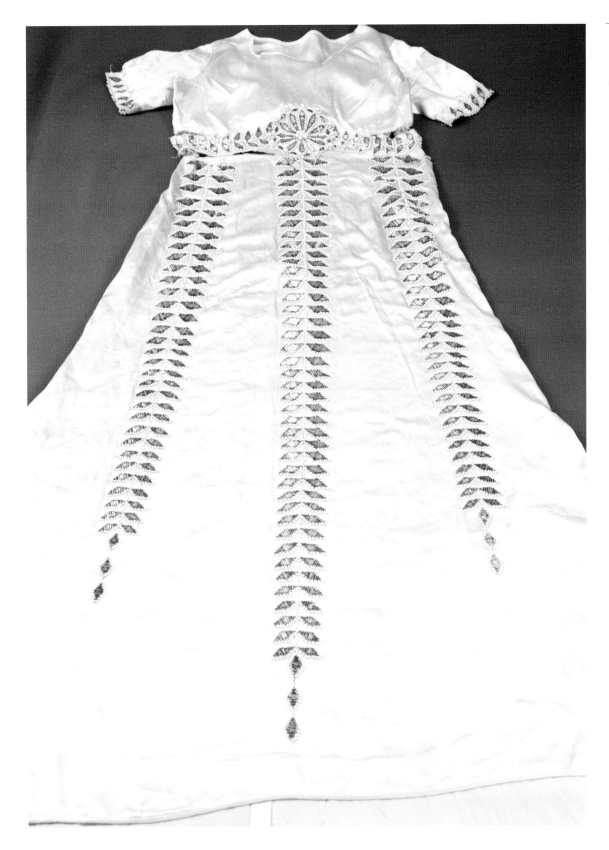

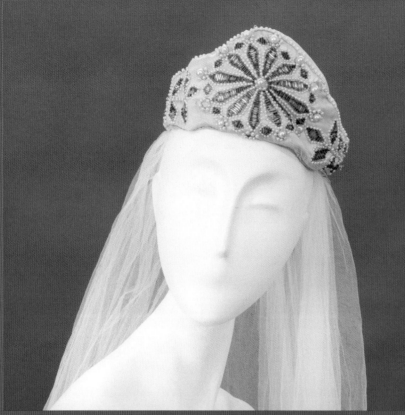

Figure 10.3.

Matching headpiece and veil. Photo by Jazmin Welch.

Figure 10.4.

Damage at waistband of dress. Photo by Ingrid Mida.

OBSERVATION

Dress Construction

The floor-length dress has a bodice of a cream fabric, with a round neckline that falls just below the clavicle at the front (Figure 10.5). The bodice has a high waist (27 ⅞ inches or 70.8 cm around) and rises to a point at the center front. The front and back of the bodice are each made from a single piece of fabric, and are joined by side seams. There are darts in both the neckline and bustline, but no additional shaping in the back. The neckline has been finished with self-fabric bias binding. The short sleeves are set in straight at the armhole, and have been finished with an additional band of beaded trim. The bust of the dress is 32 ⅝ inches (82.9 cm).

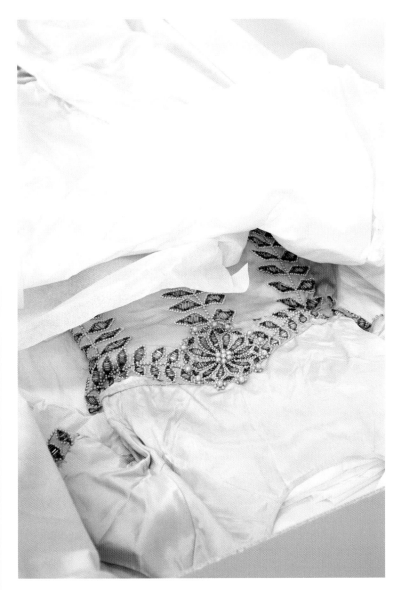

Figure 10.5.

Dress in storage box.
Photo by Ingrid Mida.

Figure 10.6.

**Lower inside edge of train,
showing finishing of hem.**
Photo by Ingrid Mida.

The long cream satin skirt flares slightly from waist to hem, and has a rounded train (roughly 32½ inches or 82.6 cm past the hem), and the underside is decorated with seed pearls (Figure 10.6). The skirt is unlined, and is formed from five lengths of fabric, none of which retain a selvedge edge. The hem of the dress is finished with self-fabric bias binding. On the center back seam of the train is a self-fabric loop 4 x 2¾ inches (10 x 7 cm) wide (Figure 10.7) that would sit at floor level (32½ inches or 82.6 cm from the hem). The closures on the dress consist of eight metal snaps in the left side seam, from below the arm to just below the waistband (Figure 10.8).

The dress is constructed with a mix of machine- and hand-stitching. Most seams are machine-stitched, with hand-finishing of the hem of the skirt (Figure 10.6). The edges of the bodice seams have been left unfinished.

LEFT
Figure 10.7.

Decorated loop on train.
Photo by Ingrid Mida.

BELOW
Figure 10.8.

**Damage to area around
snaps beneath the arm.**
Photo by Ingrid Mida.

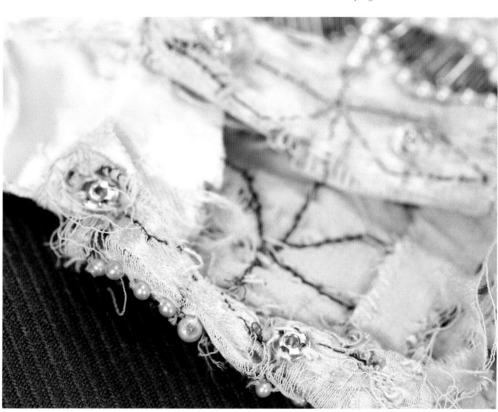

Dress Textiles

The dress consists of two different fabrics that are close in color but not an exact match. The skirt is made from a cream-colored silk satin, which was the original fabric of the dress, and the bodice is constructed from a cream synthetic fabric with a twill weave (Figure 10.9).

Both the bodice and the skirt have beadwork embellishment in an abstracted leaf and flower pattern. The main focus of the decoration is the beaded flower rosette in the middle of the waistband, and this rosette is echoed in the headpiece (Figures 10.10 & 10.3). The waistband is formed from a band of beadwork, with the rosette at the center. Three vertical bands of beading down the front of the skirt are each formed of a central stem, with a row of stylized laurel leaves on either side, and finish towards the hem with three vertically placed leaves tip to toe (Figure 10.11).

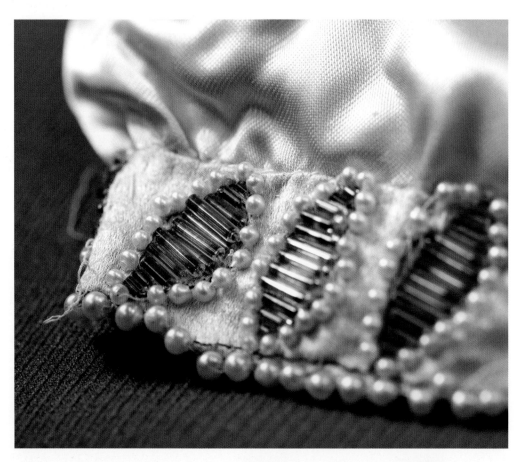

ABOVE
Figure 10.9.

Weave structure of fabric and
beaded band around sleeve.
Photo by Ingrid Mida.

OPPOSITE
Figure 10.10.

Rosette beading on dress.
Photo by Ingrid Mida.

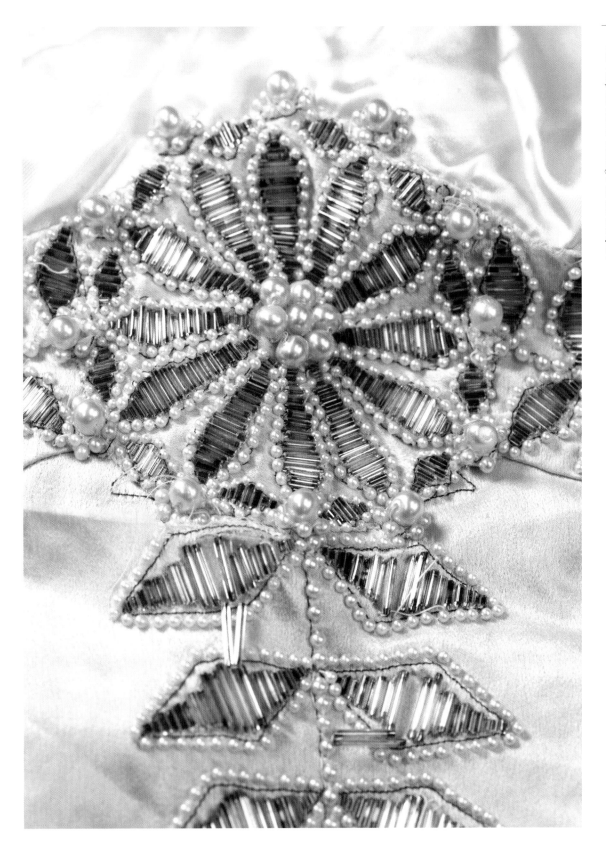

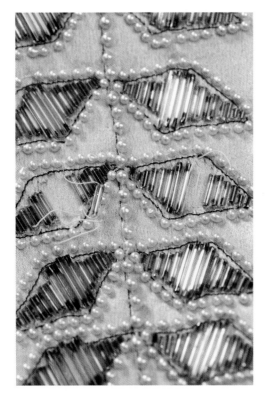

Figure 10.11.

Detail of beaded leaves.
Photo by Ingrid Mida.

Figure 10.12.

**Chain stitch on reverse of
beading.** Photo by Ingrid Mida.

The beadwork has been executed in a combination of cream seed pearls and silver glass bugle beads. The slightly oval rosette is 4½ inches (11.4 cm) wide, and 5 inches (12.7 cm) high. The seed pearls have a diameter of ⅛ inch (3 mm), while the bugle beads vary in length from ¹⁄₁₆–⁹⁄₁₆ inch (2–15 mm), to create a carefully graded pattern. The tapered stylized leaf pattern on the skirt is wider at the waistline, and narrows towards the hem. The diamond-shaped leaves are formed by bugle beads placed in parallel rows, and are bordered by the seed pearls (Figure 10.11). The flower rosette is formed by petals of bugle beads placed in horizontal parallel rows and edged in seed pearls with a center of larger pearl beads, and circled by alternating diamond shapes of bugle beads and circles of pearls (Figure 10.10).
In addition, the inner center back seam of the train has been embellished with seed pearls, and the small loop on the back of the train has also been covered with seed pearls (Figure 10.7). The stitches used for the beadwork are a mixture of straight stitch and chain stitch (Figure 10.12).

Dress Labels

The dress has no maker label. The fragile condition of the dress prohibits examination of its interior to search for evidence of a label that might have been removed.

Dress Use and Wear

The dress shows considerable signs of wear and alteration, including the replacement of the original bodice (Figure 10.4), using a different fabric, and the reattachment of the bands of original beadwork. The new bodice shows signs of wear: the seams at the waistband are beginning to open, especially at the back, where the skirt has pulled away. There is damage around the side opening beneath the arm where snaps have been pulled apart, tearing the fabric (Figure 10.8). There is a small patch of fabric that has been glued to the dress in an attempt to repair a tear (Figures 10.13). The skirt also shows of signs of wear: there are areas where the fabric has pulled, and there are slight stains and dirt marks on the fabric, especially around the hem. In a number of areas there is some beading loss, and in particular, the beading around the sleeve edges is damaged. The silver lining to the glass bugle beads has begun to tarnish, giving them a dull, darkened appearance (Figure 10.11). Several of the larger simulated pearl beads, used at the center of the rosette, have begun to decompose (Figure 10.14).

Figure 10.13.

Patch of glue inside dress.
Photo by Ingrid Mida.

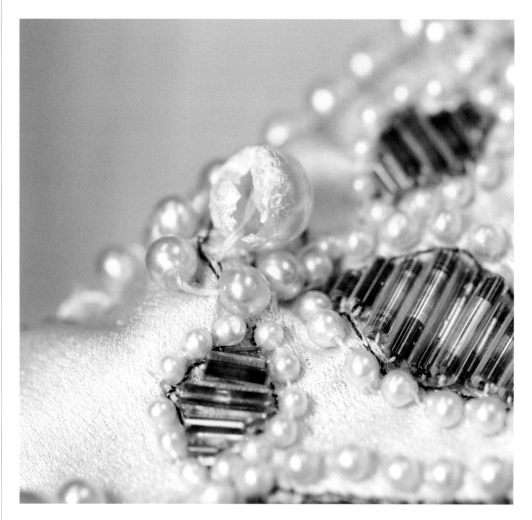

ABOVE
Figure 10.14.

Detail of decomposed bead.
Photo by Ingrid Mida.

OPPOSITE
Figure 10.15.

Beadwork on the headpiece.
Photo by Ingrid Mida.

Headpiece

The matching bandeau-style headpiece is formed from a deep band of the cream silk satin, and is decorated with identical beadwork (Figure 10.15). The deep rounded front (4½ inches or 11.5 cm) tapers to a narrow band at the back of the head (1½ inches deep or 3.8 cm). The band is stiffened with buckram or canvas that has become visible, where some of the stitching has come loose (Figure 10.16). Cream net has been sewn inside the bandeau, to form a cap section and waist length veil. This veil is double-layered and has an unfinished edge.

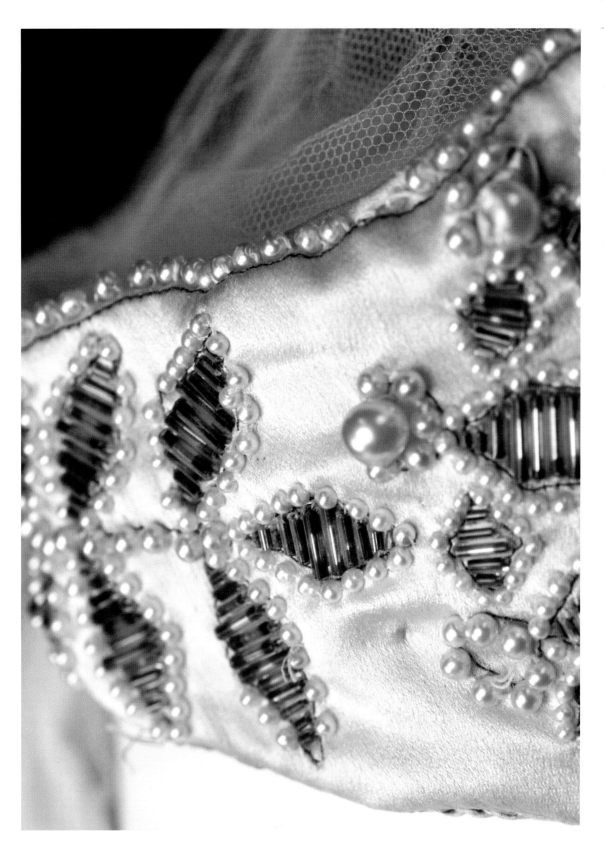

The same stylized leaf patterned band is employed on the headpiece to run around the head, with a rosette center front (4½ inches or 11.5 cm), matching the design of the rosette on the dress's waistband.

The inside of the bandeau is lined with the cream satin. It has a label that reads "*Lanvin Paris/ FAUBOURG ST. HONORE*," woven in a golden yellow script (Figure 10.17). Part of the label is hidden by alterations to the bandeau and the stitching of the net.

The headpiece also shows signs of wear and alteration. There is damage to the large pearl beads in the rosette, and the silver of the bugle beads is tarnishing. Some beads have been lost. The seam at the back of the bandeau has been altered to make the headpiece smaller (Figure 10.18), giving it a circumference of 22 inches (55.9 cm). This alteration has obscured part of the label, and the net looks like a more recent addition, because it has been stitched through the designer label (Figure 10.16). There is also damage to the net.

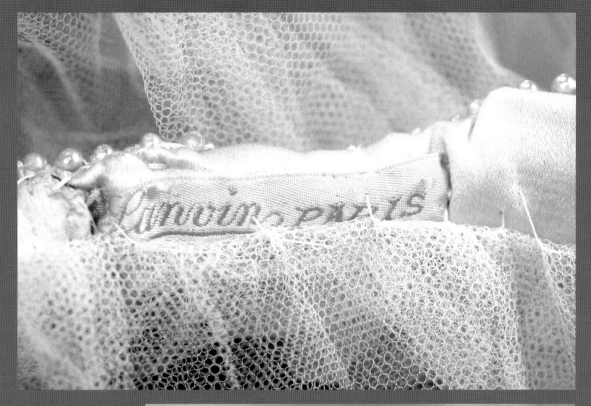

OPPOSITE
Figure 10.16.

**Exposed buckram in
headpiece.** Photo by Ingrid
Mida.

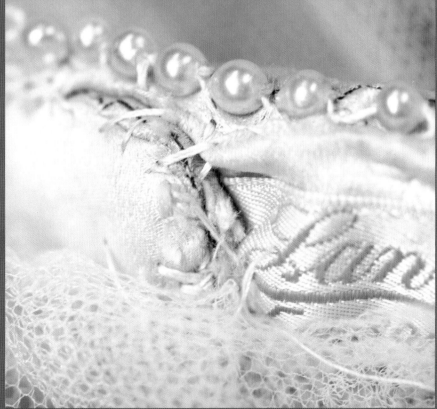

TOP
Figure 10.17.

Lanvin label on headpiece.
Photo by Ingrid Mida.

RIGHT
Figure 10.18.

Alteration to headpiece.
Photo by Ingrid Mida.

REFLECTION

This wedding dress ensemble conveys an impression of faded glory. Although the physical damage to the dress, both in terms of the alterations and decomposition, is extensive, the ensemble retains considerable beauty and opulence, with the luxurious sheen of the satin accented by the glint of the silver bugle beads.

The university collection has no provenance records or photographs associated with this ensemble, and thus there is no information about the wearer(s), or the occasion(s) on which it was worn. The collection does not have any other garments with a Lanvin label from this period, but many museum collections do, including Musée Galliera in Paris, and the Costume Institute at the Metropolitan Museum of Art in New York. As with the work of other designers in the early twentieth century, Lanvin's creations appeared regularly in fashion magazines such as *Gazette du Bon Ton* (Figure 10.1), and *Harper's Bazaar*.

The alterations and damage to this ensemble are evidence of its multifaceted history. The extensive beadwork on the dress and headpiece seem to reference Art Deco influences of the 1920s, and the dress was dated initially in the collection as 1925–1928. However, this was a time when the fashionable silhouette had a dropped waistline, in contrast to the high waistline of the case study dress (Figure 10.2). In the absence of provenance records, the strongest piece of evidence at hand to authenticate and date the dress is the label in the headpiece.

INTERPRETATION

Mary from top to toe was immaculate in white and looked better than ever I had seen her. But I think in general all brides do—it does not, I believe, proceed from their being more than ordinary beautiful, but they are more than ordinary interesting. The eternal union of two hearts very strangely engages our own, and makes us strongly picture the future or remember the past.

— *Martha Le Mesurier to her aunt, September 15, 1779*
(cited in Lenfestey 2003: 67)

Wedding dresses have long been associated with shades of white, including ivory and cream, since white denotes purity and innocence. White or cream dresses have also been the color of choice for formal balls, and the presentation of debutantes at court. Although the lack of information about

the donor of this dress makes it impossible to confirm whether it was first worn as a bridal gown, the surviving headpiece strongly implies that this was the initial purpose of the dress.

The research questions suggested by the close examination of the wedding dress and headpiece include:

1. Is the Lanvin label authentic, and can it be used to date the dress more accurately? Do the dress and headpiece fit with the Lanvin design aesthetic?

2. In what way does this dress ensemble embody memory, and the narrative of the wedding dress?

The alterations to the dress, where a bodice has been fashioned from an entirely different fabric and decorated with bands of the original beadwork (as seen on the beadwork bands that were re-sewn onto the sleeve in Figure 10.9), make it especially difficult to date the dress with precision. Historically, wedding dresses have followed the fashionable silhouettes of the period, and the short sleeves and plain neckline of the altered bodice make it atypical for the early twentieth century. The empire waistline is characteristic of dresses that date from 1909–1912, or 1916–1918. However, the geometric styling of the beaded decoration has an Art Deco feel that is seen more typically in the late 1920s. The clues appear to be in conflict.

The woven label, with its gold lettering, reads "*Lanvin Paris/ FAUBOURG ST. HONORE,*" but part of the label is hidden under the restitching of the headpiece that appears to conceal the designer's first name "Jeanne" and "22". Theorists Pierre Bourdieu and Yvette Delsaut described the significance of a label as follows: "The label, a simple word stuck onto a product, is without doubt, along with the artist's signature, one of the most economically and symbolically powerful words amongst those in use today" (cited in Saillard and Zazzo 2012: 26).

According to the House of Lanvin, the first label used by Jeanne Lanvin was "*Jeanne Lanvin Paris/22 FAUBOURG ST. HONORE.*"[2] During a research visit to the Musée Galliera in Paris, a similar label was seen inside a Lanvin wedding gown from 1909 Musée Galliera (1960.17.6). Paul Iribe designed a new label with a distinctive stylized image of a mother and daughter, introduced by the House of Lanvin in 1923, but not used in garments until after 1925. However, according to Musée Galliera curator Sophie Grossiord, the new label was not used consistently in garments by Lanvin until after 1930.[3] Although the label in the headpiece does not provide an exact dating for the ensemble, it suggests that the latest possible date for its creation is 1929. The Costume Institute at the Metropolitan Museum of Art has a wedding gown made of similar fabric, and with a beaded rosette at the bustline (1985.365.1), and this gown is dated fall/winter 1926–1927.

The next question to consider in the research process is whether the dress demonstrates characteristics of Jeanne Lanvin's work. Lanvin began her career as a milliner in 1889, transitioning into childrenswear after the birth of her daughter Marguerite Marie Blanche in 1897. Upon joining the *Syndicat de la Couture* in 1909, Lanvin presented her first couture collection, and soon became known for creating elegant, pretty, and feminine looks for women (Figure 10.19). Lanvin showed her first wedding dress in summer 1911, with wedding ensembles made by commission following the stylistic trends of the season. The illustration in *Gazette du Bon Ton* by Pierre Brissaud, from 1921, features a Lanvin wedding gown with a train, but the dress has long sleeves, and the bride wears a different type of headdress (Figure 10.1). Nonetheless, the elegant lines and beadwork of the illustrated dress are also shared characteristics of the case study dress.

Lavish beadwork is another distinguishing feature of Lanvin dresses. Concerned that her embroidery designs would be copied, and keen to maintain high standards, Lanvin established two embroidery workshops within her atelier, and maintained detailed records of all her beadwork designs (Merceron, Elbaz, and Koda 2007: 220), although these are not readily accessible to scholars. The elaborate abstracted floral beadwork on the case study dress, executed in white pearls and silver bugle beads, has symbolic qualities associated with bridal wear, both in the choice of materials and in the design.[4] For example, the stylized laurel leaves seen in Figure 10.11 represented a desire for immortality, since the laurel leaf is a plant that remains green during the winter months (Merceron et al. 2007: 107).

The shape of the headpiece in the case study resembles the Russian *kokoshnik*, a bandeau-style headdress very popular in Art Deco fashions, especially when worn with the newly fashionable bobbed hairstyles. The shaping, however, also demonstrates the earlier influence of Russian dress and decoration in Parisian fashion, which had begun with the arrival of the *Ballet Russes* in 1909, and continued with the stream of Russian aristocratic émigrés who came after the First World War, fleeing from the new communist regime in their homeland. Many of them began to work in the fashion industry, bringing vibrant and exotic colors, textures, and decorative features to French fashions. In the Musée Galliera collection, there is a very similar headpiece in cream satin, embellished with pearl beads dated 1913, but without a maker label (1983.77.4).

OPPOSITE
Figure 10.19.

"Jolibois." **Evening Dress by Jeanne Lanvin, fall/winter 1922–23.** Blue silk taffeta, multi-colored silk chenille embroidery. Brooklyn Museum Costume Collection at The Metropolitan Museum of Art, Gift of the Brooklyn Museum, 2009; Gift of Louise Gross, 1986 (2009.300.2635). Image copyright © The Metropolitan Museum of Art. Image Source: Art Resource, New York.

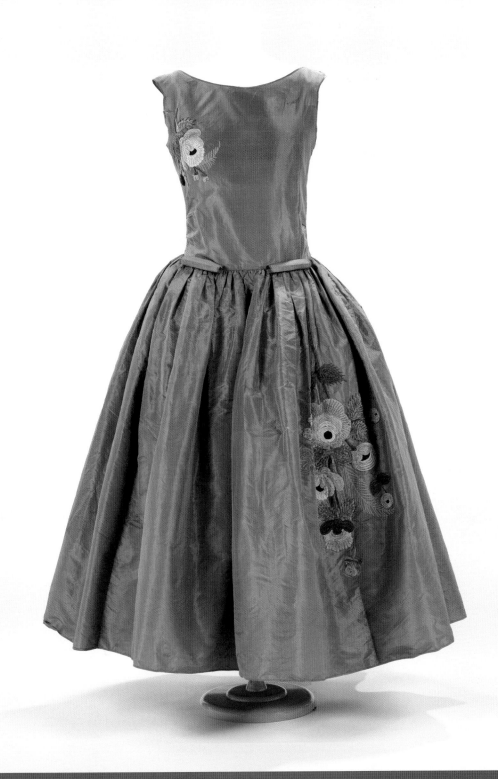

No information is available about the history of this dress before it entered the university collection, so its original wearer, and the subsequent alterations to the dress, remain tantalizing mysteries. Although it is not unusual to have little or no information about donors of garments in a museum collection, wedding dresses are more likely than most pieces of clothing to retain their personal history. This speaks to the deep sentimental importance that they have for their wearer, who may save and treasure the dress, along with photographs of the dress being worn, and information about the wedding day. As Amy de la Haye and other scholars have explored in their work on why women keep clothes that they no longer wear, special occasion clothes are often invested with a personal poignancy that gives them an importance far beyond material value (De la Haye 2005; Banim and Guy 2001). The wedding dress becomes the physical embodiment of memory. Even though we do not know anything about the woman (or women) who wore this dress, its survival suggests that it was a garment much loved and treasured. The alteration to the top half of the dress, where a new bodice has been added, as well as the changes to the headdress (in particular, the veil), imply that it was worn for a second time as a wedding dress. The damage to the dress, where the beadwork has pulled away from the original satin, may indicate that the original bodice was too damaged to repair. Wedding dresses are often made of fragile fabrics, and ornamented with heavy beadwork, a combination that quickly deteriorates as the weighty decorative elements pull at, and weaken, the base fabric.

The shape and styling of the altered bodice are very different from comparative surviving examples from the early twentieth century that, typically, have wrist-length sleeves. It is evident that another person has tried to update the dress by significantly altering the bodice, but used original bands of the beadwork around the edge of the sleeves (Figure 10.9). The synthetic fabric of the replacement bodice is visually and texturally of a lesser quality than the original satin, and feels like a fabric used more typically as a lining. Even much-loved garments can be subject to alterations for new uses, unimagined by the original wearer. Throughout history, fashionable dress has been reappropriated for use as fancy dress, with sumptuous fabrics and decoration repurposed, for a new role that retains elements of the original appearance of the garment in creating a different silhouette or look (Baumgarten 2002: 200, 204). The fact that the shaping of the bodice has little to do with the line of the skirt implies that this dress has been reused in this way; its new wearer taking the original dress to create a garment with a much more transitory role. The stitching over of the Lanvin label in the headpiece (Figure 10.18), and the likely removal of the original label from the dress, also indicate that the person making these modifications did not appreciate the significance of the Lanvin provenance.

The evidence gathered in this analysis suggests that the dress is an authentic Lanvin garment, created after 1911 and before 1929, that has been altered substantially by a subsequent wearer. This was a time, falling within the Art Deco period of 1909–1939, that saw an eclectic mix of design references, characterized by "a unique combination of exoticism and modernity" (Lussier 2003: 6). Combining influences old and new was typical of Lanvin's work, and although her designs drew frequently on inspiration from the past, most famously in her *robes de style* (Figure 10.19), she elegantly appropriated historical details to create something fresh and modern. The specific history of this wedding dress and headpiece may not have survived the ravages of time, but their survival is a tribute to the personal narrative: a garment infused with an emotional significance, and a history of wear that encompassed a stylistic reworking for another use.

NOTES

1. The wedding dress and headpiece belong to the Ryerson University Fashion Research Collection (2013.99.004A+B).

2. Email from the House of Lanvin, dated March 19, 2014. Students should note that correspondence with couture houses is atypical for object-based research.

3. Personal interview with Curator Sophie Grossiord on March 26, 2014 in the archives of the Musée Galliera in Paris.

4. For an extended analysis of the floral motif and beadwork in French couture, see the Musée Galliera exhibition catalogue for *Mariage, Exposition 16 avril au 29 août 1999, Editions Assouline, Paris,* by Curator Anne Zazou.

REFERENCES

Banim, M. and Guy, A. (2001), "Dis/continued Selves: Why do Women Keep Clothes they no Longer Wear?" in A. Guy, E. Green and M. Banim (eds.), *Through the Wardrobe: Women's Relationships with their Clothes,* New York: Berg: 203–219.

Baumgarten, L. (2002), *What Clothes Reveal: The Language of Clothing in Colonial and Federal America*, New Haven: Yale University Press.

De la Haye, A. (2005), "Objects of Passion," in A. de la Haye, L. Taylor and E. Thompson (eds.), *A Family of Fashion, The Messels: Six Generations of Dress*, London: Philip Wilson: 128–151.

Ehrman, E. (2011), *The Wedding Dress, 300 Years of Bridal Fashions,* London: V&A Publications.

House of Lanvin: 125 Years of Creation Timeline 1889–2014. Available at: www.125anslanvin.com.

Lenfestey, G. (2003), "An Alderney Wedding 1779," *Costume,* 37: 66–70.

Lussier, S. (2003), *Art Deco Fashion,* London: V&A Publications.

Merceron, D., Elbaz, E. and Koda, H. (2007), *Lanvin,* New York: Rizzoli.

Saillard, O. and Zazzo, A., (eds.), (2012), *Paris Haute Couture,* Paris: Flammarion.

Zazou, A. (1999), *"La Robe sans qualités,"* in *Mariage,* Exhibition Catalogue. Musée Galliera, Musée de la Mode de la Ville de Paris, 16 avril au 29 août 1999. Paris: Musée Publishers, Editions Assouline: 74–90.

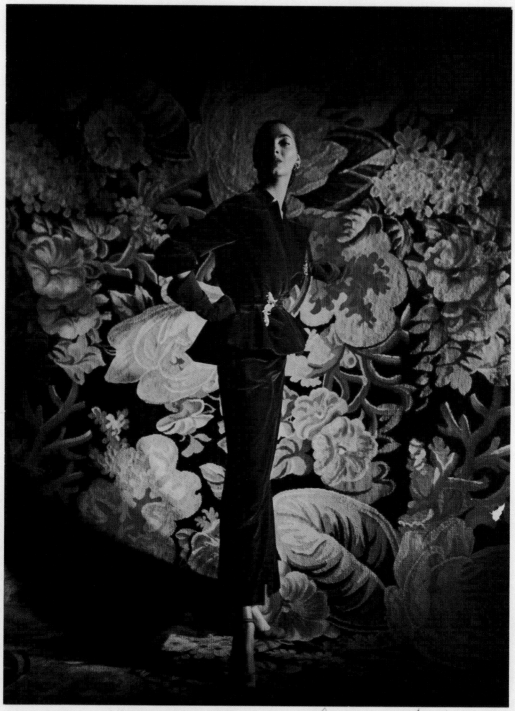

11

Case Study of a Ruby Red Velvet Jacket by Christian Dior

Many dress collections contain examples of couture garments that are valued for their aesthetic beauty, innovative construction or embellishment, exemplary design, and/or monetary value. These garments were usually highly prized by their wearers, both in terms of the financial investment required, and the prestige that their wearing conferred on the owner. In this case study, we consider the clues embodied in a ruby red velvet women's jacket with a Christian Dior label, part of a university fashion research collection, which entered the collection without a confirmed date or provenance.[1]

Christian Dior (1905–1957) is one of the most influential fashion designers of the twentieth century, despite the fact that his career was cut short by an early death. His work, exemplified by what came to be known as the *New Look*, is characterized by its fashioning of an ultra-feminine shape, which actively drew on the womanly but restrictive silhouettes of historic fashions, to create a sense of sophisticated, elegant luxury. Examples of original Dior garments and couture copies (a system of fashion diffusion, which Dior did much to promote) can be found in dress collections across the world.

The ruby red velvet jacket examined here (Figure 11.2), with its rounded shoulders and nipped-in waist, is a classic example of a Dior couture copy garment. It has a complex arrangement of the front panels, with an unusual pocket construction that provides both structural and decorative elements of the jacket. The jacket has two labels: one links the jacket to the house of Dior; and the other label is from a Detroit importer. The shape of the jacket, together with the style and design of the two labels, suggest an initial dating of around 1950. Although signs of wear are evident, especially around the collar of the jacket, both the fabric and the seams are generally structurally sound, so the garment can be examined safely in more detail. A careful study of the jacket will provide many details that illuminate the ideals of beauty for the period, as well as a consideration of the production and dissemination of designer garments. These details can be used to establish the jacket in a cultural framework of meticulously created and luxurious garments, much treasured by their owners, as laid out in the work of scholars, such as Alexandra Palmer in *Couture and Commerce* (2001), and Claire Wilcox in *The Golden Age of Couture* (2007).

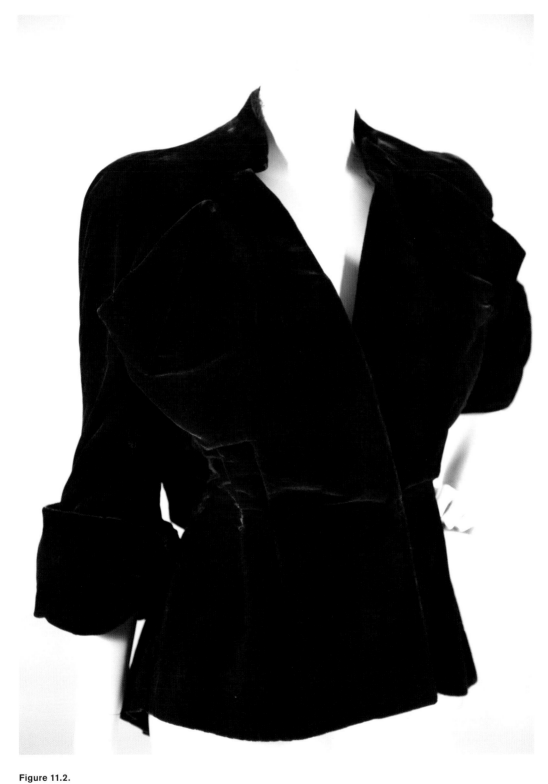

Figure 11.2.

Dior jacket front.
Photo by Ingrid Mida.

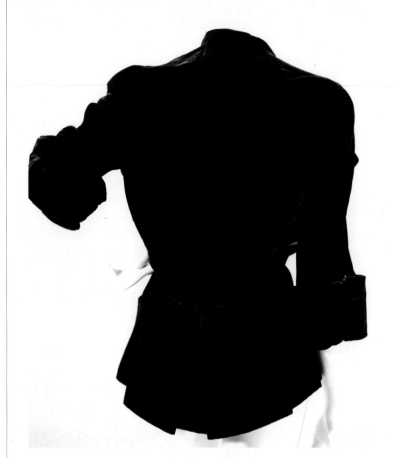

Figure 11.3.

Dior jacket back.
Photo by Ingrid Mida.

OBSERVATION

Construction

The fitted velvet jacket has a rounded shoulder line, nipped-in waist, pleated peplum, and three-quarter length sleeves (Figure 11.2). The straight center opening with a small standing collar is notched at the collarbone. The front panels of the jacket are constructed from single pieces of fabric, folded to create pockets at the upper bustline, and shaped with darts to create a peplum effect to the lower edge, with no front waist seam. The back bodice section is pleated at the waist to form a slight blouson effect (Figure 11.3), and has a separate piece of fabric to create a pleated peplum, with deep vents at either side (Figure 11.4). The sleeves are cut as one with the bodice sections, and have a deep cuff of self-fabric (4¼ inches or 10.8 cm), gathered and stitched in place on the outer edge (Figure 11.5). The seams for the sleeves are under the arm, with additional triangular underarm gussets (Figure 11.6). The inset pockets, placed at an angle with asymmetrical fold-over flaps, one on the upper breast of each front panel, serve as a decorative detail (Figure 11.7). While these pockets could be functional, their high positioning on the front of the jacket, and the way in which they form part of the jacket's construction, suggest that they were never intended for actual use.

Figure 11.4.

Peplum.
Photo by Ingrid Mida.

Figure 11.6.

Underarm gusset.
Photo by Ingrid Mida.

Figure 11.5.

Cuff.
Photo by Ingrid Mida.

Figure 11.7.

Peaked pocket.
Photo by Ingrid Mida.

The interior of the jacket is fully lined in a ruby red satin. Although most of the seams are hidden beneath the satin lining, it is possible to see at the edges of the panels that the velvet has been cut at either edge, so that there is no surviving selvedge. There is an interior narrow belt of the same red satin attached to the lining at the natural waist (Figure 11.8). Dior was known for designing highly structured garments, but this jacket does not seem to have any additional supporting or stiffening fabric between the lining and the outer fabric. This may have been to ensure that the velvet of the jacket retained its appearance of soft fluidity. The belt fastens with two painted black metal hooks and eyes. The only fastening on the outside of the jacket is a single black painted hook at the center waist, with two red thread eyes (Figure 11.9), to allow the jacket to be fastened at two different sizes.

OPPOSITE
Figure 11.8.

Lining and inner belt.
Photo by Ingrid Mida.

ABOVE
Figure 11.9.

Hook fastening at waist.
Photo by Ingrid Mida.

There is no size label in the garment so the measurement of the jacket provides useful information about the size of the wearer. The center back of the jacket is 19¼ inches (48.9 cm), the bust is 37½ inches (92.3 cm), and the waist is 29½ inches (75 cm). There is no additional shaping or boning inside the jacket and the wearer may have required a foundation garment.

This jacket offers evidence of both machine-stitching and hand-stitching. In this jacket, the seams have been carefully concealed by clever manipulation of fabric on the inside of the garment. There is also evidence of neat hand-stitching along the ends of the belt and the edge of the lining, which has been sewn to the velvet (Figure 11.8). This mixture of machine-stitched seams and hand-finishing is common practice for designer garments. The quality is further demonstrated by the tiny buttonhole stitches holding the black metal hooks in place, and forming their corresponding eyes, all in carefully matched deep red thread. The tiny gathers in some of the seams, notably the side seams, are clearly deliberate, and help to emphasize the silhouette, by visually enhancing the slim fitting nature of the jacket around the waist.

Textiles

The jacket is made of ruby red silk velvet, without any patterning. The lining of the garment is made from a matching ruby red silk satin.

Labels

The jacket has two labels. The first is placed inside along the lower left hand side, near the opening. It reads "*Christian Dior - New York Original TRADEMARK*" (Figure 11.10). The second label is placed at the back of the neck and reads "*IMPORTER Irving DETROIT*" (Figure 11.11).

The Use and Wearing of the Garment

The velvet around the collar is considerably frayed, and there has not been any attempt to mend the fraying (Figure 11.12). A number of the seams show signs of stress: there is visible pulling of the seams under the arms, around the armholes, and at the front right-hand waist. Of the two thread-worked eyes to fasten the jacket on the outside, the eye furthest from the hook is visibly more worn. There is no sign of underarm staining, or stains or marks on the exterior fabric.

OPPOSITE TOP
Figure 11.10

Christian Dior - New York **label.**
Photo by Ingrid Mida.

OPPOSITE BOTTOM
Figure 11.11.

Irving Detroit **label.**
Photo by Ingrid Mida.

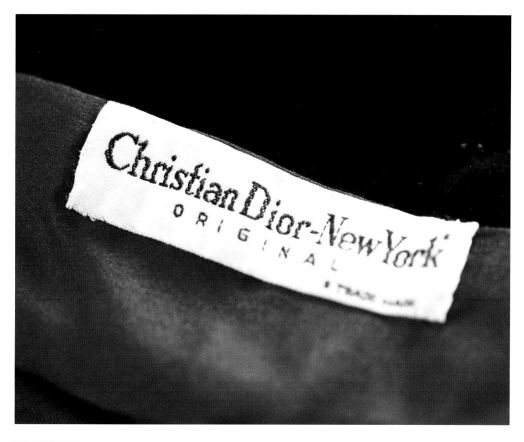

ABOVE
Figure 11.12.

Frayed collar.
Photo by Ingrid Mida.

OPPOSITE
Figure 11.13.

Detail of velvet.
Photo by Ingrid Mida.

REFLECTION

This ruby red jacket suggests extravagance. The silky sheen of the velvet invites a tactile response, and the deep color of the fabric connotes timeless luxury. Silk velvet is a fabric that has long been an indicator of wealth and prestige (Figure 11.13). The weave of velvet, where an extra warp thread is added and then cut to produce the pile, necessitates the use of a great amount of thread, thereby increasing the cost. Similarly, the deep red color of the jacket, at one time a color that could only be produced using costly dyes, increases the garment's associations with the tradition of luxury and expense. The fact that this is a garment without pattern or further embellishment increases its sense of elegance, with the uncluttered surface of the textile allowing the silhouette to be the main focus of the garment, enhanced by the lustrous sheen of the silk velvet. The shape, with its creation of an hourglass figure, is suggestive of ideals of feminine beauty. In spite of the evidence of damage and wear, this garment would be luxurious to wear.

The iconic position of Dior in the narrative of twentieth-century fashion means that he has been the subject of countless books, and his creations have been collected extensively by museums. Dior's collections were well-documented by the world's fashion press, as well as appearing in promotional literature produced by the house itself, and advertising for department stores that were licensed to sell copies of Dior models. This jacket is illustrated as part of an ensemble in *Harper's Bazaar*, September 1949 (Figure 11.1). Within the study collection to which this garment belongs, there are several other examples of Dior garments available for comparison. However, because the garment was donated anonymously, there is no specific information about the original owner of the jacket.

INTERPRETATION

The use of luxurious fabric, elegant styling, and fine details of the construction of this jacket are consistent with the level of workmanship seen in designer garments. The jacket could be used to consider:

1. Historical referencing and the cyclical nature of fashion

2. Concepts of femininity and ideal beauty

3. The marketing of couture compared to the reality of wearing such a garment

4. The nature of labelling and licensing of couture

5. Bourdieu's theory of habitus

The deep cuffs (Figure 11.5) are reminiscent of eighteenth-century dress; a reference that gives evidence to Dior's delight in historical detail, and also suggests his romanticized view of women's dress, evoking a period of dress associated with elegance and femininity. Combined with the imposing red of the silk velvet, alongside the evident skill needed to manipulate the fabric into such a distinctive structure for the front panels of the jacket, it is clear that this is a garment which draws on a range of styles and design features, to produce a piece which is signature Dior. This garment invokes luxury and can be linked to the theories of conspicuous consumption, like those of Thorstein Veblen.

The unusual pocket detail is a striking feature of this garment (Figure 11.7), and allows the jacket to be identified with Christian Dior's collection of fall/winter 1949. A photograph by Louis Dahl Wolfe of a model wearing this jacket, with a matching long, narrow skirt from "This Season in Town," in *Harper's Bazaar* September 1949 (Figure 11.1), confirms this conjecture, but it also

raises the question as to what might have happened to the skirt that would have been sold with this jacket. The magazine describes the skirt as a "bone skirt," because it was so narrow that the wearer barely had any room to move. The difficulty of moving in the skirt would surely have caused damage, similar to the type of damage seen on the jacket seams and intersections, and could explain why the skirt has not survived.

Equally, an examination of the wear and tear on the jacket offers evidence that it was worn many times, and that the garment was highly valued by its wearer. For example, perhaps the owner stopped wearing the jacket when the wear on the collar became too noticeable to be hidden (Figure 11.12). The stresses around the seams suggest that the wearer may have put on a little weight during the time that she wore the jacket, although again, there are no signs of alteration, so her shape and size cannot have changed substantially. The contrast in the wear on the thread eyes at the waist establishes that, for most of the time, the wearer fastened the jacket to give the maximum room around the waist. However, the wear under the arms demonstrates that the construction of this garment restricted the wearer's movement, making it especially difficult to raise her arms. In contrast, the lack of staining on the garment suggests not only that the garment was carefully cared for, but also that the jacket was likely worn with a blouse and possibly a slip.

This jacket also provides evidence of the ideals of femininity of the post-war period. The nipped-in waist and flaring peplum (Figure 11.14) enhances the illusion of a small waist, and conforms to the emphasis on the hourglass shape during this time, which Dior did so much to promote through the *New Look*. The lack of mobility represented by the close fit and tight armholes of the jacket fits with the well-known criticisms of Dior's *New Look*; its restrictions on women's physical movement were considered emblematic of restrictions on the role of women in society, and the "recreation of the feminine woman as an upper-class luxury object" (Wilson and Taylor 1989: 149). The evidence of cultural beliefs reflected in the jacket can be supported by an analysis of writings from the period. For example, the "inclinations of the times" were expressed in the January 15, 1946 issue of American *Vogue*, where Barbara Heggie urged women to return to the home. She wrote, "stop making decisions … stop driving the car like Eisenhower's WAC, develop a sudden inability to balance your checkbook," and "to memorize once more the age-old formula for a woman: a utensil whose potentialities for good hard wear are artfully disguised in a smoke screen of frivolity" (1946: 118). This call for women to return to the home was published thirteen months before Dior's *New Look* collection was launched, but its impact was felt through the 1950s. In a magazine article directed at the male reader, called "That Friend of your Wife named Dior", by Richard Donovan in *Colliers Magazine* June 10, 1955, the author confirms the degree of artifice in the construction of the feminine body by Dior during this period. Donovan wrote: "Monsieur Christian Dior, the stout and startled-looking grand vizier of the high-fashion Paris dressmakers,

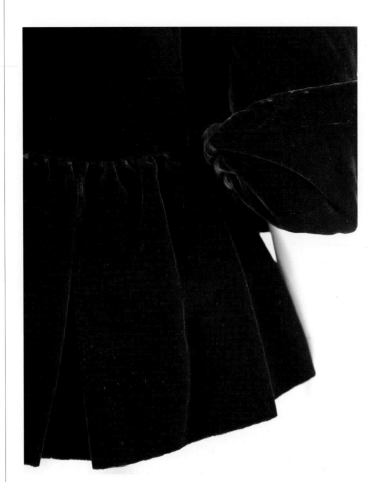

Figure 11.14.

Detail of peplum and cuff. Photo by Ingrid Mida.

is the main reason most women look the way they do today … The greatest of all M. Dior's virtues, of course, is his burning desire to make all women look beautiful … and to save them from nature" (1955: 35).

The waist measurement of the jacket at 29½ inches (75 cm) is a clear indication that, although fashion imagery depicted sylph-like models wearing couture and designer clothing, in reality, these garments were actually worn by women who did not always conform to this vision of ideal beauty, and whose shape and size was more ordinary.

The labeling of this jacket is distinctive. The *Christian Dior New York* label (Figure 11.10) appeared in late 1940s/early 1950s couture copy Dior garments which were produced for the New York salon, and here, the label clearly corroborates a dating of this period for the garment. This label indicates that it is a couture copy, ready-to-wear garment, created for the American market, not *haute couture* made-to-order. The garment is not numbered, nor does it record the name of the owner. The word "importer," and the connection to Detroit in the *Irving Detroit* label (Figure 11.11) offer a clue to the retailing of this garment, since the jacket is clearly a Dior couture copy sold in the American Mid-west. In the 1950s,

Detroit was a thriving city, supported by the automotive industry, where a certain section of its inhabitants were wealthy enough to patronize businesses selling high-class couture copies. Irving's was a specialty dress shop in downtown Detroit, on Washington Boulevard, which later opened a second shop in the smart suburb of Grosse Point. Mr. Irving regularly made trips to New York and Europe, to source the clothes for sale in his shops.[2]

Many books and articles have been written on Dior, but few offer more than cursory notations on the experience of wearing the actual garments themselves. One exception of note is Alexandra Palmer's 2001 book *Couture and Commerce*, where she set out to understand the significance of couture worn in Toronto, from a socio-economic and cultural perspective, and noted that "the association of *haute couture* with good taste is long-standing and one of its underpinnings" (2001: 6).

Pierre Bourdieu's concept of habitus provides a link between the embodiment of dress and habitus, or the choices reflected by class and lifestyle. Bourdieu wrote that aesthetic preferences are "most marked in the ordinary choices of everyday existence, such as furniture, clothing, or cooking, which are particularly revealing of deep-rooted and long-standing dispositions because, lying outside the scope of the educational system, they have to be confronted, as it were, by naked taste" (1998: 77). Wearing a garment by Christian Dior, especially one that had been photographed for a prominent women's magazine, like this velvet jacket, marked the wearer as one of the elite. The translation of habitus into a bodily experience was also considered by Bourdieu: "the social relations objectified in familiar objects, in their luxury or poverty, their 'distinction' or 'vulgarity', their 'beauty' or 'ugliness', impress themselves through bodily experiences" (1998: 77).

This jacket is an elegant and carefully crafted garment, with evidence of wear that attests to it being much loved by its owner. The careful observation of the details of construction, fabric, and label, as well as evidence of how this jacket was used and worn, offers a non-textual link to the past that can be used to enhance an interdisciplinary approach to research in dress.

NOTES

1. The jacket is part of the Ryerson University Fashion Research Collection (2000.02.053), and was donated anonymously.

2. Correspondence with Patience Nauta, dated July 1, 2014.

REFERENCES

Bourdieu, P. (1998), *Distinction: A Social Critique of the Judgement of Taste*, trans. Richard Nice. Cambridge, MA: Harvard University Press.

Donovan, R. (1955), "That Friend of your Wife named Dior," *Colliers Magazine,* June 10, 1955: 34–39.

Heggie, B. (1946), "Back on the Pedestal, Ladies," *Vogue,* January 15, 1946: 118.

Palmer, A. (2001), *Couture and Commerce: The Transatlantic Fashion Trade in the 1950s,* Vancouver: UBC Press.

Veblen, T. (2007, first published 1899), *The Theory of the Leisure Class,* M. Banta (ed.), New York: Oxford University Press.

Wilcox, C. (ed.) (2007), *The Golden Age of Couture: Paris and London 1947–57,* London: V&A Publications.

Wilson, E. and Taylor, L. (1989), *Through the Looking Glass: A History of Dress from 1860 to the Present Day,* London: BBC Books.

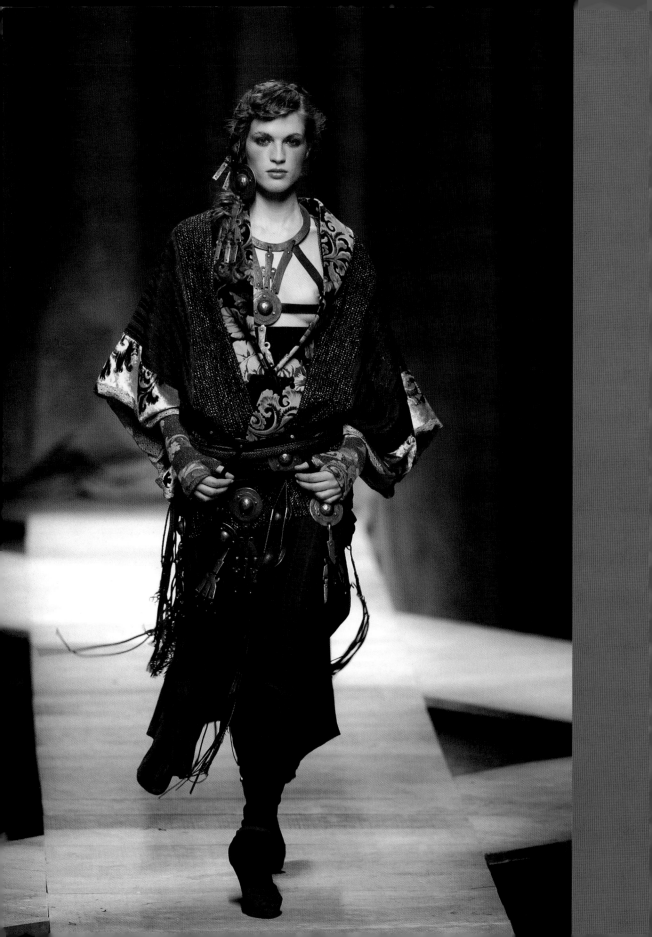

12 Case study of a Kimono-style Jacket by Kenzo

Fashionable Western dress has long shown a fascination with the shape and aesthetics of Japanese dress, especially after Japan reopened its links with the West in 1854 (Martin and Koda 1994: 73f). This relationship intensified when Parisian-based Japanese fashion designer Kenzo Takada introduced new silhouettes and textures into Western concepts of fashion in the 1970s, paving the way for other Japanese fashion designers, such as Rei Kawakubo and Issey Miyake, to radically alter the aesthetics of fashion in the 1980s. This case study considers a garment that demonstrates postmodern cultural hybridity in a womenswear jacket, from fall/winter 2004, by the label Kenzo (Figures 12.1 & 12.2). This jacket is one of several hundred items donated by a single donor to a university study collection.[1]

Kenzo Takada (b.1939) presented his first collection in Paris in April 1970, and was considered one of the first Japanese designers to adopt elements from the Japanese wardrobe, and make them fashionable for the West.[2] In describing the origins of his style, Kenzo said "No more darts, I like bold straight lines. Use cotton for summer and no lining for winter. Combine bright colors together, combine flowers, stripes, and checks freely" (cited in Kawamura 2004: 115). In 1971, Kenzo's design for a simple dress made with a kimono fabric appeared on the cover of *Elle* magazine, and he quickly achieved success and fame as one of the most creative designers in Paris. Takada sold the label in 1993, and retired in 1999.

The Kenzo jacket, with its wide, loose sleeves, and unfitted shape, adopts elements of a kimono, and also employs a mixture of fabrics in a patchwork pattern, to produce a richly layered appearance, with an exotic, slightly haphazard feel. It has a house label sewn into the back neck of the jacket, which documents that the garment originated from fall/winter 2004 (Figure 12.3).

OPPOSITE
Figure 12.2.

Kenzo Jacket front.
Photo by Ingrid Mida.

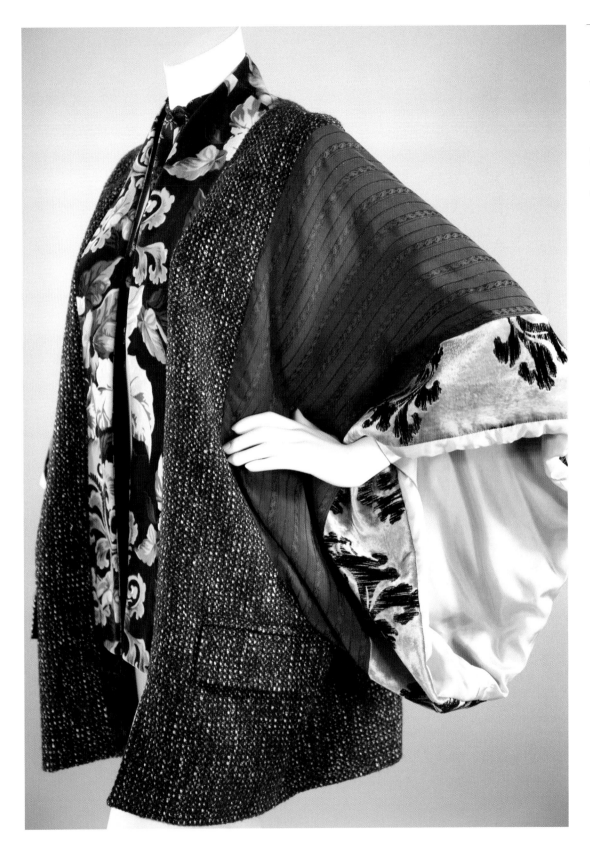

The rich mixture of textures and fabrics used for the jacket, and its combination of Japanese and Western elements, create a garment full of juxtapositions. In this way, the garment disrupts traditional notions of fashion, such as the idea of distinct items of clothing for different times of the day. The aesthetic of deconstruction, created by the mixing and piecing of the fabrics, as well as the hybrid of cultural references, make it a garment that exemplifies the idea of postmodernity in fashion.

OBSERVATION

Construction

This Kenzo jacket is loose-fitting, with a relatively simple construction. The front and back pieces (the latter with a center back seam) are made from a brown and white tweed-type fabric, and are cut with a straight lower edge that ends at thigh level (Figures 12.4 & 12.5). The wide sleeves of a figured brown synthetic silk are cut with deeply set armholes, and are trimmed with a wide band of a lime green and black velvet fabric. The collar of printed velvet is pieced at the shoulder seam, but constructed to look like a full band that runs down both sides of the front opening, and stops just short of the lower edge (Figure 12.5). The two front pieces have a false pocket flap at hip level.

OPPOSITE
Figure 12.3.

Kenzo label "ah04."
Photo by Ingrid Mida.

BELOW
Figure 12.4.

Jacket back.
Photo by Ingrid Mida.

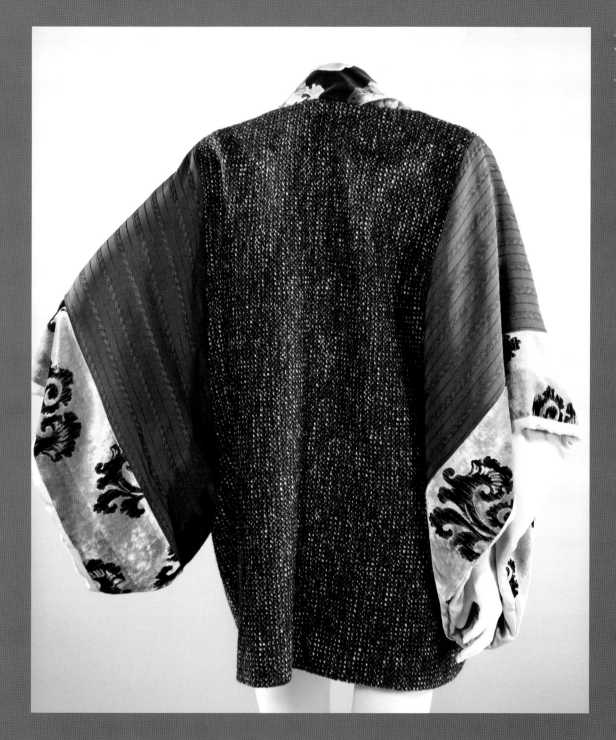

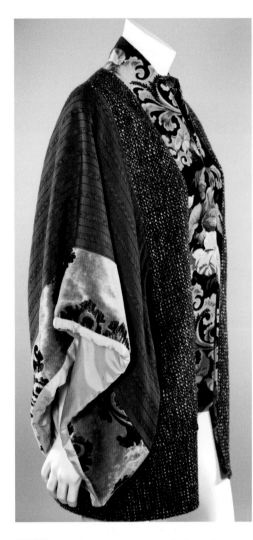

ABOVE
Figure 12.5.

Side view of jacket.
Photo by Ingrid Mida.

BELOW
Figure 12.6.

Jacket lining.
Photo by Ingrid Mida.

OPPOSITE
Figure 12.7.

Collar and necktie.
Photo by Ingrid Mida.

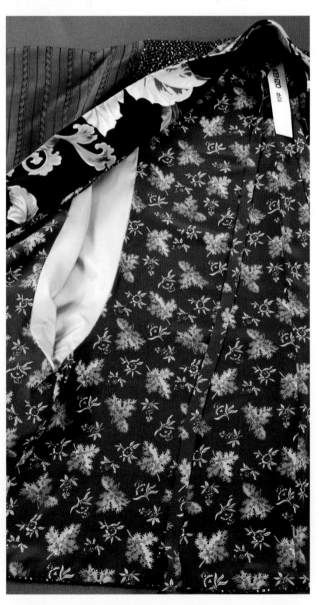

The body of the jacket is fully lined, and has a matching necktie secured in the center back seam of the lining (Figures 12.6 & 12.7). The sleeves are fully lined in a green fabric, lightly padded, and have a further padded roll around the inside of their opening (Figure 12.8). The jacket has no fastenings apart from the necktie.

The outer panels of the body of the jacket have been formed with a mixture of fabrics, to give a patchwork-like appearance (Figure 12.9). There are no visible fabric selvedges. The well-finished seams show the small regular stitches of machine-stitching, and top-stitching has been used as a decorative element on the sleeves (Figure 12.10). There is no hand-stitching apparent on the jacket.

The loose fitting nature of the garment means that it is unnecessary to take traditional measurements for the jacket. It has a center back seam of 31 inches (78.8 cm), and its wide, almost square sleeves give it a wrist-to-wrist measurement of 48½ inches (123.2 cm). The sleeve opening at the wrist is 22 inches wide (55.9 cm).

OPPOSITE TOP
Figure 12.8.

Padding on sleeves.
Photo by Ingrid Mida.

OPPOSITE BOTTOM
Figure 12.9.

Patchwork pattern of textiles.
Photo by Ingrid Mida.

ABOVE
Figure 12.10.

Machine top-stitching.
Photo by Ingrid Mida.

Textiles

The care label for the garment provides a detailed breakdown of the fibers used to create the jacket (Figure 12.11). The body of the jacket is a brown and white tweed-like fabric, made from a mixture of natural and synthetic fibers (Fabric 1: acrylic 49%, wool 30%, cotton 15%, polyamide 6%). The tweed has a silver-colored thread running through the weave, to form a lattice-like pattern. The body of the sleeves is made from a chocolate-brown synthetic silk mix, with a thin woven stripe (Fabric 2: rayon 53%, acetate 42%, cupro 3%, polyamide 2%). Two different types of velvet fabric are used as trim. The fabric around the main opening of the jacket is made from polychrome cotton velvet, printed with a brown, green, yellow, and red botanical pattern (Fabric 3: cotton 100%). The sleeves are trimmed with a deep band of lime-green velvet (which is not mentioned on the care label). Although this fabric looks like it has been embroidered by machine, with a scrolling pattern in black thread, it is evident, on closer inspection, that the pattern is actually printed onto the pile of the fabric (Figure 12.12).

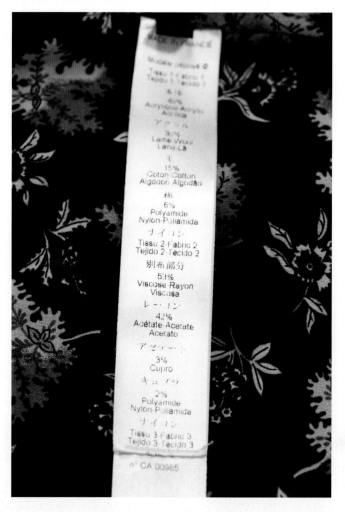

Figure 12.11.

List of fabrics in different languages on care label. Photo by Ingrid Mida.

Figure 12.12.

**Green velvet, printed with black
pattern to imitate embroidery.**
Photo by Ingrid Mida.

Two different types of lining fabric have been used. The main body of the garment and the pocket flaps are lined with a brown silk fabric, printed with a botanical pattern of leaf and flower sprigs in greens, yellow, orange, and red (Lining 1: silk 100%). The sleeves are lined with a pale green synthetic silk lining (Lining 2: rayon 100%).

Labels

The jacket has four labels. Sewn into the center back at the neck is the house label, reading "KENZO ah04" (Figure 12.3). The label is made from a white cotton tape with unfinished ends, and the signature font is printed onto the label in black and pink. The label is placed vertically in the jacket, and only sewn along the top corners with two rough stitches. Sewn into the side of the jacket is a care label, with a detailed breakdown of the fibers in each of the fabrics in five different languages (French, English, Spanish, Italian, and Japanese), alongside instructions about how to care for the garment, "Dry clean in a protective bag/ Iron on setting 1" (Figure 12.11). Additionally, it provides information about the manufacture of the jacket: "Made in France/*Modèle Déposé.*" A size label marked "38," and a further label printed with the number "CA00985," are sewn in at the same point.

The Use and Wearing of the Garment

The jacket shows little evidence of wear. There is a very small area of damage on the shoulder of the right-hand sleeve.

REFLECTION

This Kenzo jacket from fall/winter 2004 was one of several hundred designer items from a single donor's wardrobe that were accepted into a university study collection, in 2009.[1] Kenzo is a well-known Parisian design house, and the obvious stylistic references to the Japanese kimono seen in the jacket will facilitate analysis.

One of the most visually arresting elements of the jacket is the diverse mix of fabrics that create an exotic and multilayered appearance, especially with its palette of vibrant autumnal colors against the deep brown (Figure 12.9). The piecing of the fabrics, in a patchwork-like pattern—a method often associated with thriftiness and economy, as well as the idea of a Bohemian aesthetic—at first, seems at odds with a designer garment. In contrast, many of the fabrics used are visually suggestive of luxury, even though the synthetic composition of these fabrics may not carry the same connotations. For example, velvet, with its expensive pile, is traditionally made of silk, but here is produced in cotton. The synthetic velvet trimming of the sleeves has been made to look as if it is embroidered—historically, one of the most

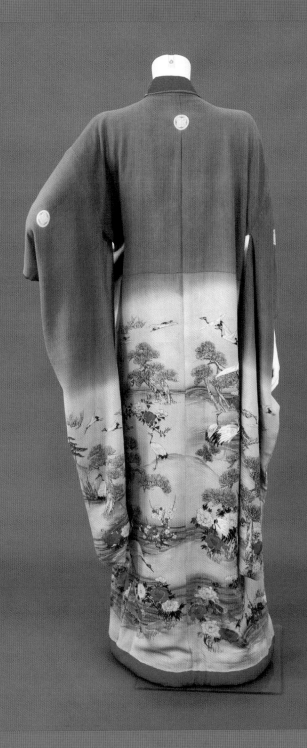

Figure 12.13.

**Kimono with padded hem, c.1930s,
Back.** Gift of R. Vanderpeer, Ryerson
FRC2013.03.005. Photo by Jazmin Welch.

expensive methods of decorating fabric—yet, in this case, the fabric has been printed to imitate embroidery (Figure 12.12). The simplicity of the construction also contrasts vividly with the multiplicity of fabrics. The types of fabrics used create a garment full of tactile contrast, with the uneven surface of the thickly woven tweed-like fabric offsetting the satin finish of the figured silk sleeve, and the smooth velvet pile. The fabric types also offer a juxtaposition of association: from the feminine and delicate connotations of the satin, to the rougher and more masculine tweed, which is traditionally used for menswear and outdoor clothing.

INTERPRETATION

The rich multilayering in this jacket, from its mixture of fabrics to its synthesis of Japanese and Western construction elements, suggests a range of research possibilities, including:

1. A sartorial cultural hybridity in a postmodern framework

2. The interpretation of a garment within a wardrobe

The case study jacket represents a key moment in the history of the Parisian fashion house Kenzo, since it comes from the first collection created by designer Antonio Marras (b. 1961) for fall/winter 2004 (Figure 12.1). In designing this jacket, Marras held true to Kenzo's reputation for successfully combining Eastern and Western design components, and the jacket clearly demonstrates this cultural hybridity. Many of its elements reference the simple and loose construction of the traditional, iconic Japanese garment, the kimono (Figure 12.13). The jacket's "T" shape follows the lines of a kimono, as does the band of trimming fabric around the front opening, which references the collars of the kimono: the *uraeri* and *tomoeri* (inner and outer collar, respectively). The traditional kimono is fastened with the *obi*, a carefully tied waist sash, but the Kenzo jacket has no fastenings, and in this way resembles the *uchikake*, an outer robe worn unbelted over a kimono by brides (Liddell 1989: 149). Similarly, the sleeves, with their large, wide opening and gentle padding, make a stylistic reference to the kimono. At first glance, the shape of the sleeve seems similar to kimono sleeves, but the way in which they are set into the body of the jacket at the armhole is actually closer to Western garment construction (Figures 12.14 & 12.15). The use of the shaped sleeve at the armhole, instead of the straight seam of a kimono sleeve, highlights the conflation of the two design aesthetics; evidence that Marras embraced the multicultural heritage of Kenzo, while making his own clear stylistic statement as new designer for the house.

RIGHT
Figure 12.14.

Kenzo jacket sleeve.
Photo by Ingrid Mida.

BELOW
Figure 12.15.

Kimono sleeve, c.1930s.
Gift of R. Vanderpeer,
Ryerson FRC2013.03.003.
Photo by Ingrid Mida.

The runway image of the jacket during Paris Fashion Week (Figure 12.1) demonstrates the way in which it lends itself to be worn in an array of styles. Unlike the structured formality associated with the wearing of a traditional kimono, with the careful tying and placing of the *obi*, this jacket was styled for the runway, belted loosely at the waist, suggesting a garment which can be adapted to suit the taste of the wearer. This aspect of the jacket speaks to a world of postmodern fashion, where no singular silhouette dominates, and the individual has the freedom to combine and style garments to fit to their personal aesthetic.

The way in which fabrics are combined in this garment offers another powerful reference to the history of the house. When Kenzo created his first collections for his own label in the 1970s, he could only afford to buy his fabric from flea markets, and so he pieced his finds together, to create new textiles (Kawamura 2004: 115). This unconventional combination of fabrics, often in clashing colors and prints, along with a mixing of cultural references, became signature elements of the label. As this jacket clearly illustrates, Marras's first collection continued this tradition. Many other looks from the fall/winter 2004 collection by Marras also incorporated this play of textures, colors, and patterns. In addition, the jacket's floral botanical printed fabrics are markers of the brand's signature use of flowers as a key symbol, both in terms of patterning, and as the house perfume.

The care label, with its text printed in five languages, offers a manifest illustration of the globalization of twenty-first century fashion (Figure 12.11), and reinforces the jacket's position in the sartorial framework of cultural hybridity. Kenzo's initial use of iconic references, such as the flower, the choice of fabrics, and the use of quilting techniques, and straight lines, were all rooted in Japanese tradition, but he soon came to adopt other ethnic elements. Yuniya Kawamura's book *The Japanese Revolution in Paris Fashion,* considers Kenzo the "first Japanese to introduce Japanese culture to the international world of fashion" (2004: 121), which in turn paved the way for designers like Rei Kawakubo and Issey Miyake in the 1980s. In the book *Japan Fashion Now*, Valerie Steele points out, however, that while Kenzo drew on aspects of Japanese culture, they were not central to his work (2010: 16). Although this jacket mixes references from Western and Japanese dress, many other garments by the Kenzo label mash up elements from other non-Western cultures, including Mexico and India, creating fashions that embody an aesthetic of cultural hybridity.

This jacket is also emblematic of the postmodern sensibility in contemporary fashion. In the essay "Fashion, or The Enchanting Spectacle of the Code," the sociologist Jean Baudrillard argues that there is a presupposition of death in fashion, by which elements from the past are recycled and reborn, creating a cycle of ephemeral appearances, and a myth of change. Fashion draws on what "has been," and exercises "enormous combinatory freedom," in a mix of cultural references and styles, to create an

aura of high culture and perfection (1993: 89). Although Baudrillard does not use the term "postmodern" within his essay, his arguments are consistent with a postmodern analysis of the fashion system, in that postmodernism denotes a radical challenge to cultural myths, power structures, and aesthetics, in which ambiguity, plurality, and subjectivity substitute for certainty and singularity. Baudrillard's declaration that fashion codes no longer exist reflects the ideology of postmodernism, because the metanarrative of a code of fashion has been rejected. Furthermore, his argument that fashion is "always retro," with a recycling of styles from the past to create an illusion of change, is consistent with the postmodern aesthetic of pastiche. By defining fashion as an emblem of modernity, he denotes the rupture of traditional fashion codes, and emphasizes the temporal nature of fashion in a postmodern world. In this Kenzo jacket, there is an eclectic mixing of fabrics, and a spirited blending of stylistic and cultural references (such as the kimono silhouette with the Western notion of a set-in sleeve) that illustrate the concept of postmodernity in fashion. The playful combination of fabrics—with the tweed referencing menswear fabric worn during the day, and the luxurious velvets and satins connoting feminine evening wear—challenges notions of daywear versus eveningwear. Additionally, the fabrics are recombined in an aesthetic that is a pastiche of textures and colors, nullifying the polarity of masculine and feminine, as Baudrillard predicted. In this way, this jacket offers an emblem of postmodernity, with its combinatory freedom and mix of cultural references and styles.

An alternative interpretation of this jacket would be to consider its place as one element in a women's wardrobe. In the book *Through the Wardrobe, Women's Relationship with their Clothes*, Ali Guy, Eileen Green and Maura Banim consider how women construct their identity through the purchase, consumption, and retention of clothing. They write: "Every day, as women dress themselves, they make particular choices from their unique clothing sets to develop a personal look, and through their dressed appearance women reflect and construct their identity" (2001: 14).

This Kenzo jacket is one of several hundred pieces that were donated to Ryerson University's Fashion Research Collection from the family of Kathleen Kubas, after she passed away in 2008, at the age of seventy-nine. Her large wardrobe included many designer garments from Gucci, Issey Miyake, Dolce and Gabbana, Jean Paul Gaultier, Moschino, and Louis Feraud, as well as hats by Philip Treacy, Eric Javits, and Stephen Jones. Bold colors, especially fuchsia-pink, dominated her wardrobe, and much of the clothing would have served to emphasize her tall, slender figure. Many of her clothes were purchased from Toronto's preeminent high-end fashion store, Holt Renfrew, and the CA00985 number on one of the jacket's labels confirms that.[3] Although she owned several garments by Japanese designer Issey Miyake (Figure 12.16), this jacket is the only Kenzo garment from

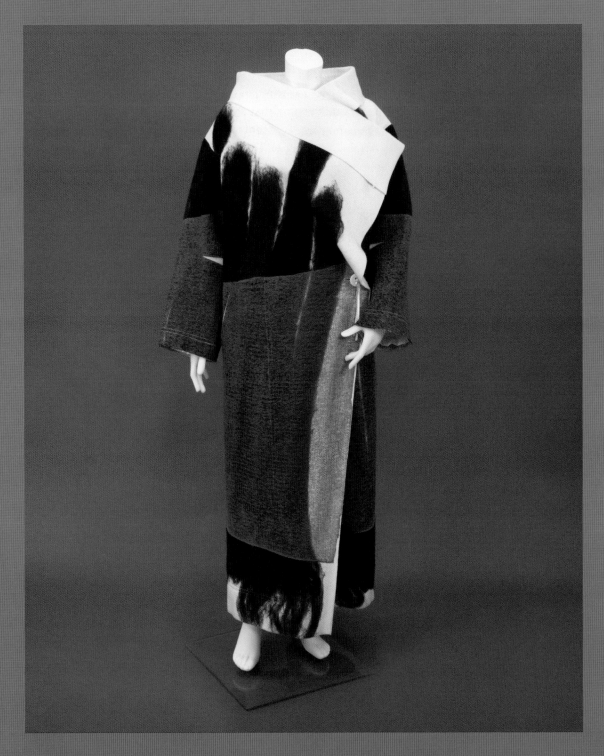

Figure 12.16.

Issey Miyake coat, c.1990s. Gift of Kathleen Kubas, Ryerson FRC2009.01.680. Photo by Jazmin Welch.

her wardrobe. However, it is one of many coats and jackets donated at the same time, including examples by Karl Lagerfeld, Jean Paul Gaultier, and Issey Miyake, that reflect her fondness for blanket-like coats, many of which have only a belt for closure. This Kenzo jacket, dating from fall/winter 2004, may have been purchased around the time that she suffered a serious decline in her health, and thus may be representative of her desire to remain fashionable, in spite of her reduced mobility. The jacket is very lightly worn, with only a very slight mark on the shoulder of the right sleeve, perhaps as the result of a shoulder bag rubbing at that spot. Although the runway version of this jacket was shown with a belt, there is no indication that a belt existed at the time of the donation, and the jacket shows no wear marks at the waist. As a colorful and fashionable statement piece, this Kenzo jacket is emblematic of the donor's *avant-garde* tastes, in a city long known for its conservative fashion sensibility (Palmer 2001: 282–92).

This Kenzo jacket is a garment full of juxtapositions, from the fabrics employed, to its combination of Japanese and Western shaping. Consistent with the Kenzo design philosophy of "inverting the Orient," this pastiche of fabrics, textures, and styles personifies postmodernity in a globalized world.

NOTES

1. The jacket is part of the Ryerson University Fashion Research Collection (2009.01.686), and was donated by the family of Kathleen Kubas.

2. Japanese designer Hanae Morae (b.1926) presented her "East Meets West" collection in New York for the first time in 1965, but did not show in Paris until 1977.

3. CA numbers are issued by the Canadian Competition Bureau on request to: "Canadian manufacturers, processors or finishers of a textile fiber product or Canadians engaged in the business of importing or selling any textile fiber product" (Canadian Competition Bureau).

REFERENCES

Baudrillard, J. (1993), "Fashion, or The Enchanting Spectacle of the Code," in M. Gane (ed.) *Symbolic Exchange and Death*, London: Sage: 87–100.

Canadian Competition Bureau (2014). Available at: http://www.competitionbureau. gc.ca/eic/site/cb-bc.nsf/eng/h_02575.html

Guy, A., Green, E. and Banim, M. (eds.) (2001), *Through the Wardrobe: Women's Relationship with Their Clothes*, New York: Berg.

Kawamura, Y. (2004), *The Japanese Revolution in Paris Fashion*, Oxford: Berg.

Liddell, J. (1989), *The Story of the Kimono*, Toronto: Fitzhenry and Whiteside.

Martin, K. and Koda, H. (1994), *Orientalism: Visions of the East in Western Dress*, New York: Metropolitan Museum of Art.

Palmer, A. (2001), *Couture and Commerce: The Transatlantic Fashion Trade in the 1950s*, Vancouver: UBC Press.

Steele, V. (2010), *Japan Fashion Now*, New Haven: Yale University Press.

Appendix 1: Checklist for Observation

GENERAL

1.	**a.** What type of garment is it? Coat and Skirt	**b.**	Is the garment intended for: Male, Female, Unisex? Female
2.	**a.** What are the main fabrics that have been used to make the garment? Wool, silk	**b.**	Are these fabrics predominately natural in composition (silk, wool, cotton, linen), synthetics or a blend? natural
3.	What are the dominant colors and/or patterns of the garment? brown, monochromatic	**4.**	Does the garment have any labels? yes
5.	What decade or general period does the garment or accessory belong to? 1916	**6.**	Can the garment be handled safely without causing further damage? yes
7.	What are the most unusual or unique aspects of the garment? the buttons	**8.**	Does the collection have any other garments like it, either by the same designer or from the same period? no

CONSTRUCTION

9. Describe the main components of the garment, such as the bodice, collar, sleeves, skirt.

this garment is composed of both a skirt and a jacket. Neither are heavily embellished, although the jacket does have some brass, looped buttons from the waist to the neckline and then at the end of the sleeves. A belt at the waistline accentuates the natural waist and a small brown fur collar adds some extra warmth. The chest area also has some texture in light pleating around the buttons, while the skirt remains fairly simple.

→ High neck

If relevant to your research, note measurements in both imperial and metric measurements such as:

a. Bust **c.** Hips **e.** Sleeve length

b. Waist **d.** Waist to hem **f.** Other

10. Does the structure of the garment emphasize one part of the body?

The garment seems fairly streamlined, although the waist is accentuated

11. Is the garment machine-stitched, handmade or a combination of these methods?

12. How is the garment closed or fastened?

buttons + loops

13. Are there any front, side, flap, or hidden pockets?

14. Are there any remarkable features in the construction, such as a bias cut, or use of nontraditional materials or structural elements?

15. Is the fabric selvedge visible in the seams, and has this been incorporated into the cutting or construction of the garment?

16. Is the type of construction consistent with the dating of the garment?

yes - 1916 WWI era

17. Is the garment reinforced in any way, such as padding, boning, metal hoops, or wire reinforcements?

there is no reinforcement

18. Is the garment lined?

yes - with silk

TEXTILE

19. What is the dominant textile or material that has been used?
Is it a natural or man-made fiber?

wool

20.	Has the dominant textile been subjected to a finishing process, such as bleaching, pressing, or glazing?
	No
21.	Have any other textiles been used in the garment or in the lining?
	fur, wool, silk inside
22.	Does the garment incorporate a stripe or pattern? Is it woven into the fabric or printed or formed by a different method such as stenciling, painting or manipulation of fabric?
	no pattern – monochromatic
23.	Is there any form of applied decoration such as appliqué, trim, lace, beading, embroidery, buttons, ruffles, pleated bands, or bows? Are there signs that any such decoration has been removed?
	pleated down front – no removal
24.	Has the fabric been reinforced in any way with padding, quilting, interfacing, wires, or boning?
	no
25.	Has the textile faded or otherwise changed in color with the passage of time?
	in surprisingly good condition

LABELS

26.	Is there a maker label? If so, is the label consistent with the designer's *oeuvre* and does it offer clues as to dating such as a number or season?
	No maker
27.	Is there a store label to identify where the garment was purchased? Does this reveal anything about the garment's history?
	Chandler & Co
28.	Are there any care labels or information about the garment?
	CM Grain
29.	Are there any size labels in the garment?
	No
30.	Is there a marking inside the garment that indicates the specific owner of the garment, such as an embroidered initial, nametag, or laundry mark?
	CM Grain

USE, ALTERATION AND WEAR

31.	Has the garment been structurally altered in any way?
	No
32.	Where does the garment show wear?
	on the inside – yes in the lining of the back
33.	Is the garment soiled or damaged in any way? Have seams ripped, silk split, or fabric decomposed? Is there evidence of insect damage?
	silk split
34.	Has the garment been dyed to alter its original color? Have trim or other forms of embellishment been unpicked or removed?
	No
35.	Does the styling of the garment conform to the predominant fashions of the period, or does it represent a hybrid, perhaps custom-made for the owner?
	Conforms – militaristic

SUPPORTING MATERIAL

36.	Does the collection have any provenance records associated with the garment?
37.	Are there any photographs of the garment?
	yes
38.	Are there any further documents or information about the garment that might indicate the original price of the garment?
	gives date – 1916
39.	Are there any manufacturer, store tags or original packaging associated with the garment?
	Chandler & Co. Boston MA.
40.	Are there any similar garments by the same designer, or by other designers from the same period, in this collection?
	No

Appendix 2: Checklist for Reflection

SENSORY REACTIONS

Sight	**2.**
1. Does the garment have stylistic, religious, artistic or iconic references? WWI references → era	Is the garment stylistically consistent with the period from which it came? Does it seem to reflect the influences of that period or diverge from it? yes → consistent

Touch

3. What is the texture and weight of the cloth or other materials used to construct the garment?

wool — not necessarily coarse, but still heavy

Sound

4. Would a person wearing this garment make noise?

not a lot

Smell

5. Does the garment smell?

a little dusty/old

PERSONAL REACTIONS

6. What was the impetus to examine this garment?
Were you interested in the person who wore it, the maker, or some other aspect of its object biography?

I liked its simplicity

7. Are you the same gender and size as the person who wore or owned the garment?
Did a person who was bigger or smaller than you wear it? Would the garment fit your body?

similar size

8. How would it feel on your body? Would it be tight or loose? Would the garment cause discomfort or pain?

I think it would be fairly comfortable, yet firm

9. Would you wear this garment if you could? Is the style and color appealing to you?

If it was during that time period, yes

10.	Does the garment or accessory demonstrate a complexity of construction or element of mastery in the design? Does the dress artifact have a functional component to the design?
	functionality: warmth, seems mass-produced

11.	Did the maker want to invoke emotion, status, sexuality, or gender roles with the garment? Does the garment seem to express humor, joy, sorrow or fear?
	militaristic – practical yet feminine

12.	Do you have an emotional reaction to the garment? Can you identify a personal bias that should be acknowledged in your research?
	no

CONTEXTUAL INFORMATION

13.	If you were permitted access to the provenance record for the artifact, what does this information reveal about the owner, and their relationship to the garment?

14.	Does the museum, study or private collection have other garments that are similar, or by the same designer/maker?
	no

15.	Do other museums have similar objects? Can you identify similar objects in online collections of dress?
	no

16.	Have other scholars written about this type of garment or the designer's work in books or peer-reviewed journals?

17.	Are there similar garments or related ephemera (advertisements, fashion photographs, packaging, and other print material) available for sale on Etsy, eBay, online vintage retailers, or on auction sites?

18.	Are there photographs, paintings, or illustrations of this garment, or of similar garments in books, magazines, museum collections, or online?

19.	Has this garment, or others like it, been referenced in documents, such as letters or receipts, or magazines, novels, and other forms of written material?

20.	If the maker of the garment is a known designer, what information is available about them? How does this garment fit into their *oeuvre*? Have there been exhibitions of the designer's work? Has the designer written an autobiography or been profiled in magazines or journals?

Index